Toledo

Treasures

Toledo

SELECTIONS FROM THE TOLEDO MUSEUM OF ART

Treasures

Hudson Hills Press, New York | The Toledo Museum of Art

This book has been published with the assistance of the Andrew W. Mellon Foundation; the Clement O. Miniger Memorial Foundation; the National Endowment for the Arts; and Sotheby's.

FIRST EDITION

Library of Congress Cataloguing-in-Publication Data
Toledo Museum of Art.
 Toledo treasures : selections from the Toledo Museum of Art.
 p. cm.
 Includes bibliographical references and index.
 ISBN 1-55595-118-X (alk. paper)
 1. Art—Ohio—Toledo—Catalogues.
2. Toledo Museum of Art—Catalogues.
I. Title.
N820.A67 1995 95-21385
708'.171'13—dc20 CIP

FOR THE TOLEDO MUSEUM OF ART
Project Supervisor: Sandra E. Knudsen
Editor: Terry Ann R. Neff, Tucson, Arizona
Photography
Toledo Treasures Plates: Tim Thayer, Oak Park, Michigan; Photography, Inc., Toledo, Ohio; and David Mohney, Rochester, New York (p. 186)
Short History Illustrations: Timothy J. Cross, Maumee, Ohio, page 18; Hanson Productions, Sylvania, Ohio, page 25; Hauger & Dorf, Toledo, page 17; Balthazar Korab, Ltd., Troy, Michigan, pages 10, 20, 26, 27, and 28; Tim Thayer, Oak Park, Michigan, page 22; The Toledo Museum of Art Archives, pages 12, 13, 21, and 23

FOR HUDSON HILLS PRESS
Editor and Publisher: Paul Anbinder
Proofreader: Fronia W. Simpson
Designer: Betty Binns
Composition: Angela Taormina
Manufactured in Japan by Toppan Printing Company
Published in the United States by Hudson Hills Press, Inc., Suite 1308, 230 Fifth Avenue, New York, New York 10001-7704.
Distributed in the United States, its territories and possessions, Canada, Mexico, and Central and South America by National Book Network, Inc.
Distributed in the United Kingdom, Eire, and Europe by Art Books International Ltd.
Exclusive representation in Asia, Australia, and New Zealand by EM International.

Contents

Foreword

THE STORY OF THE TOLEDO MUSEUM OF ART is a dramatic one. Beginning modestly in 1901, the Museum has grown over the generations both in the involvement of the community in the life of the Museum and in the careful building up of an extraordinary collection. The vast majority of the works of art shown here are the fruits of the generosity of our founders, Edward Drummond Libbey and Florence Scott Libbey. Of the 129 objects in this book, eight were their direct gifts and a hundred more were acquired wholly or in part with funds from their bequests. Many other donors have also been inspired to add significant works of many kinds to the collections over the years.

Under the terms of Edward Libbey's will and that of his wife, their estates were placed into two separate trusts with their own sets of officers. The Toledo Museum is the only beneficiary of these endowments. Edward Libbey's legacy to the Museum specifies that some funds be used for capital and operating expenses—today they still provide almost one third of our operating funds—while at least 50 percent of the income is restricted to the acquisition of works of art. This foresight is the explanation for collections that have made The Toledo Museum of Art nationally and internationally distinguished. Credit lines for works of art given by Edward Libbey or in his will read simply, "Gift of Edward Drummond Libbey," while those for objects purchased with Libbey funds after his death in 1925 read "Purchased with funds from the Libbey Endowment, Gift of Edward Drummond Libbey." Florence Scott Libbey also inherited the estate of her father, Toledo real-estate developer Maurice A. Scott. Her bequests left funds to support general operations and the education and music programs of the Museum, as well as funds for the acquisition of works of art. There are no restrictions on use, but Florence Libbey funds have often been used for accessions in the fields of American art and European decorative arts, which were of partic- ular interest to her; they are designated, "Purchased with funds from the Florence Scott Libbey Bequest in Memory of her Father, Maurice A. Scott."

The collections of the Museum range from ancient Egyptian to contemporary art, focusing on the art of the ancient Mediterranean world, Western Europe, and the United States, a pattern set by our founders. The Libbeys gave us a number of great paintings from their own collection. Edward Libbey's greatest pride was the Old Masters, but he and his wife also acquired both American and European nineteenth-century and contemporary art. One of his earliest gifts to the Museum, George Bellows's *Bridge, Blackwell's Island* (p. 153), arrived with the disclaimer: "You need not hang this canvas now unless you care to. I feel that some day it will be important, for the painter shows great promise." As the president of the most innovative glass companies of his day, Libbey was naturally interested in the art of glass making, with its intertwined strands of craftsmanship, fashion, and design. He gave the Museum more than four thousand glass objects, the foundation of our nearly encyclopedic collection of glass making from the ancient world to the present. Reproductions, both plaster and bronze, of famous classical and European sculptures were originally provided by Florence Libbey, but the Libbeys increasingly sought out the best originals. Attracted by contemporary Dutch painting, Edward Libbey purchased the work of various Dutch Hague School artists, then gradually began to buy paintings by Holbein, Rembrandt, Ribera, Constable, Turner, Homer, and other great masters. His last major acquisition, in honor of the 1926 reopening, was Manet's *Antonin Proust* (pp. 134–35).

This book offers a brief history of the Museum and highlights a selection of objects that represents the scope and quality of the collection. This is an agonizingly self-imposed, limited selection. It could readily have been doubled or tripled with as many works of first quality. The works of art are arranged in roughly chronological sequence. Rather than attempting to outline the history of art, the texts endeavor only to provide a brief commentary to tempt the reader to visit the galleries. Development of the book was very much a collaborative effort, with director and staff reviewing the selection, arrangement, and texts at regular intervals throughout the project. A special tribute is owed to Elaine D. Gustafson, who worked on the project as research curator from 1992 to 1994. She wrote many entries and contributed to many more, in addition to being in charge of photography, correspondence, and overall coordination of project details. We were fortunate to have a distinguished former staff member of the Museum, William Hutton, and a colleague from The University of Toledo, Marc S. Gerstein, add their expertise to this publication. William Hutton wrote about nineteen paintings and objects, ranging in date from the thirteenth to the nineteenth centuries, some of which he helped acquire while chief and later senior curator. He also helped write the short history. Marc Gerstein contributed eleven texts about French paintings of the nineteenth and early twentieth centuries, an area of his expertise. The Museum's distinguished curatorial staff wrote the balance of the texts. Individual author credits are listed on p. 187. The Museum's registrars, Patricia J. Whitesides and Steven J. Nowak, helped with many stages of the work. The staff of the Art Reference Library

was invaluable: Anne O. Morris, librarian; Judith Friebert, associate librarian; Diane Scoles, assistant librarian for reference; and Margaret Buhl, library assistant. Julie McMaster identified photographs from the Museum's archives. Darlene Lindner, administrative assistant, and Kimberly Oberhaus, curatorial secretary, helped everyone with endless patience. Above all, Sandra E. Knudsen, our coordinator of publications, was the ringmaster for this book. It was she who kept us on schedule, helped us to write more cogently, and also acted as author for a dozen entries and the short history of the Museum.

The editor, Terry Ann R. Neff, was invaluable as a fresh voice, drafting pilot entries, cutting and rewriting text, cheerleading, and nudging our partisan languages into line. Anne Humphrey reviewed the completed manuscript from the vantage of a docent who has explained the Museum's collections to thousands of adults and children. New photography of most objects was the work of Tim Thayer, Oak Park, Michigan. It has been a pleasure to work with Paul Anbinder, president of Hudson Hills Press, and designer Betty Binns on details of book design and copublication.

Generous grants from the National Endowment for the Arts, a federal agency, Sotheby's, the Clement O. Miniger Memorial Foundation, and the Andrew W. Mellon Foundation have supported production costs.

I am often asked how such a significant art museum came to be in Toledo. The answer is quite simple: vision. Edward Drummond Libbey and Florence Scott Libbey decided about 1900 that Toledo needed an art museum that would be the center of the life of Toledo, a home to all different kinds of groups, and the teacher of all citizens, and they dedicated much of the rest of their lives to creating a vibrant institution and to ensuring that it would live and prosper. The Toledo Museum of Art is a private, nonprofit arts institution. We believe in the power of art to ignite the imagination, stimulate thought, and provide enjoyment. Through our collections and programs, we strive to integrate art into the lives of people. Our purpose thus remains close to the desires of our founders:

Let us broaden the scope of the Museum. Let its influence enter into the civic improvement of our city, into our parks, our playgrounds, our schools, into the beautifying of our homes, externally and internally, and be a factor and an inspiration for all those things which better civilization and elevate mankind.
—E. D. LIBBEY, *Twelfth Annual Report*, 1913

The Museum's mission has evolved over the years as we have sought to more effectively fulfill the expectations of our audiences in a constantly changing world. This book continues the Toledo Museum's efforts to reciprocate regional pride in almost a century of art collecting and education. The treasures in our galleries belong to everyone, first to the Toledo community that has loyally supported its growth and care since 1901, and beyond that to the world and to the future.

DAVID W. STEADMAN

Director

May 2, 1995

The Toledo Museum of Art. This view shows the east (Peristyle) wing and center section from Monroe Street. The 1912 building, expanded in 1926 and 1933, has accommodated more than eighty years of dramatic growth in art collections, new facilities, and changing programs.

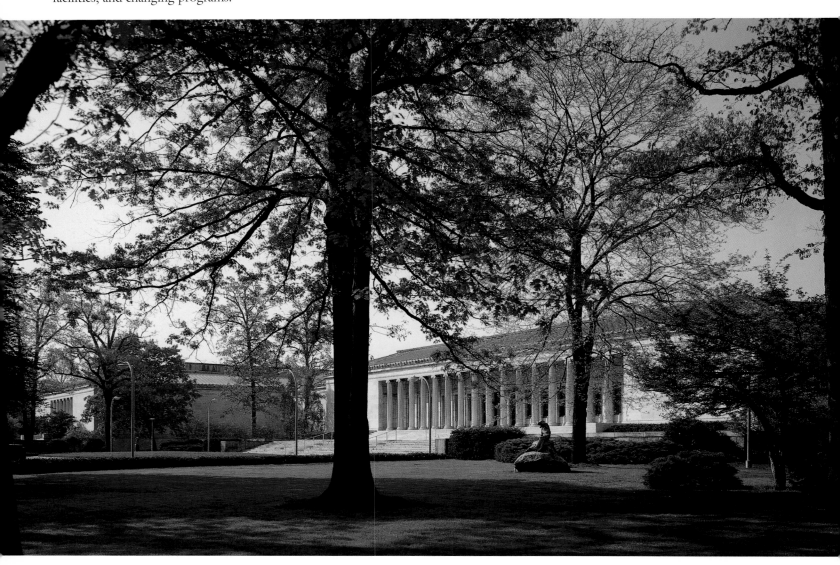

In League with the Future

A Short History of The Toledo Museum of Art

THE TOLEDO MUSEUM OF ART was founded in 1901 at a time when Americans were establishing cultural institutions fostering art, music, and literature to celebrate the social and economic triumphs of the age. People believed in progress and the unity of labor, art, and society. Clubs, societies, and institutes sprang up so that everyone could enjoy the creations of great poets, artists, and musicians. Community groups founded public art museums, which often included schools, some only for drawing and painting, others also for design and applied arts: the Museum of Fine Arts, Boston (1870), The Metropolitan Museum of Art, New York (1870), the Philadelphia Museum of Art (1876), The Art Institute of Chicago (1879), The Detroit Institute of Arts (1885), The Carnegie Museum of Art, Pittsburgh (1896), and The Saint Louis Art Museum (1904). Toledo's citizens formed groups to promote education, libraries, drama, music, and art exhibitions. The idea for a permanent museum of art surfaced at the Tile Club, begun in 1895 to provide its members an opportunity to draw from a living model. "Tilers" were prominent among the seven men who incorporated the Toledo Museum on April 18, 1901, and among the 130 men and women who signed its articles of incorporation on May 10. Suddenly an art museum existed: it had no art and no building, but there was a president (Edward Drummond Libbey), a board of fifteen trustees, and a membership.

Edward Libbey was the force that coaxed Toledo's vision of an art museum into reality. In 1888 he had brought his New England Glass Company from Boston to Toledo, attracted by cheap natural gas, good sand for making glass, and a strategic location on rail and shipping routes. The city of Toledo was becoming prosperous at the same time. From 50,137 inhabitants in 1880, population rose to 81,434 in 1890, 131,822 in 1900, and 243,164 in 1920. By 1920 a dozen Libbey companies employed tens of thousands of people worldwide, using revolutionary methods to mass-produce and market bottles, tablewares, tubing, light bulbs, and sheet glass. By then, too, Toledo's

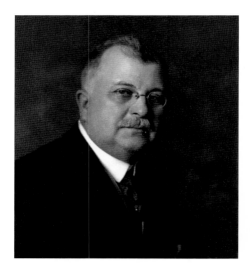 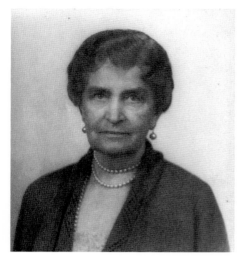

industrial focus was on the new automobile industry, employing one third
of the city's wage earners.

Libbey was born and raised in Boston, the dominant city in American
intellectual life and a leader in art education. At the age of twenty-two,
when he visited the Philadelphia Centennial Exposition of 1876, Libbey saw
the largest and most varied examples of international arts and technology
yet assembled in the United States. He must have been proud when his
father's New England Glass Company won prizes for cut-glass tablewares.
Over the next fifteen years, the company became admired for superior lead
glass cut, pressed, or decorated with engraved, enameled, or gilded orna-
ment, and for Art Glass in exotic colors and shapes. Libbey traveled in
Europe, and on trips to negotiate business agreements with major glass
houses, he also visited exhibitions, galleries, and famous churches.

Florence Scott also traveled widely in Europe, particularly Germany, as
a young woman. Her grandfather, Jesup W. Scott, one of the first editors
of the *Toledo Blade,* prospered in the real-estate business in Toledo, and gave
both land and money for the newly created University of Toledo. His three
sons, William, Frank, and Maurice, increased and developed the family real-
estate holdings up and down the Maumee River. Florence, the eldest of
Maurice's three daughters, married Edward Libbey in 1890.

The Libbeys were part of a new generation of Americans who remembered
but had not fought in the Civil War, who witnessed the final settling of the
United States, and for whom the transatlantic telegraph cable (1866), the
transcontinental railroad (1869), and the introduction of telephone and electri-
cal services to businesses and homes were proof of human progress. Natural
beauty, civic responsibility, and handmade as well as industrial products were
honored. Florence Libbey's friends included young women with professional
careers. Rosa Lang, the first German instructor at Chicago's Armour Institute
(now the Illinois Institute of Technology), may have been one catalyst that
set the Libbeys on the road to founding an art museum. In April 1900 she
introduced Edward and Florence Libbey to the president of the Armour
Institute, Frank Wakely Gunsaulus, who also was the most famous preacher

in the Middle West. An ardent supporter of education, he advocated its benefits—technical, moral, and artistic—as the birthright and obligation of all Americans. An energetic collector himself, he wrote, lectured, and encouraged communities throughout America to establish and support institutes for the arts.

The Libbeys felt a growing desire to share their good fortune with their community. A friend remembered Edward Libbey musing earnestly while watching students leave Toledo's Central High School, certain that "someone will always take care of their physical needs, but who will take care of their aesthetic needs?"

The Toledo Museum's first exhibitions in 1901 were staged in rented rooms in the downtown Gardner Building. In 1902 Edward Libbey underwrote the remodeling of a house on Madison Avenue at 13th Street; courthouse, library, and high school were all within a few blocks. After two years, both spirit and financial support flagged. As president of the board, Libbey wanted someone to provide the energy to make this groundwork come to life. George W. Stevens was held by his contemporaries to be "the best loved man in Toledo." A poet, amateur astronomer and painter, storyteller and entertainer, he had worked as a newspaperman and advertising manager and spent summers studying painting in the Catskills or sketching abroad. He had come to Toledo in 1890, and worked for several newspapers, writing humorous verse and stories that were printed around the country. His wife, Nina Spalding Stevens, had been educated at the School of Applied Design for Women and the Art Students League in New York.

George Stevens shared Edward Libbey's belief that an art museum might be made as useful to a community as its public library or its public schools: "The first thing I want to do is remove from the minds of the people the idea that The Toledo Museum of Art is an ultra-exclusive association, or an expensive luxury. It is neither one nor the other. It has something to give that all the people want and we want them all with us." He became director in November 1903; Nina Stevens was named assistant director.

A membership campaign event in 1912, showing the genesis of the broad commitment Toledo has made to its Museum.

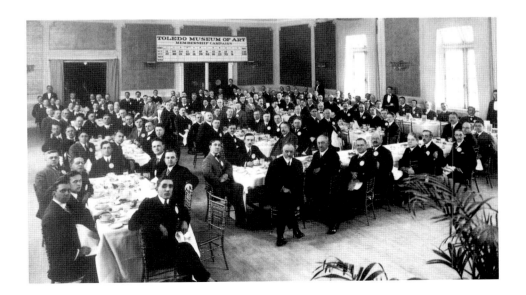

The Stevenses threw themselves into building support. The method they devised was breathtakingly practical: mass art education of all the children and citizens of the city. George Stevens coaxed the newspapers to publish a steady stream of reviews, announcements, and anecdotes about how the life of Toledo was enhanced by the art museum. Nina Stevens talked tirelessly to new clubs to study art history, free drawing and life classes, the Athena Society of women artists, the Toledo Camera Club for young men, and gave daily talks on exhibitions in the galleries and noontime talks to working women. Close relations were established with the schools, and the activities of the Museum were carried into stores, factories, and churches. The dynamic husband-and-wife team inspired and cajoled the entire city over the next twenty-five years into a lasting understanding that an art museum was vital to the health and welfare of Toledo.

The Collection

In the beginning there was no collection, a condition that altered very slowly, given years of shoestring budgets. The Stevenses sought to fill the void with the nucleus of the present Art Reference Library and casts of celebrated sculptures. Edward Libbey begged friends and fellow trustees to help. A few people bought paintings from visiting exhibitions, and there were sporadic gifts. Edward and Florence Libbey traveled to Egypt for the winter of 1905–6 and sent back hundreds of objects, ranging from a mummy and amulets to fragments of low-relief carvings. Working with minimal resources, as there would not be significant art purchase funds until far later, George Stevens initiated the graphic-arts collection, buying at the 1911 estate sale of the American artist John LaFarge, and forming a remarkable collection of the French etcher Charles Meryon. Another of Stevens's wide-ranging interests focused on the history of writing, printing, illustration, and binding, a field into which art museums have seldom ventured in such depth; the arts of the book have thus become a distinctive feature of Toledo's graphic-arts collection. Another significant step was taken in 1912, with the opening of the first part of the present building: Florence Libbey established the Maurice A. Scott Gallery for American art in memory of her father; in it were the Winslow Homer (p. 139), George Bellows (p. 153), Frederic Remington (p. 152), and Childe Hassam, to which the Libbeys later added paintings by J. A. M. Whistler, Ralph Blakelock, and Albert Ryder.

Edward Libbey determined to build a comprehensive glass collection "which would show the complete development of the art from antiquity to the present." In 1913 he acquired some eighty pieces of European glass, and in 1917 the entire collection, almost five hundred objects, formed by the pioneer historian of American glass, Edwin AtLee Barber. Two years later he bought the vast and nearly encyclopedic Thomas E. H. Curtis collection of ancient and Islamic glass. In later years, Owens-Illinois, the successor parent company of Libbey Glass, gave its corporate collection of Libbey wares from the 1880s to the 1940s (p. 150), and in the 1960s and 1970s the Museum received the early American pressed and related glass collected by Mr. and Mrs. Harold G. Duckworth. The Museum's commitment to

contemporary studio glass has been strengthened in recent years by gifts from artists Dominick Labino and Dale Chihuly. Collectors Dorothy and George Saxe significantly enhanced the collection with their 1990 gift of glass from the late 1970s and 1980s (p. 176).

In 1922 Arthur J. Secor, then vice president of the board, said to George Stevens: "I watch the procession of people, men, women, and children, passing by my house [on Scottwood Avenue, opposite the Libbeys' Toledo home] on Sunday, a never-ending file up the street to the Museum, and I turn around and look at my collection of paintings and feel selfish. I am giving them to the Museum tomorrow." By 1933 he had given his entire collection, which reached from seventeenth-century Holland to 1890s America, with particular strength in the nineteenth-century French Barbizon School and painters related to it.

At Edward Libbey's death in 1925, his own collection was left to the Museum. The first pictures he had owned were by the Barbizon painters and their Dutch Hague School contemporaries, but after he bought the early Rembrandt (p. 88), it was joined by outstanding pictures by Hans Holbein the Younger (p. 71), Jusepe Ribera (p. 89), John Constable, and J. M. W. Turner (p. 123). His last major acquisition, made in anticipation of the 1926 building expansion, was Edouard Manet's *Antonin Proust* (pp. 134–35).

Following Libbey's death and that of his wife in 1938, the Museum had increasingly generous acquisitions funds. Blake-More Godwin, employed as curator in 1916, and director from 1927 to 1958, continued the efforts to build a collection that would be known for the quality of its carefully selected works of art. Godwin proceeded to acquire Islamic art; medieval, Renaissance, French Impressionist, and American painting; Asian art; and glass. His first purchase was a flask of Mamluk enameled glass, a peer of the lamp in this book (p. 61). In steady succession came major paintings by Edgar Degas (p. 147), Claude Monet (p. 162), Vincent van Gogh (pp. 142–43), Edward Hopper (p. 159), Pablo Picasso (p. 154), Piero di Cosimo (pp. 66–67), Paul Gauguin (pp. 144–45), and El Greco (pp. 80–81). Other works included the late Roman beaker (p. 50), Persian pottery (p. 60), the Guo Hsi scroll (pp. 54–55), the Cloister arcades (pp. 56–57), and sculpture by Auguste Rodin, Pierre Renoir, Aristide Maillol (p. 161), and Henry Moore.

World War II slowed Museum acquisitions to a trickle, but Blake-More Godwin and his associate director, Otto Wittmann, who joined the staff in 1946, becoming director in 1959, recognized the unique opportunities of the postwar international art market. Wittmann drew up a plan for broadening the collection, recommending that the primary criterion be the acquisition of art of the highest quality without regard to its culture, material, or an artist's relative unfamiliarity. By the time Wittmann retired in 1977, the collection had tripled in size. He formed significant bodies of seventeenth-century Dutch and Flemish and eighteenth-century French painting, two major fields that were then temporarily out of the limelight. He was early

among those whose timely acquisitions acknowledged the stature of seventeenth-century Italian and French, eighteenth-century Italian, and nineteenth-century American art. He led the collections into new fields, giving, for example, medieval enamels and ivories, or later furniture, metalwork, and ceramics, the same discriminating attention as other art forms, often emphasizing this by directly associating the decorative arts with painting and sculpture. He greatly strengthened the art of the ancient Mediterranean cultures and initiated the African collection. The graphic arts were significantly enriched, and extended to include photography. Almost half of the works illustrated in this book were acquired during Wittmann's tenure; his connoisseurship established the excellence of the collection, an accomplishment that gained him and the Museum international recognition.

Roger Mandle, associate director from 1974 and director from 1977 to 1988, was responsible, working with the Museum's curators, for a series of outstanding acquisitions in virtually every field in which the Museum collects. While these included antiquities such as the amphora by Exekias (pp. 38–39) and paintings by Jacopo Bassano (pp. 72–73), Valentin de Boulogne, Jacob Jordaens, Rembrandt, Thomas Gainsborough, and Jean-Antoine Gros (p. 115), there was particular emphasis on seeking major twentieth-century works. The Pablo Picasso (p. 155), Marsden Hartley (p. 157), Piet Mondrian (p. 165), Max Beckmann (pp. 170–71), Joan Miró (pp. 168–69), Henri Matisse (pp. 172–73), Louise Nevelson (p. 174), and Mark di Suvero (p. 178) are among the results of this effort. In 1984 a magnificent gift from Molly and Walter Bareiss of books by modern artists (see p. 148) at once made the Museum a prime resource in that field. The Apollo Society, a support group for art acquisitions, was inaugurated in 1986. Each year its members choose one field in which the appropriate curator presents candidate works; the members' vote determines the new accession (pp. 177 and 181).

In the six years that David Steadman has been director, this distinguished tradition has been furthered with exemplary works ranging from the ancient Roman portrait of Domitian (pp. 46–47), Bertel Thorvaldsen (p. 114), and Eugène Delacroix (p. 117) to Constantin Brancusi (pp. 166–67), Anselm Kiefer (p. 179), and Dale Chihuly (p. 177). The Museum has also commissioned works from Howard Ben Tré (p. 183), Sol LeWitt (pp. 184–85), and Wendell Castle (p. 186).

Over the past twenty years, several major components of the Museum's collections have been published in scholarly catalogues. Those of the European (1976) and American (1979) paintings have been paralleled by two volumes of the *Corpus Vasorum Antiquorum* devoted to ancient Greek vases (1976 and 1984). More recent are catalogues of the early ancient glass before the invention of glass blowing (1989), *Contemporary Crafts and the Saxe Collection* (1993), and American glass from 1760 to 1930 (1994). Those of glass from the lands ruled by ancient Rome are forthcoming.

More than sixty thousand visitors thronged to see *Vienna Art Treasures,* on view in Toledo for only four weeks in 1951. Here tapestries and armor from the imperial Hapsburg collections are seen in what is now the Great Gallery (compare p. 26).

Exhibitions

When the Toledo Museum was young and had virtually no collection, exhibitions were its mainstay. George and Nina Stevens received, hung, taught, and packed up as many as sixteen exhibitions a year, few of them on view for more than two or three weeks. Most American museums benefited from a cycle of traveling exhibitions. These ranged from ones organized by art dealers and artists' associations to those featuring local artists. In 1905 the Libbeys and Stevenses met Paul Durand-Ruel in Paris. He arranged for the first show of Impressionist paintings ever in Toledo, which dazzled and bewildered the town, and in 1907 an exhibition of Henry Ossawa Tanner's paintings first attracted African-American audiences.

The 1912 Inaugural Exhibition for the new building was an extravaganza of American, European, and Japanese painting and sculpture lent for the occasion. For forty years, beginning in 1914, an annual summer exhibition of paintings on the art market gave private buyers and the Museum one means of considering contemporary work. Another series, which has continued unbroken from 1918 to the present day, is the annual juried exhibition organized by the Toledo Federation of Art Societies in cooperation with the Museum; this is the most comprehensive view of current work in all media by artists from seventeen counties in Ohio and Michigan.

After the building was enlarged in 1926, the number and types of temporary exhibitions were strengthened. Blake-More Godwin projected one substantial show of foreign painting each year, starting with a centennial exhibition of Goya in 1928, and another of American art, in addition to a large number (no fewer than thirty-eight in 1935) of smaller shows. In 1939 and 1940 visiting scholars organized major surveys of Spanish and Venetian painting, the most art-historically significant exhibitions yet staged here. Another landmark event featured forty-three masterpieces of European painting lent to the New York and San Francisco world's fairs, which later toured American cities, including Toledo in 1940.

Two landmark workshops, conducted by Harvey Littleton with Dominick Labino on the grounds of the Museum in 1962, proved that it was possible for artists to melt and blow glass under studio as well as factory conditions. Here Littleton (seated) and Labino (right) demonstrate glass blowing for a CBS camera crew in 1970 in the new Glass-Crafts Building, in conjunction with the exhibition *Glass National III.*

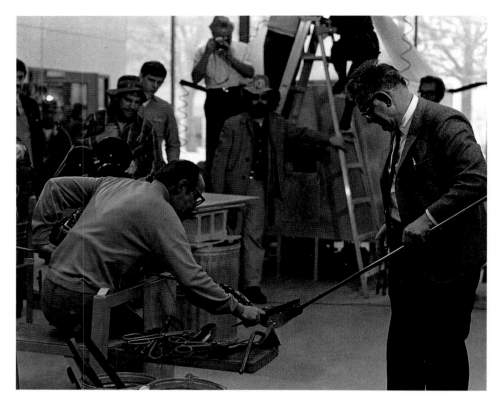

Following World War II, two altogether extraordinary exhibitions toured the United States under American military escort: *Masterpieces from the Berlin Museums* in 1949 and *Vienna Art Treasures* in 1951. The feat of attracting many tens of thousands of visitors for the Berlin pictures and the brilliant Vienna exhibition placed Toledo among significant American exhibition venues. There followed a succession of major international exhibitions such as *Van Gogh* and *Dutch Painting, the Golden Age,* the latter organized by Toledo with The Metropolitan Museum of Art, New York, and the Art Gallery of Ontario (both 1954); *German Drawings* (1956); *São Paulo Masterpieces* (1957); and *British Paintings of the 18th Century* (1958). Otto Wittmann enhanced this vigorous program, including *The Splendid Century: French Art 1600–1715* and *The Arts of Thailand* (1961); *Barbizon Revisited* (1962); *Treasures of Versailles* (1963); *The Age of Rembrandt* (1966); *Libbey Glass 1818–1968* (1968); and *Painting in Italy in the 18th Century* (1971). Wittmann further initiated *The Age of Louis XV: French Painting 1710–1774* (1975). A consortium of four museums in Toledo, Detroit, Cleveland, and Buffalo then organized *Heritage and Horizon: American Painting 1776–1976* to mark the Bicentennial.

Contemporary glass art leaped into Toledo's consciousness in 1960, when programs built around the exhibition *New Design in Glass,* organized by The Corning Museum of Glass, attracted more than 50,000 visitors. In 1962 the grounds of the Toledo Museum were the site for two pioneering workshops that demonstrated how artists working independently of a factory could use molten glass as a creative medium. The studio glass movement, which

recognizes these workshops as its starting point, shortly became of such importance that Toledo organized the first national juried exhibition of American glass artists, the *Glass National* exhibitions, the second of which in 1968 was so successful that the Smithsonian Institution arranged to circulate it to twenty museums nationwide. In 1972 Toledo organized *American Glass Now* jointly with the Museum of Contemporary Crafts, New York, a traveling exhibition to mark the tenth anniversary of the studio glass movement. The Museum has sustained its encouragement of contemporary glass, most recently with *Contemporary Crafts and the Saxe Collection,* circulated to three American museums in 1993–94.

The 1980s and 1990s saw some extraordinary projects spearheaded by the Museum, most notably *El Greco of Toledo* (1982), initiated by Roger Mandle and organized with the Museo del Prado, Madrid, and the National Gallery of Art, Washington, which set a Toledo attendance record that stood unbroken for ten years. In 1984 the Museum, the Arts Commission of Greater Toledo, and Crosby Gardens, now the Toledo Botanical Gardens, organized the *Citywide Contemporary Sculpture Exhibition,* showing new work by thirty-three sculptors. *Silver for the Gods: 800 Years of Greek and Roman Silver* (1977) and *The Amasis Painter and His World* (1985), the first one-man exhibition of an ancient Greek vase painter, reflected the strength of the ancient art collection. With four other museums—The Carnegie Museum of Art, Pittsburgh; The Minneapolis Institute of Arts; The Nelson-Atkins Museum of Art, Kansas City, Missouri; and The Saint Louis Art Museum—Toledo formed a consortium sharing both art and staff to organize two major exhibitions: *Impressionism* (1990–91) and *Made in America: Ten Centuries of American Art* (1995–96). Using opportunities created by extended renovations, the Museum has also several times presented its own collections afresh, including the important loan of American paintings to the IBM Gallery, New York, in 1986; the 1989 in-house exhibition *Baroque: Splendor and Drama 1600–1750;* and the spectacular 1994 Canaday Gallery installation *Toledo Treasures,* a dazzling feat that made most of the European collections available during *The Age of Rubens,* the magisterial sequence of seventeenth-century Flemish painting for whose Toledo showing David Steadman was instrumental; the exhibition set a new record of 234,030 visitors.

There can be few cultures, periods, or media not represented at various times by major showings: Asian art; nineteenth- and twentieth-century painting, sculpture, and work by craftsmen; ancient art; African art; the Old Masters; the decorative arts of many eras; video art; industrial design; and folk art. Prints, drawings, the book arts, popular art, musicology, and photography have been the media for large numbers of major presentations. Non-Western art has long been featured in significant exhibitions. In 1981 the Museum created a minority advisory committee to help plan programs to reach a wider constituency. Now named the Committee for Cultural Diversity, its members play an expanding role in the development and evaluation of Museum programs.

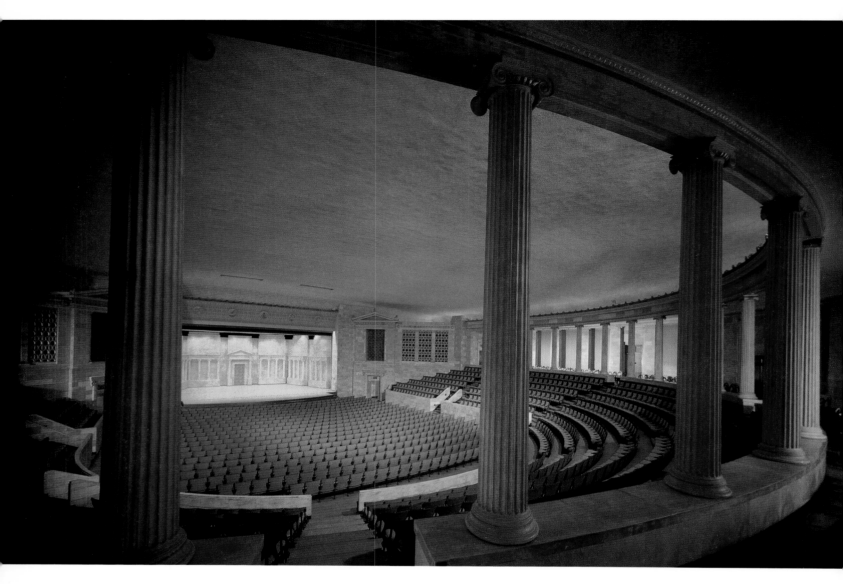

Music

From early years music was among the arts in which the Museum took an active role. Encouraged by Florence Libbey's own interest in music, this direction developed in a way exceptional among art museums. In 1931 a professional staff position was established to prepare both programming for the Peristyle then under construction and for education in music appreciation, history, and theory. Peristyle concerts presented international orchestras, ensembles, and soloists, and a later Gallery Series featured major chamber musicians. There has also been a long tradition of recitals and concerts by artists from the region served by the Museum. Since its founding in 1943, the Toledo Symphony has traditionally performed in the Peristyle, and in 1995 a new association was forged between Museum and Symphony.

Education

From the beginning the Museum took a strong interest in art education. In his first annual report as president, Edward Libbey suggested that the Museum "allow teachers and pupils free admission to all exhibitions upon certain days, for it is my opinion that the object of our institution, the

education in and cultivation of art, can find no better field than in our public schools." A year later he voiced the then-revolutionary proposal that the Museum be open to the public free of charge every day of the year. Museums around the country requested copies of the February 1908 issue of the *Museum News,* devoted to descriptions of programs benefiting more than five thousand children.

In 1919 a house on one side of the Museum was converted into a School of Design furnished with looms, potter's wheels, kilns, workshops, studios, and classrooms. Nina Stevens was named dean of the School; later Molly Ohl Godwin, wife of director Blake-More Godwin, took over and continued its ambitious programs from 1927 through World War II. The curriculum was based on the theory that "all forms of art expression are essentially dependent upon design principles" and could be taught like language, with rules for color, shape, and line. Free Saturday art classes for children were reformulated in a disciplined sequence of five levels, music in three. Instruction in methods for art teachers began in 1924, and a landmark class for children of preschool age was inaugurated in 1934.

By the 1950s the School no longer taught applied arts, focusing instead on the fine arts. Strengthening the program by emphasizing opportunities to study original works of art in the galleries was a goal of Otto Wittmann, Godwin's successor as director: "Without art the Museum would be only a school. Without education the Museum might become only a warehouse. Both must be present if the Museum is to continue to play its significant cultural role in our community." The training program for volunteer docents, inaugurated in 1947, has greatly increased access to the collections through gallery talks for schools and adult groups. Music docents were added in 1969.

Starting in 1921 the Museum agreed to provide all art courses for credit at The University of Toledo, offering instructors, studio space, library, and access to the collections. From 1938 to 1941, a Carnegie Corporation grant supported an annual visiting scholar, whose duties included the first graduate-level art history instruction for University of Toledo and other

The Museum Docents are a hundred women and men who undergo rigorous training before they begin explaining the collections and exhibitions to children and adult visitors.

Sculptor Albert Paley (right) conducting a public demonstration in the Center for Sculptural Studies during the *Art to Art* residency program in 1995, as part of the seventy-fifth anniversary celebration of the collaboration between the Museum and The University of Toledo Department of Art.

students. In 1985 University art disciplines in studio art, art education, and art history, although still housed in the Museum, were administratively separated from the nonacademic programs in museum education, and in 1987 they were formally constituted as the Department of Art of The University of Toledo.

The joint 1989–91 capital campaign of the Museum and University of Toledo had two significant results for education at the Museum. The University's Center for the Visual Arts was built adjacent to the Museum. The connecting passageway symbolizes the benefits of a great art collection closely linked with excellent facilities for art history, art education, and studio art. The combined resources and efforts of the University and the Museum have created a strong visual-arts program.

Museum space vacated by University classes has been reborn as the Godwin Center for Museum Education. Its new facilities include the Community Learning Resource Center, which offers books, video and audio tapes, materials for teachers, and electronic media for study and loan, and a refurbished and expanded slide library. The Godwin Center continues to provide art and music tours for school children and adults; early childhood programs to introduce very young children to art, artists, and art museums; classes for children; and studio classes for adults, including the studio glass and photography programs, as well as public lectures, demonstrations, and performances.

The Building

The first Museum building was a converted house on Madison Avenue to which were added exhibition galleries and classrooms. George Stevens argued that as long as the Museum occupied a temporary building, no one would make gifts of any great importance; but once in its own permanent building, the collection would grow. Although this plea came in the middle of the 1908 recession, Libbey announced he would pledge $105,000 if the Toledo community would raise $50,000. It was raised in less than twenty days. The ten thousand school children who crowded the Museum contributed $500 in pennies, nickels, and dimes, which Stevens cannily exhibited in a great pile in a downtown bank window, generating nationwide publicity. The outpouring of popular enthusiasm so pleased the Libbeys that

Edward Libbey increased the value of his pledge, giving works of art from his own collection, while Florence Libbey gave the building site on Monroe Street, the former home of her father, together with adjacent property.

As president of the board, Edward Libbey took an active role in the creation of the new building, including the study of museum buildings in Europe and America. He met Edward B. Green, of the firm Green & Wicks, architect of Buffalo's acclaimed Albright Art Gallery (1905), and commissioned Green to design the new Toledo Museum of Art, "the style being Greek Ionic of the Periclean period." The main floor had an entrance court (see p. 158), twelve galleries, library, offices, and a hemicycle auditorium. The building comprised what is today the front half of the center of the Museum. Dedicated in front of an overflowing crowd on January 17, 1912, it immediately changed the way the Toledo Museum was perceived. The budget was still a shoestring, but people crowded in. Attendance in 1913 leaped to 97,234, or 57 percent of the city's population, and to nearly 118,000 in 1914.

After only five years Stevens announced to Libbey and the board that the new building was already too small to serve visitors properly and needed at least to double in size. Libbey—his resources having grown from the initial stock offering of the Libbey-Owens Sheet Glass Company, as well as the extraordinary success of product, licensing, and royalty income from his other companies—agreed to give $400,000 to a building fund, provided half that amount were pledged by popular subscription. By the end of the year, Stevens succeeded in raising the money, but World War I intervened and construction was postponed indefinitely.

In 1923 Edward Libbey promised $850,000 to pay for the additions and left on a long trip abroad, while George Stevens and Blake-More Godwin supervised the expansion. The Monroe Street façade was not changed, but Edward Green designed a fourteen-column portico on the Grove Place façade, doubling the size of the building. The additions provided a larger auditorium and created an interior circuit of galleries. More than six

Ground-breaking in March 1924 for the first expansion of the Museum building. Director George W. Stevens wields the shovel in front of a small group of Museum trustees and staff, including Blake-More Godwin, curator, immediately behind Stevens, and Nina Stevens, dean of the School of Design, second from Godwin's left.

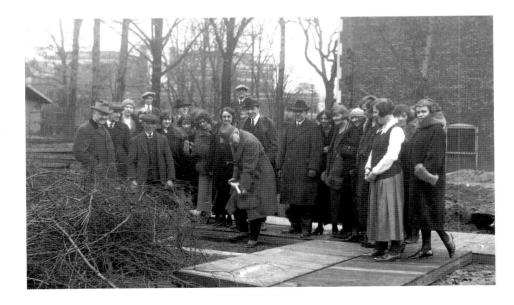

thousand objects waited in storage to fill the thirteen skylit galleries. Edward Libbey returned in the fall of 1925 to admire the galleries in the process of installation, but he died suddenly in November, mourned by the entire city. The reopening festivities in January were subdued by Libbey's death, and less than a year later, in October 1926, George Stevens died, mourned as deeply as his friend and patron.

The loss of both Libbey and Stevens was devastating to the city, but the Museum confidently continued to grow according to their vision. In twenty-odd years the Museum had become a solid reality. In 1903, 15,000 people visited the Museum; in 1926, 150,000. Staff had grown from two to about forty.

Edward Libbey left the Museum generously endowed, not only to acquire works of art (see Foreword, p. 7) and to conduct educational programs, but for future enlargement of the building. Then in the spring of 1930, when ten thousand Toledo workers were unemployed, Florence Libbey renounced her life interest in the funds designated in her husband's will, so that "work might proceed at a time when the expenditure of a large sum of money would do the greatest economic good." Edward Green and his son were invited to design east and west wings for the just recently expanded building. The ground level of the west wing was to provide classrooms and studios, with galleries on the main floor. East-wing additions included the Classic Court and the 1,710-seat Peristyle. At its opening in 1933, the Peristyle was seen as the aesthetically and acoustically finest and best equipped concert hall west of the Atlantic coast. Its achievement, as well as its general form, inspired by ancient Greek theaters, was due to Florence Libbey. Renovations have ensured its status among distinguished venues for music, dance, and other presentations. Before work on the new building was completed, medieval architectural elements had been acquired to create the Cloister (pp. 56–57). More than 2,500 workers had been employed on these vast new additions, dedicated in January 1933. Much of the new space was left unfinished, to be completed as future accessions warranted. This foresight meant that after 1945, the empty spaces of the east and west wings could gradually be filled by galleries. In 1958–59 the building was air-conditioned to control temperature and humidity to protect the works of art. Year by year the Museum revised the installations of its growing treasures of Dutch, French, American, English, and Italian art. Otto Wittmann's comment was that "the greatest untold story in this community is the growth of the permanent collections . . . since the end of the war."

Somewhat unusually for an American urban museum, the Museum is sited in a residential neighborhood, though it fronts on a principal street. In the early 1930s the Museum had bought property across Monroe Street to create a small park. Before construction of Interstate 75 began in the 1960s, Wittmann persuaded highway planners to swing its route away from the Museum building. More land was acquired to form a parking area, and in the 1970s, through the foresight of trustees, considerable additional land was acquired. Today twenty-six acres surround the building, and in cooperation with neighboring churches, businesses, and the Old West End historical district's residents' groups, a plan was developed in 1984 for long-term

development of the area. A comprehensive landscape-design project for the Museum's surroundings was initiated in 1995.

A Glass-Crafts Building, the gift of Owens-Illinois, Inc., Libbey-Owens-Ford Company, and Owens-Corning Fiberglas Corporation, dedicated in 1969, houses studio workshops for glass and ceramics. In 1970 the two-story Art in Glass gallery within the Museum was funded by Mr. and Mrs. Harold Boeschenstein to display some two thousand objects; a further six thousand are in the John D. Biggers Glass Study Room, opened in 1976.

A new public entrance on Grove Place in 1972 made the galleries and classrooms more accessible from the parking lot. Galleries for graphic arts led to the new Grace J. Hitchcock Print Study Room, and a restaurant, museum store, and the Little Theater lecture hall were also created to serve visitor needs. Collector's Corner was initiated by the Museum Aides as a sales and rental gallery featuring the work of regional artists and craftsmen.

From 1977 to 1992 the Museum embarked on a four-phase program of major renovation. Phase I made essential modifications to the education facilities, including the Plough Pavilion entrance, student gallery, and music classrooms. In 1980–82, Phase II, designed by the New York architectural firm of Hardy Holzman Pfeiffer, achieved an ambitious remodeling of the center core to create a new ground-level public entrance and Herrick Foundation Lobby, visitor facilities, a skylit stairway from the Tillotson-Fallis Court linking the ground and main floors, and the Ward and Mariam Canaday Gallery for special exhibitions in the large space once occupied by an auditorium. In 1987 Phase III renovated the Museum's fifteen oldest galleries surrounding the center core.

Renovation and new construction comprised under Phase IV were funded by the Museum's first public capital campaign, led by its trustees, and undertaken in cooperation with The University of Toledo. Extensive internal renovation from 1990 to 1992 included the Peristyle concert hall and comprehensive work by the Chicago architectural firm of Hammond Beebe and Babka that extensively modified the Classic Court and west-wing galleries. To improve circulation, a dramatic east-west axis was opened through the building, the Great Gallery was given a grandly classical

Three Museum directors celebrate the reopening of the renovated west-wing galleries in November 1991: (from left) David W. Steadman, Otto Wittmann, and Roger Mandle.

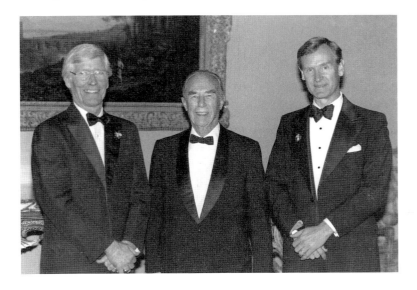

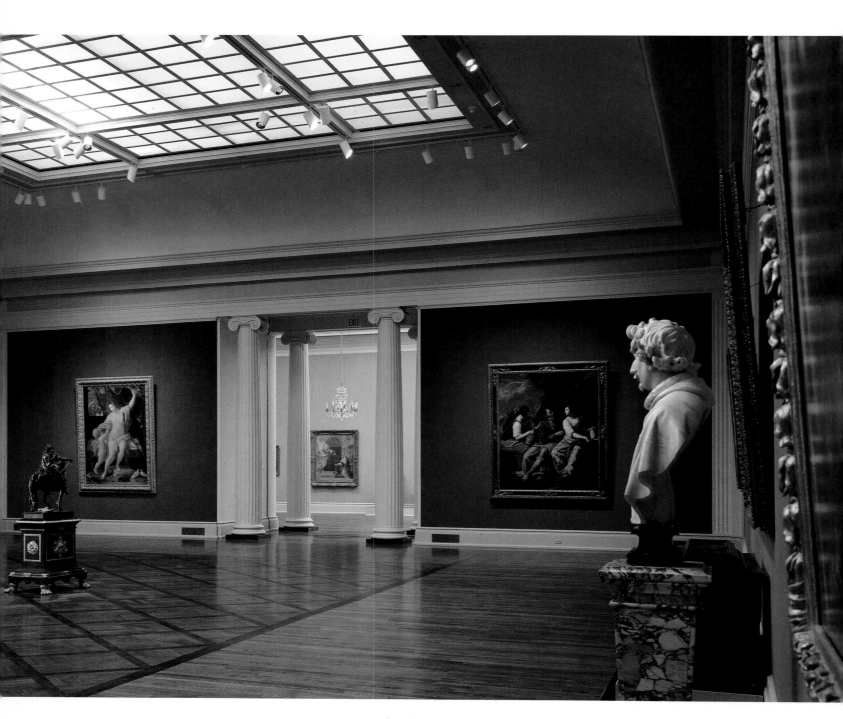

Renovations to the Great Gallery in 1990–91 raised its ceiling and shortened its length to create a spatially harmonious double cube. Other changes included a deep cove molding, a stately entrance flanked by Ionic columns, warm red wall covering, and rich parquet flooring to set off the Museum's most grandly scaled examples of Baroque art.

treatment, and other spaces were reorganized or their architectural details augmented and refined in harmony with the building's basic style. Clerestories replaced skylights for improved protection against ultraviolet light, while still retaining the Museum's widely esteemed generous natural lighting. Heating, air conditioning, and humidity controls were extensively updated. Revisions also created the Museum's first adequate laboratory to serve its comprehensive art conservation program.

A further aim of Phase IV was a new building for the University's department of art, long located in the Museum itself, that would also house the

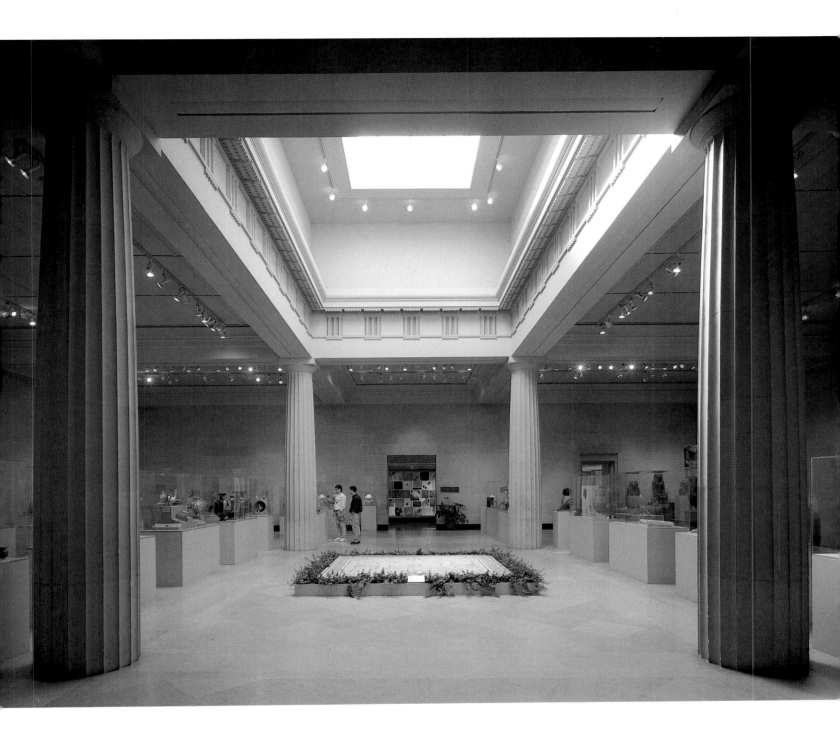

Cutting a light well through the ceiling and roof was the most dramatic change during the 1990 renovation of the 1933 Classic Court. Sunlight bathes the collection of art of the ancient Near East, Egypt, Greece, Italy, and Rome. The glass mural *Vitrana* (1969) by Dominick Labino is seen through the far doorway opening into the Art in Glass gallery.

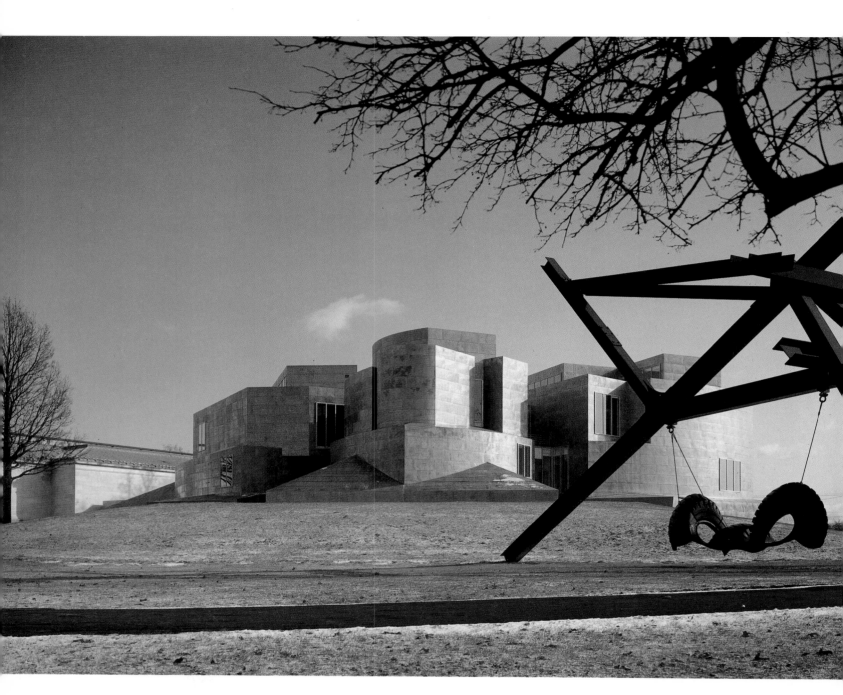

The Center for the Visual Arts of
The University of Toledo, adjoining the
east wing of the Museum. Designed by
Frank O. Gehry and Associates Inc., and
completed in 1992, it houses studio,
lecture, and student facilities, offices, art
supply store, exhibition gallery, and the
Museum's Art Reference Library.

Museum's Art Reference Library. Following a nationwide search, Frank O. Gehry of Los Angeles was chosen as the architect. He sited this four-level structure, dedicated in December 1992, adjacent to the Peristyle wing. Its strongly sculptural silver-gray metal and green glass forms are a striking counterpoint to the Museum's severely classical style. On a nearby site, Gehry also designed the studio workshop for sculpture and metalwork.

Development

The endowments created by Edward and Florence Libbey, and the missions they envisioned, have inspired many donors in succeeding generations. Their support has been, and is, essential, for it is only with the continuing generosity of many that this great institution will meet the needs of the future. It could be said that the entire history of the Museum has been one of unbroken, many-sided development. In a specific sense, for example, members have helped to support education programs since the early days. Since its founding in 1957, the Art Museum Aides has made the annual membership campaign its principal mission. Other volunteer services have also developed to the extent that more than six hundred individuals now act in some dozen different capacities. But it was not until the 1960s that the trustees and director established an office responsible for planning the Museum's future fiscal well-being. The President's Council was founded to encourage major donors, and more recently the Business Council and the Museum Partners have been organized to attract new energies to the Museum's many missions.

In 1995 The Toledo Museum of Art is strong, vital, resilient, and growing. It reflects the region's broad cultural context and the hundreds of people who support its missions. Its reputation is based on the quality of the collections of art and their distinguished presentation in beautiful galleries; it also rests on the many varied and excellent programs, classes, concerts, and activities that benefit so many adults and children. The staff has grown from two to almost two hundred, and the Museum has an annual operating budget almost a thousand times that of its founding years. But we believe that if they were to return today, Edward and Florence Libbey and George and Nina Stevens would immediately recognize their vision at the core of our daily work:

> The Toledo Museum of Art is now, we believe, fixed upon a permanent basis. . . . We believe it is worthy of the earnest support of every citizen in Toledo, and the work now being done, and which will be done in the coming years, will prove not only beneficial to our citizens but will have an influence toward higher education . . . which will bring pleasure and benefit to all.
> —E. D. LIBBEY, *Twelfth Annual Report*, 1913

29

Toledo

Treasures

Egyptian, early Dynasty 11 (2123–about 2040 B.C.)
Stele of Zezen-nakht, about 2000 B.C.

THE BOLD FIGURE of Zezen-nakht stands as a commanding presence facing the tightly packed lines of brightly colored hieroglyphs on this stele, or gravestone. He is shown as embodying the power and nobility idealized by the ancient Egyptians. His skin is brick red, tanned by years of overseeing workers in the harsh sun on his estates. The trappings of his wealth and success are carefully rendered—intricately beaded wig; clean-shaven face; amber, yellow, and blue-green collar piece and wrist bands representing carnelian, gold, and faïence beads; freshly starched linen kilt; and tooled leather sandals. His walking stick and wand are symbols of authority.

This stele was originally placed in the offering chamber of Zezen-nakht's tomb in a vast cemetery at Naga-ed-Dêr, a village in Upper Egypt, about seventy miles northwest of Thebes and Karnak. The stele is one of nearly a hundred from this site.

For about two hundred years, from the end of Dynasty 6 to the beginning of the Middle Kingdom with Dynasty 11, the landed nobility challenged the power of the pharaoh, and the weakened central government watched helplessly as nobles vied among themselves. The tombs of this period of strife, called the First Intermediate Period, are humble in comparison to their Old Kingdom predecessors. In Naga-ed-Dêr, tombs carved into the soft rock along the banks of the Nile are frequently little more than burrows comprising a simple offering chamber with undecorated mud-plaster walls. The deceased were buried in pits under the floors of these chambers or in tunnels in their back walls. Steles like this were positioned against the rock wall near the burial pit or mounted into the mud-brick wall blocking the entrance to the burial tunnel.

Ancient Egyptian hieroglyphs, pictorial symbols for sounds and words, were carved in relief and painted bright colors. The inscription on this stele tells us that Zezen-nakht was a hereditary prince and an overseer of the army, both common titles for officials of high rank. The inscription also mentions that he was beloved of his father, praised by his mother, and loved by his brothers, sisters, and his troops. Below the inscription a carved row of funerary offerings represents food for Zezen-nakht in the afterlife; the items form a virtual inventory of what could be found in the pantry of an ancient Egyptian house.

From the village of Naga-ed-Dêr in Upper Egypt; Stuccoed limestone with polychrome paint; 29½ × 36 in. (74.9 × 91.5 cm); Purchased with funds from the Libbey Endowment, Gift of Edward Drummond Libbey, 1947.61

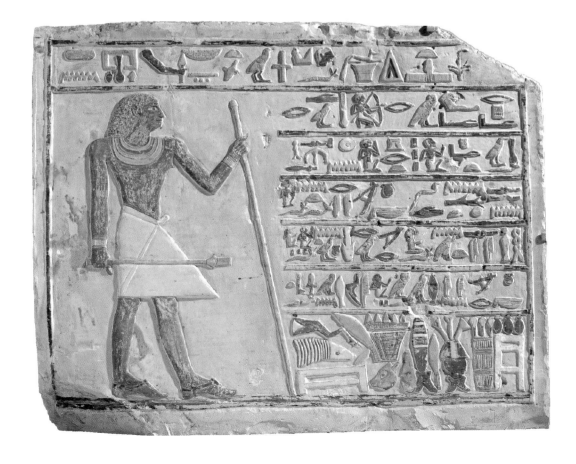

Sumerian, Early Dynastic (about 2900–2460 B.C.)
Head of a Female Votive Figure, about 2600 B.C.

THE INTENSE STARE, even from eyeless sockets, gives this face a haunting quality that hints at the supernatural. Indeed, this head once crowned a figure commissioned by a private donor for a temple. The size of the head indicates that the complete figure, if upright, must have been among the largest of its kind. The unnatural thickness of the neck was necessary to support the massive head. The hands of such votive figures, usually folded across the chest, often hold vessels in which offerings to the deity could be placed.

When it was made, this head would have had a far more naturalistic appearance. Evidence from comparable examples indicates that the eyes were inlaid with shell, with disks of lapis lazuli forming irises and pupils. The eyebrows and the groove between the brow and the turban were once filled with dark bitumen, which not only represented the hair protruding from under the turban but also framed the upper portion of the face with a dark line against the pale alabaster. Even the edges of the eye sockets were outlined in bitumen to represent kohl, the dark eyeliner used by both men and women. The holes through the fleshy earlobes once held gold earrings, perhaps enriched with lapis lazuli.

The region of the Tigris and Euphrates rivers is almost devoid of stone suitable for sculpture. Material for statues such as this had to be imported at great expense, and thus there was little opportunity for Sumerian sculptors to hone their technique on practice pieces. Yet, oddly enough, Sumerian votive figures appear fully developed: the carving is masterful. Here, for example, the stiff pleats of the ample, lobed turban capture the texture of a linenlike fabric, and the contrasting smooth polishing of the alabaster skillfully conveys the appearance of skin. The benevolent smile and the slight upward tilt to this head, lifted in prayer, have a telling intensity. The serene, optimistic expression implies the confidence and sophistication of the culture of Sumer.

Reported to have been found in the region of the Diyala River, perhaps Khafaje, east of Baghdad in modern Iraq; Alabaster; H 6¹¹⁄₁₆ in. (17 cm), W 7⁹⁄₁₆ in. (19.2 cm), D 7⁵⁄₁₆ in. (18.6 cm); Purchased with funds from the Libbey Endowment, Gift of Edward Drummond Libbey, 1945.36

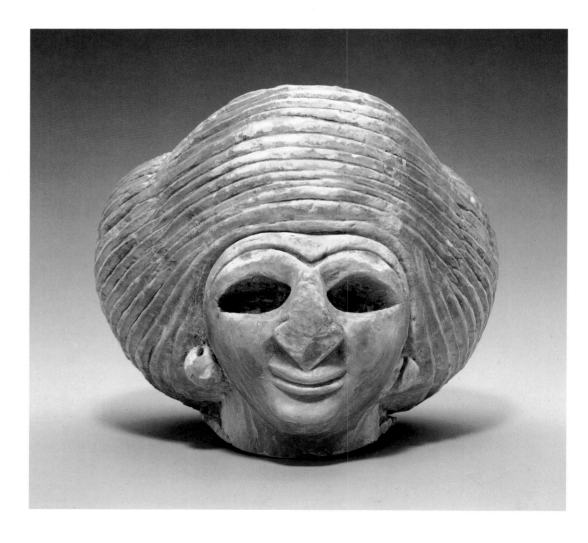

Iranian, Iron Age I–II (about 1350–800 B.C.)
Statuette of a Woman, about 1000–900 B.C.

THE MASSIVE HIPS and buttocks of this boldly simplified ceramic form suggest that it may have been one of the figures of fertility goddesses made throughout the eastern Mediterranean and the Near East during the prehistoric era. It was made at the height of the Amlash culture, named for the region around the village of Amlash in Iran near the southwestern shore of the Caspian Sea. The balance between swelling curves and geometric rigor; the masklike face, turned slightly to one side; and the precisely incised details give this figure an appeal that is as valid today as it must have been in its own time.

In the Amlash region over fifty tombs have been found containing an impressive array of bronze, silver, gold, and ceramic figures or vessels shaped in an almost endless variety of ingeniously stylized animal forms. Among these works, the masterful treatment of the human figure, particularly the female form, is acknowledged as one of the Amlash culture's outstanding achievements.

Because the culture left no written records, little is known of why these figures were made or how they were used. Although the figures are hollow, most scholars do not think they were used as vessels, as much thin-walled, decorated Amlash pottery to serve the needs of daily life has also been discovered. Because several of these figures were found lying on broad, raised platforms, perhaps altars in Amlash tombs, it is more likely they were dedications to a fertility goddess. The holes pierced in the ears may have been for gold jewelry to enrich the offering.

Terra cotta; H 18¼ in. (46.3 cm); Purchased with funds from the Libbey Endowment, Gift of Edward Drummond Libbey, 1987.196

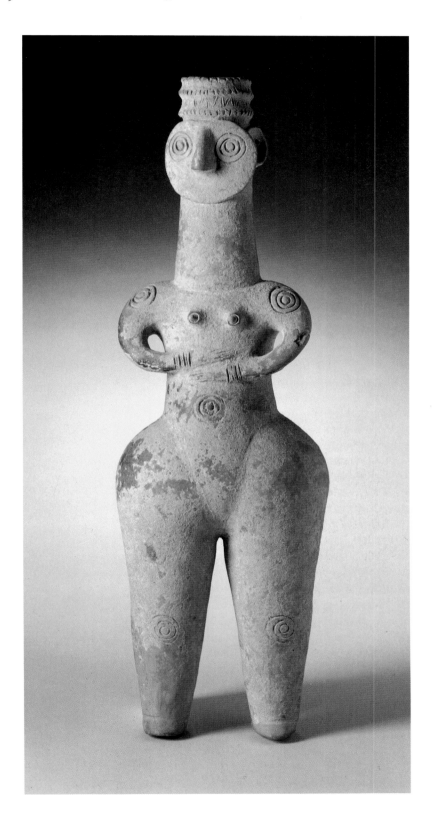

Egyptian, New Kingdom, Dynasty 18 (1540–1296 B.C.)
Amphoriskos, about 1350 B.C.

TREASURED FOR THEIR RARITY, transparency, brilliant colors, and optical effects, glass objects and vessels from their beginnings and for centuries remained small in size and reserved for luxury purposes. This bottle dates to the start of ancient Egypt's glass industry. Designed mostly as closed containers to hold aromatic oils, scented unguents, incense, or cosmetics, bottles such as this imitated the shapes of ceramic, metal, or stone vessels; their colors emulated precious and semi-precious stones such as lapis lazuli, turquoise, and jasper. Because most examples have been found in the ruins of temples, palatial residences, and graves, though rarely in private houses, they seem to have been made for an aristocratic or priestly clientele.

This bottle was produced by the core-forming method, the earliest technique devised for making glass containers. The process involved winding threads of molten glass compactly around a preshaped core material—probably a combination of clay, mud, sand, and an organic binder—then fusing and smoothing the clinging, hot glass threads into the basic shape by rolling the form on a flat stone slab. Threads of opaque yellow and white were then trailed around the vessel and some were tooled into a festoon pattern. After the bottle had been slowly cooled, the core was scraped out, leaving a rough, pitted interior surface. The rim disk, loop handles, and footed base were applied separately after further reheating. This labor-intensive technique resulted in vessels that vary considerably in size, proportion, color scheme, and decoration; each is thus unique.

The beginnings of glass making in Egypt before Dynasty 18 are documented only by a few sporadic glass objects. During the New Kingdom, under the vigorous pharaohs of Dynasty 18, a wide variety of glass objects and vessels like this dramatically appeared. This phenomenon has led some scholars to suggest that the Egyptian pharaoh Thutmosis III (1479–1425 B.C.) may have returned from his military campaigns in Palestine and Syria with glass makers from that area. These New Kingdom glass makers in Egypt, perhaps at first Near Easterners and later native Egyptians, operated in workshops under royal patronage and established the basic technique that would dominate glass vessel making in the eastern Mediterranean for the next thirteen centuries. This vessel was most probably made during the reign of Amenhotep III (1391–1353 B.C.) or Akhenaten (1353–1335 B.C.).

Glass; H 4¹³⁄₁₆ in. (12.3 cm); Purchased with funds from the Libbey Endowment, Gift of Edward Drummond Libbey, 1951.405

Egyptian, Late Period, Dynasty 25 (about 715–656 B.C.)
Statue of Pharaoh Tanwetamani, 664–656 B.C.

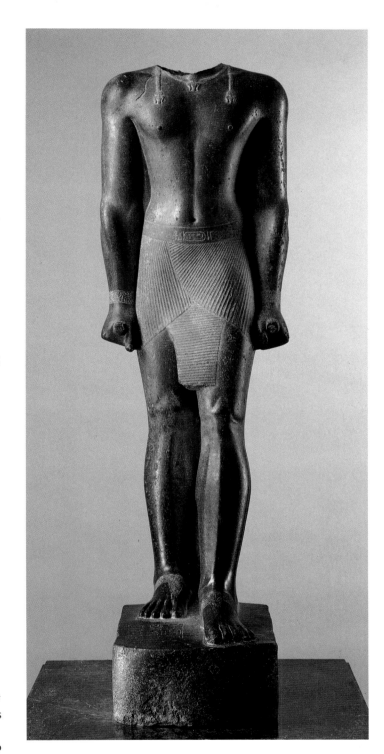

THIS OVER-LIFE-SIZE STATUE was erected as an enduring memorial to the pharaoh Tanwetamani (reigned 664–656 B.C.). The pharaohs who ruled Egypt from 750 to 656 B.C. were descendants of the viceroys of the kingdom of Kush, located in the modern Sudan to the south of Egypt and Nubia. A vassal kingdom of Egypt for centuries, Kush was thoroughly Egyptianized, but retained considerable independence thanks to its control of trade goods from south and central Africa. The last ruler of Dynasty 25, Tanwetamani survived the conquest of Egypt by Assyrian invaders from Mesopotamia and retreated to his ancestral lands in Kush.

This statue follows traditions used for almost three thousand years for Egyptian royal statues: left foot striding forward, hands clenched at the sides, nude except for kilt and jewelry. The space between the body and the arms and legs was left filled with stone, lessening the danger of breakage but also increasing the effect of solidity and mass. The roughened surfaces on sandals, wristlets, and ornaments on shoulders and chest were once covered with gleaming gold leaf.

Inscribed on the plinth in front of the left foot and on the column that braces the back is his name: "The Horus Wah-meret, King of Upper and Lower Egypt Ba-Ka-Re, Son of Re Tanwetamani, Beloved of Amun of Napata in the Holy Mountain, Endowed with life like Re forever." "Amani" was the Nubian version of the Egyptian name Amun, so this king shared the name of the god. The "Holy Mountain" is Gebel Barkal, where rows of colossal statues honoring the rulers of Dynasty 25 lined the roads leading to the entrance of the Great Temple of Amun. Centuries later, these royal statues were thrown down and broken.

Black granite; H 79½ in. (202 cm); Purchased with funds from the Libbey Endowment, Gift of Edward Drummond Libbey, 1949.105

Exekias (potter) and a **painter of Group E** (probably also Exekias), Greek, made in Athens
Amphora and Lid, 550–530 B.C.

THE BOLD SHAPE of this vase and the energetic chariot race enlivening its surface epitomize the city of Athens's celebration of man as the measure of all things. The form is an eminently functional storage jar for wine, oil, or grain called an amphora ("carried by two handles" in ancient Greek). However, the scenes reflect a focus on the human figure that is unprecedented in earlier Greek vase painting. This innovation has been traced to a group of Athenian potters and painters whose names have not been recorded, save for Exekias, the first letter of whose name, "E," was adopted to give Group E its name.

Both sides of this amphora show a *quadriga* (four-horse chariot) competing in an athletic event called a *polemisteria,* a race said to have been invented by the mythical Greek hero Theseus. The pursed-lipped driver whistles to his spirited team; a foot soldier in full battle armor stands in each chariot. While the images look identical, Exekias has taken care to name the competitors: Stesias (on the front), Anchippos (on the back). Both must have been celebrated athletes, for their names appear on other vases of this period. Two of the horses on the front of the vase also have inscribed names: Kalliphora ("a horse with a beautiful mane and tail") and Pyrichos ("a fiery, red-brown horse").

The action represents a crucial moment in the race as the two chariots make the final turn. Given the restraints of the black-figure painting technique and the shape of the vase, Exekias introduced not one but two innovations: the scenes on both sides of a vase are conceived as parts of a single event, and this is the earliest known rendering of a turning chariot. The nobility of the horses, the rich patterns incised on their chest straps, manes, and tails, and the nervous cadence of their raised front legs compared to the even rhythm of their firmly planted hind legs are all executed with a remarkable economy of line. Yet despite this attention to the horses, Exekias showed man as their master. The warriors reign with heroic importance at the pinnacle of each composition, emphasized by the crests of their helmets breaking through the lotus-palmette frames.

Earthenware; H 18⅛ in. (46.2 cm), DIA 10⅞ in. (27.6 cm); Purchased with funds from the Libbey Endowment, Gift of Edward Drummond Libbey, 1980.1022

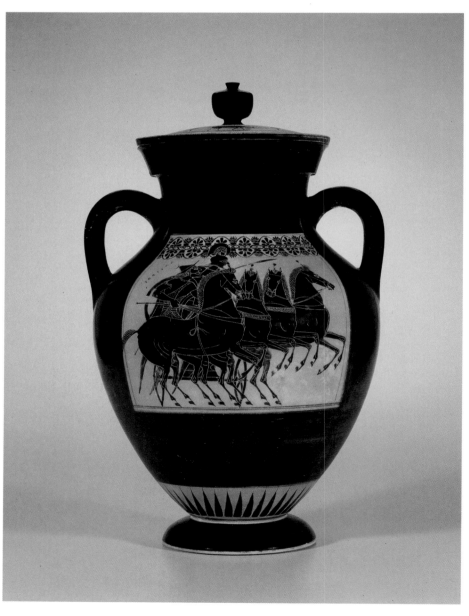

SIDE B

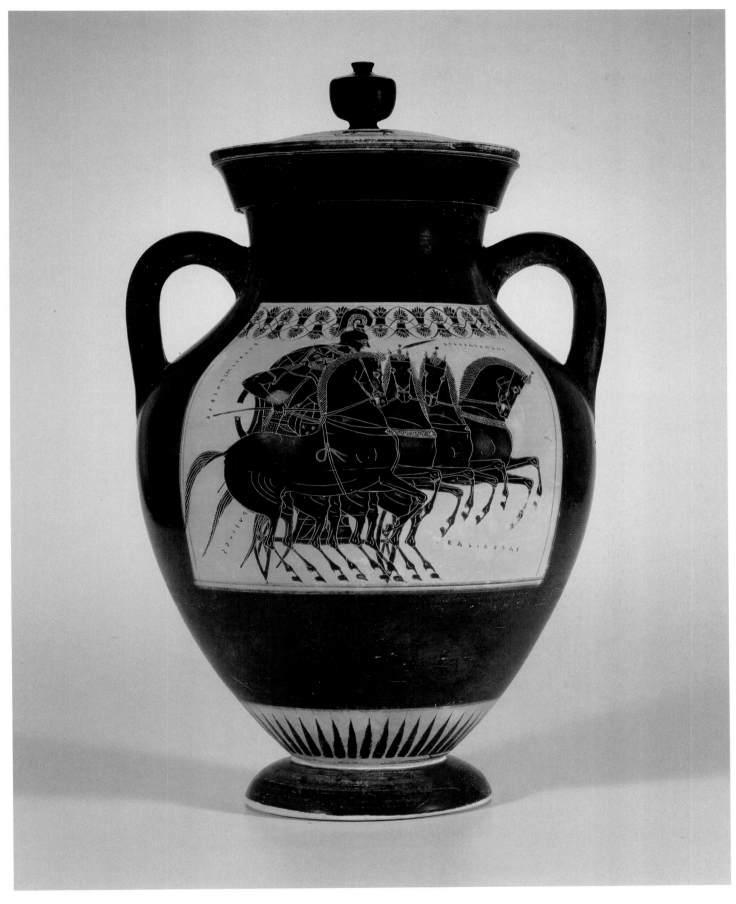

SIDE A

The Naukratis Painter, Greek, made in the province of Lakonia
Amphora, about 560 B.C.

THE RIGOROUSLY PRECISE decoration of this vase is perfectly in character with the austere society of ancient Lakonia, a province both respected and feared. Lakonia was ruled by Sparta, its principal city. Unlike other Greek city-states, Sparta was ruled by kings who directed both military and religious affairs. Family life was rejected in favor of a communal existence dictated by the state. Men, women, and children lived under harsh military discipline. Even the work of craftsmen and artists was carefully prescribed. While Lakonia is not generally remembered for its

contributions to Greek art, architecture, or literature, local artists did produce bronzes and ceramics of fine quality that were exported to other Greek city-states.

This amphora (a two-handled storage jar) is unique, for it is the only decorated Lakonian vessel of this shape known. The decided bulge in its neck distinguishes it from amphoras made elsewhere in Greece. The restrained elegance of the curves of its profile and the meticulous proportions rival the exacting detail of the painted decoration. This is the work of one of Lakonia's most accomplished artists,

the Naukratis Painter, who is named after the port of Naukratis in the Nile delta, the principal Greek city in Egypt where many important Greek works of art have been found. This vase resembles those made in contemporary Corinth, a city whose potters covered their wares with a buttermilk-colored slip before painting friezes of fanciful animals and intricate patterns. Here the principal band of decoration shows pairs of roosters, lions, sphinxes, and goats confronting elaborate floral motifs. Above and below, the surface is filled with registers of precisely painted lotus buds and blossoms, pomegranates, a meander pattern, rays, and, on the foot, widely spaced pairs of strokes with a band of tongues below, all rendered with almost mechanical rigidity.

Compared to the freer and more creative spirit shown on an almost contemporary vase from ancient Athens (see p. 38–39), this amphora epitomizes the control and rigor at the core of Lakonian society. The differences between these two vases, representatives of their respective societies, help us to understand the clash of Athens and Sparta in the Peloponnesian Wars at the end of the next century.

Earthenware; H 10 15/16 in. (27.7 cm), DIA 7 5/8 in. (19.3 cm); Purchased with funds from the Libbey Endowment, Gift of Edward Drummond Libbey, 1964.53

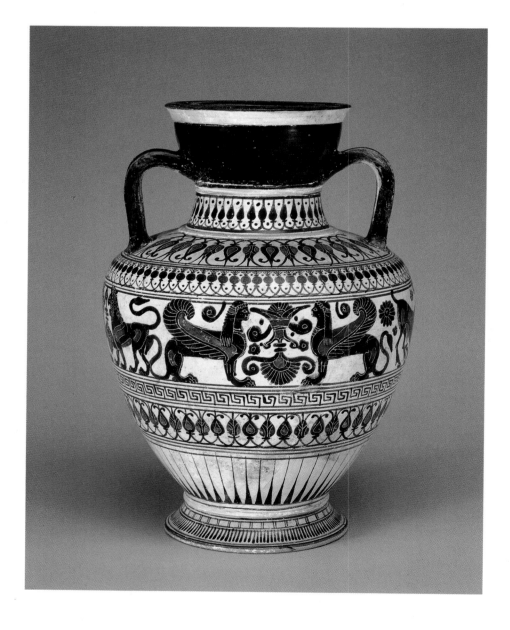

The Creusa Painter, Greek, made in the province of Lucania in southern Italy
Volute Krater, 400–380 B.C.

THE ANCIENT GREEKS never drank undiluted wine, but instead mixed it with water in large vessels called kraters. This type of vessel is known as a volute krater because of the spectacular, scroll-like handles decorated with ivy leaves placed above the rim. In the center of the krater, Dionysos, the god of wine, sits with his wife, Ariadne. In his left hand is a *thyrsos,* a staff with a pine-cone finial; in his right is a *kantharos,* a stemmed drinking cup. Ariadne lovingly places a laurel wreath, symbol of victory, on his head. The two sit in a cave—shown as a cutaway of a hill—a remarkable landscape innovation at this time in Greek art. Above, the god Pan, with goat horns, shaggy legs, and tail, harvests grapes with a satyr, a lusty male follower of Dionysos with goat ears and a horse tail. To the left, another satyr is accompanied by two maenads, female followers of Dionysos. The one riding on the satyr's shoulders plays the double pipes, while the other maenad carries a stand for a drinking game called *kottabos.* To the right, a woman, perhaps another maenad, offers a deer to her companion. A satyr appears from behind another hillock, indicated by an incised line. The scene shows festive preparations for a ritual in honor of Dionysos.

Although his name is unknown, this painter's distinctive style has been identified on more than 130 vases. Characteristics include decorative banding on diaphanous garments that often reveal robust bodies in a variety of poses that display a mastery of the human form in space; crosses interspersed among the meanders in the band below the scene; and the use

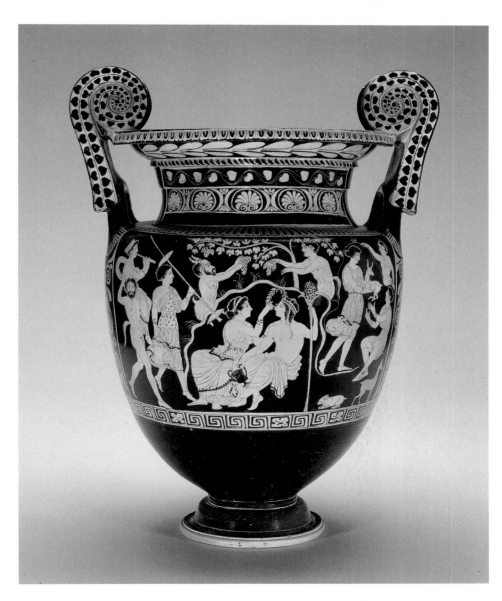

of fine-line incision, a holdover from the older black-figure technique that is seen here in the tufts of grass on top of the central hill. The artist has been named the Creusa Painter because his style was first identified on a krater in the Musée du Louvre showing Medea's deadly gifts to Creusa, daughter of the king of Corinth. The Creusa Painter was a leader among the second generation of vase painters who worked in the Greek province of Lucania, just

above the instep of the boot of southern Italy. His animated works rival the finest of those of Athens at this time. This volute krater is considered his masterpiece.

Earthenware; H to top of handles 23¼ in. (59.1 cm), DIA with handles 17¾ in. (45 cm); Purchased with funds from the Libbey Endowment, Gift of Edward Drummond Libbey, 1981.110

The Painter of Vatican 238, Etruscan
Kalpis, 520–510 B.C.

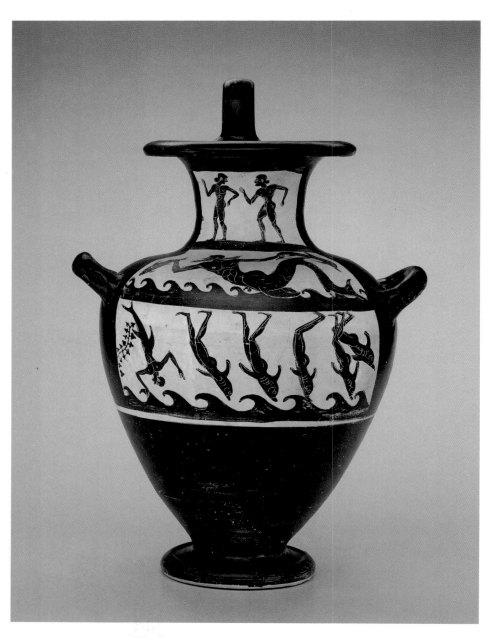

along the top of the sail, and ivy entwined the mast and oars. Dionysos, changed into a terrifying lion, sprang at the pirate captain. In fear, the other pirates dived into the sea, and in mid-air were transformed into dolphins.

It is this horrific moment in the myth that the artist (named after a vase in the Vatican Museum on which his distinctive style was first noticed) depicted. Although the pirate ship and Dionysos do not appear, an ivy tendril on one of the oars indicates they are just beyond the left side of the picture. Two subsidiary scenes, one with two nude figures on the vessel's neck and the other with a merman or Triton, a son of Poseidon, god of the sea, holding a fish and a dolphin, underline the terror of the metamorphosis occurring in the main scene. They show other stages of transformation, from fully human to half-human and from half-fish to fish. One of the rare illustrations of this myth, this vase is the only Etruscan one, and also the most complete pictorial narrative of this story known.

Earthenware; H 20½ in. (52.1 cm), DIA with handles 13 15/16 in. (35.4 cm); Purchased with funds from the Libbey Endowment, Gift of Edward Drummond Libbey, 1982.134

THE EXOTIC HALF-MAN, half-fish creatures on this vase used for transporting water capture our attention and suggest that the artist was recounting an amusing story. However, to the ancient Greeks and Etruscans, these images evoked fear and respect for Dionysos, the god of wine. The scene on the belly shows six man-dolphins diving into the sea. The figure at the left is human above the waist and dolphin below, while the rest are dolphins above the waist with human legs. They were probably painted while the artist held the vase with the bottom up, for the feet appear to be walking upside down on a groundline that forms the upper edge of the panel. Well known in antiquity, the story is told in the Homeric Hymn to Dionysos number 7. Pirates from the Tyrrhenian Sea kidnapped Dionysos and brought him aboard their ship. Magically the bonds that held him fell from his hands and feet, wine flowed throughout the ship, a vine with grape clusters spread

Etruscan
Statuette of Hercle, early fourth century B.C.

THE HEROIC PHYSIQUE, knotty club, bow and arrow, and lion skin forming a helmet around the head with its paws knotted over the chest identify this figure as the Greek hero Herakles (Hercules to the Romans). While he was superhuman to the Greeks, to the Etruscans who inhabited central Italy north of Rome, he was a god called Hercle, revered as a protector of men as well as mountains, streams, and gateways. In Greek mythology, Herakles was required to perform twelve labors to atone for killing his own children in a fit of madness. Greek images of Herakles often show him holding only one of the weapons used in his labors, but this Etruscan statuette presents him with a weapon in each hand as symbols of all the labors. Although the god stands at ease in one of the distinctive Etruscan poses for Hercle, his bent elbows, the angle of his club, and the flex of his right knee, echoed by the outward thrust of the lion skin's tail, suggest dynamic action.

While the pronounced angles of the limbs and bulging torso muscles are decidedly Etruscan, this statuette owes much to Greek sculpture of the fifth century B.C., which the Etruscans knew well through examples brought from Greece itself and from the Greek colonies in southern Italy. The composition, with the weight borne on a straight leg creating an outward thrust to the figure's right hip, reveals the strong influence of the Greek master sculptor Polykleitos. The solemn expression on Hercle's face—his furrowed brow, intense stare, and firmly set mouth—also recalls Greek sculpture of the fifth century.

The Etruscan words on Hercle's right leg translate "I belong to Heracle." Chiseled after casting, the inscription indicates that this statuette may have been dedicated in a sanctuary devoted to Hercle. The letter forms and the unique spelling, "Hercle," suggest a southern Etruscan site. Scholars have speculated that modern Orvieto, probably to be identified with the wealthy Etruscan city of Volsinii, famous for its bronze making, may be where this statuette was cast.

Bronze; H 9½ in. (24.2 cm); Purchased with funds from the Libbey Endowment, Gift of Edward Drummond Libbey, 1978.22

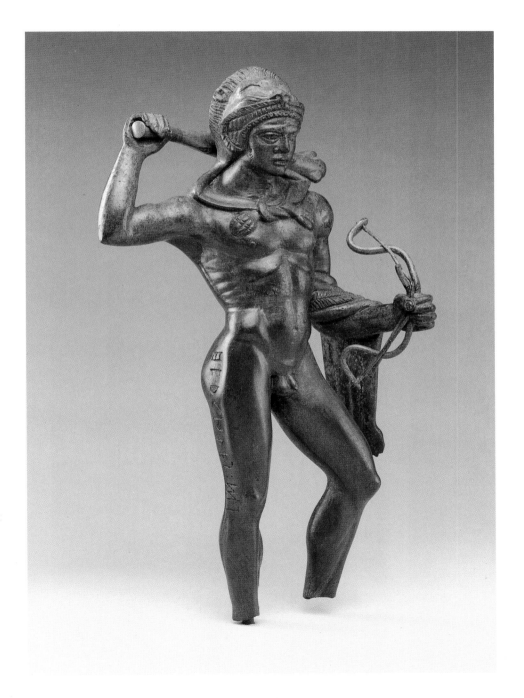

Greek, probably made in the Eastern Mediterranean
Krater, 225–175 B.C.

THE THINNESS OF THE GLASS and this bowl's expansive form suggest at first that it was made on a blow pipe, but this vessel dates from almost two centuries before the invention of glass blowing. The bell-shaped foot, profiled on the inside, and the bowl were cast in one piece by heating chips of glass in a multipart mold until they fused. In a risky and laborious process, the vessel was then meticulously ground and polished both inside and out by pressing it against a rotary lathe, then finishing it with hand tools. Because of the difficulty of handling such a large object on a lathe, the thickness of the sides varies. The exterior was decorated with six lathe-cut ridges. The splendid state of preservation, graceful shape, almost colorless material, and thinness make this footed bowl a masterpiece of glass making. Only five bowls

from antiquity made in this manner are known to survive; this one is the only intact example.

This bowl reflects the extravagant taste of the Greek world during and following the conquests of Alexander the Great. Lavish jewelry, perfumes, clothes, furniture, and exotic foods were flaunted by the Hellenized rulers of kingdoms from Persia to North Africa, and by the aristocrats and merchants in scores of independent city-states. Transparent, colorless glass was a luxury intended to mimic rock crystal, and glass makers began to make entire table services with it. Shapes and decoration were influenced by styles first established in clay and metals like bronze and silver.

About sixty vessels called the Canosa Group form the earliest documented class of cast Hellenistic glass tablewares. The name comes from the many examples discovered in the cemeteries near

Canosa di Puglia (ancient Canusium) in southeastern Italy. This bowl was purportedly found with as many as fourteen other cast-glass vessels and filled with a cache of gold jewelry. Five groups of glass vessels from Canosa have been identified, and single examples have been found in Greece, Asia Minor, North Africa, Sicily, and Etruria. Canusium was an undistinguished, Hellenized, south Italian community, but its wealthy residents avidly imported luxury goods. The date of the Canosa Group is unsettled, but it is probably about 225 to 175 B.C., a time of relative peace and great prosperity in the Mediterranean world.

Reported to have been found in Italy; Glass; H 6 15/16 in. (17.7 cm), DIA RIM 8 5/8 in. (21.9 cm), DIA BASE 3 1/2 in. (8.9 cm); Purchased with funds from the Libbey Endowment, Gift of Edward Drummond Libbey, 1980.1000

Græco-Persian
Rhyton in the Shape of a Zebu, 200–100 B.C.

AT PERSIAN AND GREEK BANQUETS from the sixth through the first centuries B.C., horn-shaped rhyta made of clay, ivory, silver, and even gold were popular as drinking vessels. The custom was to fill the horn with wine through the open top but to drink from the stream of liquid that flowed directly into the drinker's mouth from the small spout at the front of the vessel. A rhyton without a base, such as this one, may have passed from hand to hand until empty.

This rhyton was made in two parts: the horn and the hollow forequarters of a zebu, an exotic hump-backed bull. Both were formed from cast cylinders of silver by hammering over molds; a cast ring conceals the join. The bull's solid horns, ears, and forelegs were cast separately and attached with solder. Gilding decorates most surviving silver rhyta, but this example is unusual because it uses sheet gilding: thick gold foil rubbed on the silver, adhering to the surface solely by friction. Since less expensive amalgam gilding replaced sheet gilding during the second century B.C., this rhyton can be dated quite accurately.

The zebu belongs to a long tradition of Near Eastern royal hunt imagery: wild bulls and lions were vanquished by the ruler, symbolizing his protection of the kingdom from threats. Alexander the Great and his Greek army conquered the Persian empire in 333 B.C. After Alexander's death in 323, his empire was divided among his Macedonian generals. A zebu appears on the coinage issued by one of these generals, Seleucus I, who became the ruler of Persia and founder of the Seleucid Dynasty, starting in 305 B.C. The image may allude to widespread propaganda that Seleucus was so strong that once when a wild bull brought for sacrifice to Alexander broke loose from its ropes, Seleucus

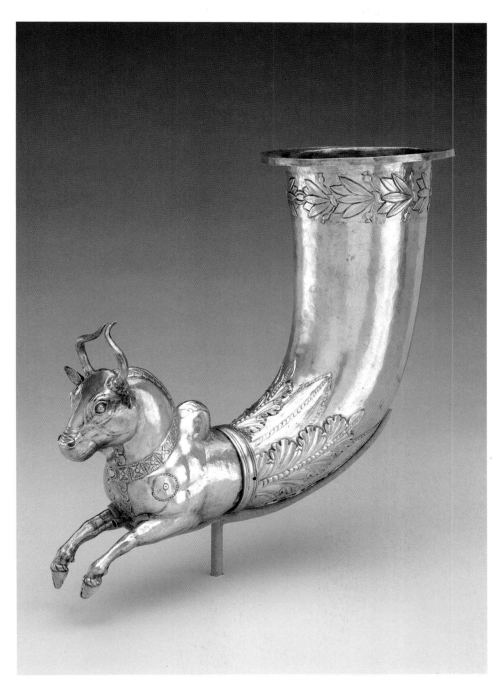

restrained it with his bare hands. The story justified Seleucus's right to rule, both as a mighty warrior and as a close friend of Alexander. The decoration of ruffled acanthus and pointed nymphaea caerulea leaves on this rhyton is characteristically Greek. The mix of Greek and Persian motifs and the rich materials provide a glimpse of the lavish artistic achievements of the

Hellenistic Near East following the conquests of Alexander.

Silver with sheet gilding; L 16⅞ in. (42.8 cm), WT 40.2 oz. (1.14 kg); Purchased with funds from the Libbey Endowment, Gift of Edward Drummond Libbey, 1988.23

Roman
Portrait Bust of the Emperor Domitian, about 90

TITUS FLAVIUS DOMITIANUS (51–96, reigned 81–96) was a spoiled younger son when he succeeded his charismatic elder brother Titus in 81. Praised early in his reign as a benevolent ruler, whose virtues at least balanced his vices, his later years were filled with acts of greed, debauchery, and cruelty. The contemporary biographer Suetonius described Domitian in his *Lives of the Caesars* as vain, avaricious, and cruel; this penetrating portrait suggests that much of his reputation was deserved. Self-aggrandizing, Domitian was the first emperor to demand the title *dominus* ("lord") from his subjects and to insist on subservient protocol at his court, in contrast to the more relaxed customs at the courts of his father, Vespasian, and his brother. He was so

hated by the time of his assassination in 96 that the Roman senate officially damned his memory, decreeing that all public statues and inscriptions bearing his name be destroyed. Consequently, only a handful of portraits of Domitian are known; this is the best-preserved example that survives.

Ancient Roman sculptors created some of history's most remarkable portraits. The fashion of the time called for representing a sitter's actual appearance, even if unattractive. Thus Domitian's plump checks, receding chin, sneering lips, and shifty eyes pitilessly express his insecure and ostentatious personality. The ornately curled hair and refined polish of the skin convey a veneer of elegance that is disturbingly contradicted by the raw physical power asserted by the thick neck and broad chest. Vain of his appearance,

Domitian is known to have written a treatise on hair care. Ironically, the hair of this portrait actually represents a wig concealing his baldness in later life. The highly polished modeling of the skin, contrasting with the matte drapery and locks of hair, reveals the hand of a master sculptor.

Marble; H 23⅞₆ in. (59.6 cm), W 16¼ in. (41.3 cm); Purchased with funds from the Libbey Endowment, Gift of Edward Drummond Libbey, and from the Florence Scott Libbey Bequest in Memory of her Father, Maurice A. Scott, 1990.30

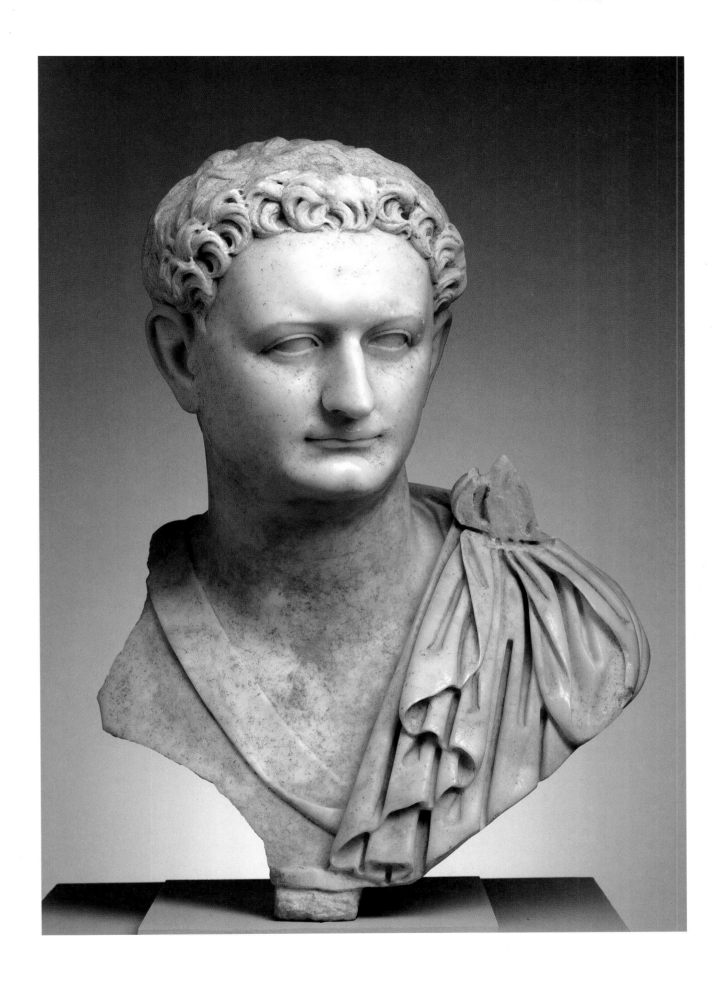

Roman
Helmet, 75–100

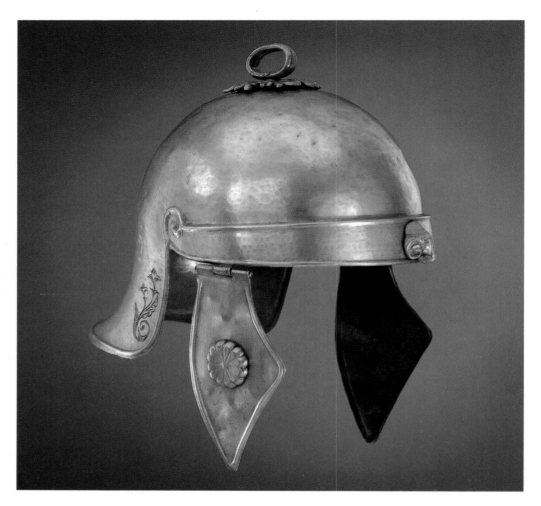

Although made of silver, this helmet resembles exactly the standard bronze or iron helmets worn by soldiers of the Roman legions from the first through the early third centuries. They consist of a hemispherical crown with hinged cheek pieces and a ring or knob on top; the interior was lined with leather. This is the only surviving silver Roman helmet known. The precious metal indicates that the owner was probably a high-ranking Roman or allied officer, or possibly a soldier who received it as a military award. It may have been buried with him as a symbol of his career. Because the metal could not have withstood a blow from a sword, the helmet must have been worn only in triumphal processions or other ceremonies.

The ring on the top is fitted to a riveted base so that it turns in all directions, allowing the helmet to be displayed hung on a wall or spear when not in use. The stylized oak leaf under the ring may allude to the *corona civica* ("civic crown" made of oak leaves), one of the highest Roman military decorations, awarded to the man who in battle saved the life of a Roman citizen. The ram's head on the brow is associated with the goddess Minerva and her aegis, or protective cloak, made of a wild goat skin. This symbol may identify the helmet as belonging to a member of the *legio I Minervia,* whose soldiers bore ram's-head decorations on their helmets and are shown on the Column of Trajan in Rome marching under a ram's head borne on their legionary standard. The legion was

formed by the emperor Domitian in 83 in Germany, which remained its base, but it also fought on the eastern frontier commanded by the future emperor, Hadrian, during Trajan's first Dacian War of 101–2 and by Lucius Verus in the Parthian War of 165.

Reported to have been found in 1936 in a tomb in the necropolis of Emesa (modern Homs), Syria; Silver with incised decoration and bronze ornaments covered in gold leaf; H 12⅜ in. (31.4 cm); Purchased with funds from the Libbey Endowment, Gift of Edward Drummond Libbey, 1958.45

Roman
Statue of a Youth, about 140

ONLY A HANDFUL of life-size bronze sculptures from the ancient Mediterranean world survive. This youth descends from the centuries-long Greek tradition of statues dedicated in honor of victorious athletes. Athletic competition was a distinctive part of ancient Greek culture, and thousands of commemorative statues crowded temples and city centers. The standard type was an idealized nude figure (athletes competed without clothes). Hollow-cast bronze was a favorite medium, more costly than marble and with the advantage of allowing arms and legs to be extended from the body without added supports. Bronze also had the benefit of imitating the golden-brown of suntanned skin.

Although by the first century B.C. Rome had conquered the Greek kingdoms and city-states of the eastern Mediterranean, Greek literature, philosophy, and art were highly prized by the new rulers. Original Greek works were avidly sought, and vast numbers of replicas were commissioned to decorate the townhouses and country villas of the rich. Some copies seem closely faithful, but most incorporate modifications to suit Roman preferences. Other variations on traditional types are actually entirely new creations.

The artist who made this youth mingled elements from several popular Greek traditions. The technology of bronze casting allowed for easily adjusting the type. Here the several pieces forming head, torso, legs, and arms were cast separately and welded together. The stance and bony, oval face may be associated with an athletic type developed by the fifth-century-B.C. Greek sculptor Polykleitos, but the rather undeveloped torso and the long, slender legs suggest adolescent grace more than athletic robustness. The long curls of hair, tapering fingers, pouting lips, and heavy, linear eyelids reflect Roman taste. The artist's final working of the wax model shows as satiny ripples on the surface. In a

Greek statue, the missing lowered right arm might have held a wreath or palm branch, symbols of victory, and the extended left arm, a shield or libation bowl. As a Roman variation, this youth may have carried a lamp or torch. The Romans viewed the Greeks' devotion to statues of athletes somewhat skeptically, and their own statues were often functional, with hands outstretched to hold lamps or trays in gardens and banquet rooms. Handsome Greek slaves were valued by the Romans, so it is not surprising that Roman statues of adolescent boys suggest the attractions youth and beauty offer in addition to athletic prowess.

Bronze; H 56⅛ in. (142.6 cm); Purchased with funds from the Libbey Endowment, Gift of Edward Drummond Libbey, 1966.126

Roman
Beaker, 350–400

LUXURY TABLEWARES of the Roman Empire included elaborately decorated vessels, not only of gold and silver but also of glass. From the middle of the first century B.C., glass blowers made containers and drinking vessels for all classes of ancient Roman society. Some workshops exported their products widely. One such regional workshop in or near the city of Colonia Agrippenensis (modern Cologne) specialized in making finely decorated glass bowls and beakers; the city's

wine, grain, and luxury glasswares were exported to markets all over western and northern Europe.

This conical drinking vessel, called a beaker, is made of thin, transparent glass and decorated using a distinctive engraving technique in which outlines and some details were indicated by parallel wheel-cut lines, and then the interiors of the shapes lightly abraded to show drapery and other details. The spinning copper wheel could cut only straight lines, so curved contours had to be approximated with short, straight cuts.

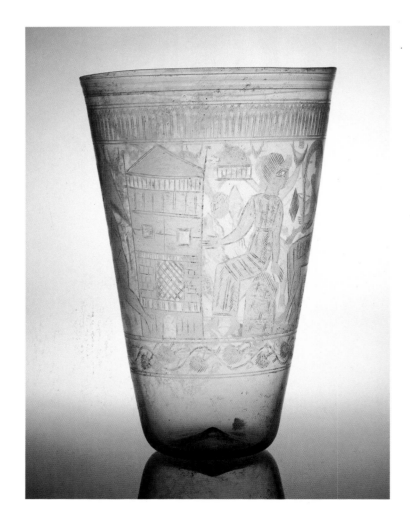

Characters and scenes from Greek mythology, plays, and biblical stories formed the repertory of figurative decoration. A tall building with an open portico at the top dominates the scene on this beaker. Such structures, typical of Roman cities, had shops on the street level with multistoried living quarters above for the families of artisans and shopkeepers. To the right of this building two women sit side by side on a rock; both turn to face a young man standing beside a palm tree. He fills the outstretched drinking cup of one of the women. To his right two winged cupids flank a large wine jar. The decoration has been interpreted as scenes from a popular play or entertainment in Rome, with the tall building and the domed structures in the background identified as famous palaces and temples, such as the Pantheon. Another interpretation is that the buildings are mausolea, while the palm tree, cupids, and wine suggest a funerary banquet where the living and the dead meet at the threshold of the afterlife. A glass bottle with a similar scene probably made in the same workshop near Cologne was found in a tomb near Amiens, France. Both vessels may have been made to be placed in a tomb rather than for use in daily life.

Reported to have been found by 1840 in Worringen, near Cologne, Germany; Glass; H 8 in. (20.2 cm), DIA RIM 5 7/16 in. (13.8 cm); Purchased with funds from the Libbey Endowment, Gift of Edward Drummond Libbey, 1930.6

Romano-Egyptian
Portrait of a Woman, 200–230

ANCIENT TRAVELERS were amazed and intrigued by the Egyptian custom of mummifying their dead; the idea was alien to both Greeks and Romans. However, first the Greeks who ruled Egypt after the conquest of Alexander the Great in 332 B.C. and then the Romans who ruled after the conquest of Augustus in 31 B.C. adopted this Egyptian practice. Mummies were usually enclosed in wood or plaster coffins decorated with sculpted, portraitlike masks. During the Roman period, portraits painted on wooden panels were placed above the mummy wrapping over the face of the deceased and secured at the edges by additional wrappings. These mummy portraits are often called "Fayum portraits" after the Fayum oasis region some two hundred miles up the Nile from Alexandria. There, in the dark, arid tombs of Romano-Egyptian cemeteries, hundreds of these portraits have been discovered since the late nineteenth century. The earliest were painted in the middle of the first century; the practice ended in 392 when the Christian emperor Theodosius prohibited mummification.

The painting technique is probably of Greek origin. The wooden panel was smoothed and primed with white gesso. While some early examples used pigments in hot wax, others, like this, were painted in the tempera medium, using pigment mixed with egg. Here, the artist enhanced bright highlights in the face and neck by allowing the white gesso to show through the translucent layers of tempera. Flesh tones and contours were swiftly but delicately indicated by lines of hatching, while strong bars of color form the curved shadows of lips and eyes. The round features, liquid eyes, and rather bulbous nose of this young woman suggest a candid and lively personality.

Many mummy portraits bear Greek names and inscriptions, suggesting they were the fashion among families of Greek descent who formed the core of the wealthy merchant and civil-service class in Egyptian towns and cities during the Roman period. It has been suggested that these portraits were commissioned and hung in homes during a person's lifetime. When the sitter died, the panel was taken down and placed in the mummy wrappings. The textured lower edge of this portrait may indicate where a frame was removed, while the angles at the upper left and right may have been cut to conform with the head of the mummy.

Tempera on linden panel; H 13⅛ in. (33.3 cm), W 8½ in. (21.6 cm); Purchased with funds from the Libbey Endowment, Gift of Edward Drummond Libbey, 1971.130

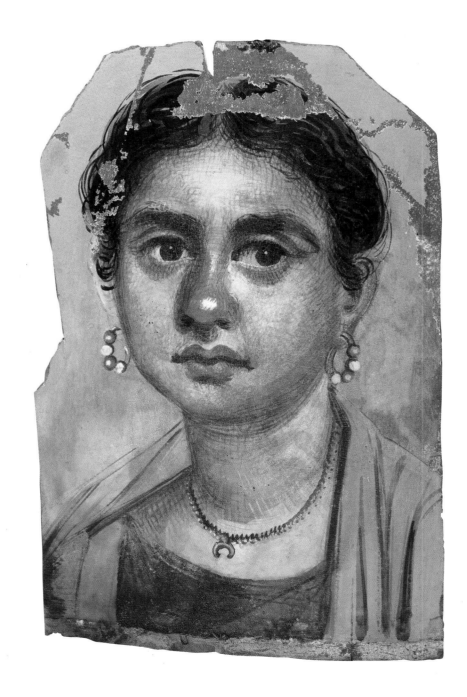

Chinese, Northern Wei Dynasty (386–535)
Guanyin, about 530

THE SERENE FACE of this figure typifies the Buddhist desire to give form and substance to spiritual concepts. Buddhism, a religion that originated in India in the fifth century B.C., was introduced into China during the Han Dynasty (206 B.C.–A.D. 220). As did other countries that eventually adopted Buddhism, China altered the basic ideas and models of Indian Buddhist art to satisfy its own religious and aesthetic needs, typically modifying images away from India's sensuous, rounded forms toward a flatter, more linear stylization.

Despite the fact that he appears in the guise and garments of Maitreya, the Future Buddha, an inscription identifies the figure as Guanyin, the Bodhisattva of Mercy and Compassion, a mortal who has attained enlightenment but has chosen to delay his entrance into Paradise in order to save mankind. The figure is a manifestation of the one absolute Buddha, the incarnate source of all knowledge. Unlike Indian artists who differentiated deities and their roles, Chinese artists merged characteristics and attributes into one generalized Buddha type and relied on inscriptions to identify the specific deity. This figure stands frontally on a lotus base atop a square pedestal. He raises his right hand in a gesture signifying protection or assurance from fear; his left hand makes a sign of charity. Atop his head is a protuberance symbolizing zsupernatural wisdom and insight. His elongated earlobes recall the heavy, princely earrings he had renounced. Swirling flames, leaves, and lotus and honeysuckle flowers enrich the mandorla behind the figure. The cascading drapery is rendered as flattened, repetitive folds and winglike projections. The swooping rhythms of the drapery and mandorla surface contrast with the deity's detached serenity and establish an upward movement, which would have been intensified by the flickering of candlelight over the burnished gold surface.

Images such as this were dedicated in temples and monasteries or on family altars in an effort to secure both material and spiritual well-being for the donor and his family. While the date inscribed in Chinese characters on the reverse of the base is equivalent to 571, the sculpture resembles works made fifty years earlier. This suggests that the inscription was added later, upon the death of the person for whom it was intended, most likely one of the members of the Lo family whose names appear on the back of the mandorla.

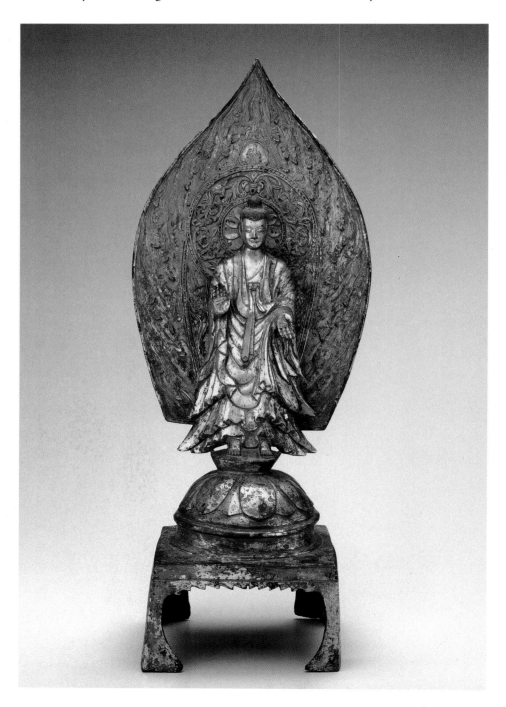

Gilded bronze; H 23 in. (58.4 cm); Purchased with funds from the Florence Scott Libbey Bequest in Memory of her Father, Maurice A. Scott, 1956.55

Indian (Tanjore District)
Parvati, about 1150–1200

THE COUNTLESS GODS and goddesses that make up the Hindu pantheon have for centuries provided Indian artists with an array of subjects. Although these images represent manifestations of divinity, their human forms are often blatantly sensuous and youthful. It is this divine celebration of the body, seen here in this figure of the female deity Parvati, that distinguishes Indian religious art from other forms of religious art. Parvati and her husband, the god Siva, are regarded as the divine exemplars of human love and are often shown surrounded by their family. Originally this sculpture was probably paired with one of Siva. Parvati's slender proportions and rhythmic curves remind us that she is the embodiment of femininity and fertility.

Indian craftsmen were required to use traditional techniques and to follow strict canons of iconography and proportion recorded in religious manuals for sculpture, architecture, and other crafts to give tangible form to such sacred inner visions. The special attributes, temperaments, and powers of the deities were conveyed by a system of symbolic poses, gestures, and accessories, as well as accompanying attendant figures. Here, Parvati is presented in a classic figure composition that has been repeated with minor variations since the second century B.C. Gracefully posed on a circular lotus-shaped base, she wears sheer, form-hugging pants that are held up by an elaborate girdle. Her upper body is adorned with intricate necklaces; her arms are embellished with armlets and bracelets; rings ornament her fingers. Her hair is arranged in a tall chignon, while her elongated earlobes are adorned with floral jewelry that falls onto her shoulders. She may have once held a lotus flower or bud in her right hand. The extreme length of her right arm echoes the sensuous curve of her hip. There is a sense of harmony and elegance about her movements as she

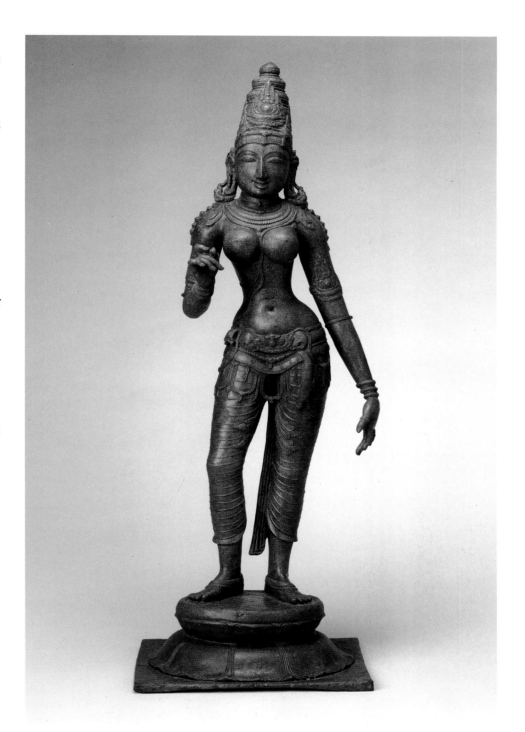

thrusts her hips sideways and gestures with her fingers, evoking the movements of a rhythmic dance.

This figure was made during the reign of the Chola kings, the dominant cultural, artistic, religious, and political dynasty that ruled southern India from about the ninth to the thirteenth centuries. The bronzes produced during this period are often considered the summit of bronze art in India.

Bronze; H 32 in. (81.3 cm); Purchased with funds from the Libbey Endowment, Gift of Edward Drummond Libbey, 1969.345

Chinese, Southern Sung Dynasty (1127–1279) or Yuan Dynasty (1279–1368)
Winter Landscape

THIS EXTRAORDINARILY LONG hand-scroll—nearly thirty-three feet—was never intended to be seen in its entirety, but unrolled only sections at a time by the seated reader. Nor did the artist intend to portray a single visual experience, but rather a horizontal movement through time and place, with each segment symbolizing a fragment of eternity. By reflecting upon the diverse images, the viewer would experience an imaginary journey through nature that would nourish and refresh his spirit. This goal—to wander through time and place—explains in part the painting's shifting perspectives.

Like a piece of music, the composition flows rhythmically through varied sequences of open, isolated, or densely worked passages of visual interest. Overall, a feeling of grand space pervades. The artist used the technique of atmospheric perspective, a method of creating the illusion of space and distance by rendering forms in progressively lighter tones as they recede in depth. The mountains in the distance are reduced to occasional crests in an endlessly stretching horizon, while scattered masses of heaving rock and cliffs are shrouded in mist. The foreground, islets, and craggy hills and rocks are all composed of the same indeterminate matter that seems to have taken shape momentarily and spontaneously—especially evident in the brilliant finale: a fantasic vision of bubbling, rocklike formations. The human figures who

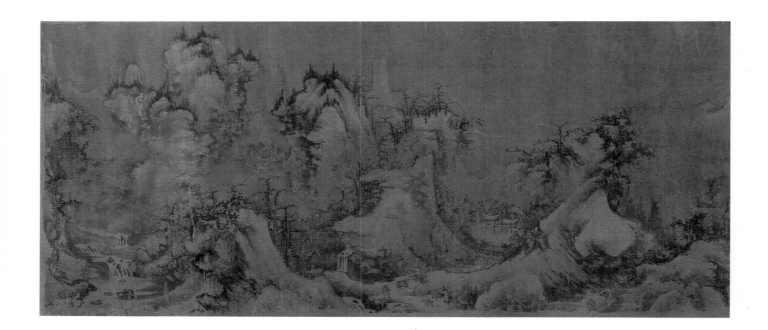

inhabit this landscape are restricted to the scroll's bottom edge and are reduced in scale and presence to minor elements secondary to the overwhelming forms of nature.

The importance of this renowned scroll lies not only in its extraordinary length and quality but also in the fact that it is among the oldest Chinese handscrolls known. It reproduces an important lost landscape painted earlier during the Northern Sung Dynasty by Guo Xi (about 1020–1090), who distinguished himself not only as an artist but also as the author of an important treatise on landscape painting. The unknown painter of this scroll is not considered less worthy for imitating an existing work, because styles developed by earlier masters were revered for centuries and later artists studied and reproduced them so that they could attain a sense of identity with tradition.

Ink and opaque colors on silk; painting 21 11⁄₁₆ × 189¼ in. (55 × 480.7 cm), scroll 22 ³⁄₁₆ × 400 ³⁄₁₆ in. (56.4 × 1016.5 cm); Purchased with funds from the Libbey Endowment, Gift of Edward Drummond Libbey, 1927.151

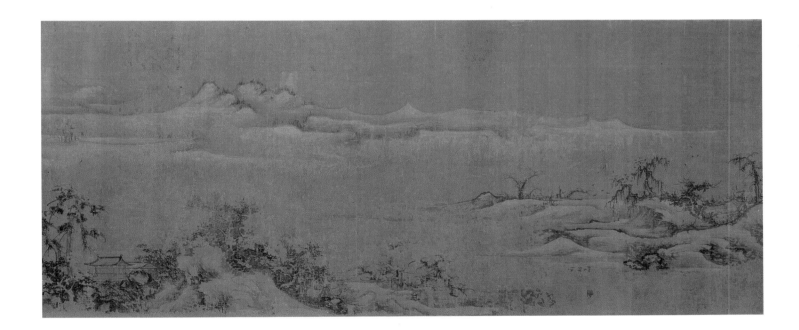

French
The Cloister, about 1150–1400

THE STONE COLUMNS, plinths, and arches of the Museum's Cloister are sections of cloister arcades from three long-demolished or abandoned monastery sites in southwestern France that demonstrate changes in architectural and sculptural styles between about 1150 and 1400. The word "cloister," derived from the medieval Latin *claustrum,* a device for locking, came to mean a place thus secured, or "cloistered." Today it usually refers to the open courtyard surrounded by covered walkways that formed the heart of a medieval monastery and served many important functions: reading, prayer, washing, and, often, burial.

The Romanesque arcade with round arches from the priory of Espira de l'Agly near Perpignan (right background), whose cloister may have been built in 1134–46, reflects the powerfully architectural style of the sculpture workshops associated with the Benedictine abbey of Saint Michel de Cuxa that were widely influential in the Rousillon region. Its massive proportions and cubical capitals with heraldic birds, winged lions, and stylized foliage contrast with the paired, more slender, spiral-fluted columns and narrative capitals of the second Romanesque arcade, from the Benedictine abbey of Saint Pons de Thomières near Béziers (left background). These capitals depict events from the Old and New Testaments and the life of the early Christian martyr Saint Pons. Two, dating about 1150, are fully Romanesque, while the other four, which reflect the transition to the naturalism of the Gothic style, were made later in the century, or even as late as 1220–25. The third arcade, with characteristic Gothic pointed arches and faceted column bases, is from the Cistercian abbey of Nôtre Dame de Pontaut in Gascony (foreground), whose cloister was built in the late fourteenth or early fifteenth century. The anecdotal scenes and bizarre animals depicted on its capitals are thought to represent moralizing allegories.

The Cloister, installed in 1932 as part of the Museum's new west wing, is an eloquent expression of the increasing American interest in medieval art during the 1920s and 1930s. The Philadelphia Museum of Art opened its cloister in 1931. By 1933 the Metropolitan Museum in New York had established the design of its remarkable branch museum of medieval art, The Cloisters. Toledo's Cloister serves as the focus for the Museum's collection of European medieval art. Seen in its center is a marble wellhead of 1467 from Venice whose Veneto-Byzantine motifs show medieval style surviving into the Renaissance. Shown elsewhere in the Cloister are sculpture, painting, textiles, ivories, enamels, and metalwork.

Marble; Purchased with funds from the Libbey Endowment, Gift of Edward Drummond Libbey, 1929.203–.208 (Saint Pons de Thomières); 1931.81–.88 (Nôtre Dame de Pontaut); 1934.93A–E (Espira de l'Agly); 1936.19 (wellhead)

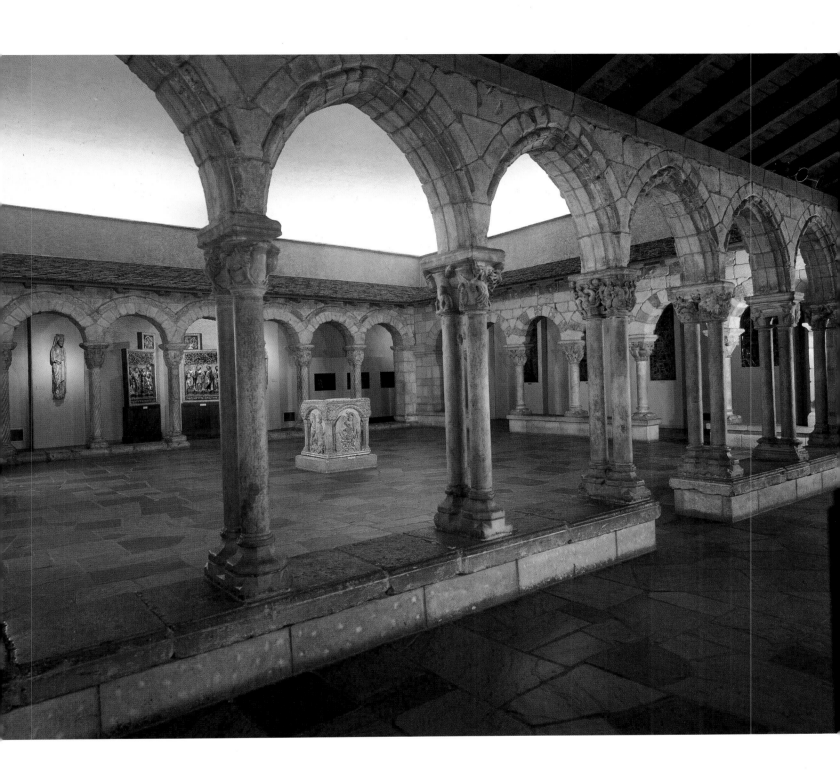

French
Polyptych: The Life of the Virgin, about 1280–90

FROM ANCIENT TIMES ivory was esteemed as a rich and rare material. The Middle Ages placed it with gold and jewels as the substances most fit to evoke the splendor of heaven on earth. It was prized for its translucent whiteness and its ability to be worked in miniature as finely as larger-scale sculpture in stone or wood. Ivory carving flourished between about 1270 and 1400 in Paris, which was then the artistic center of Europe. It encapsulates the Gothic taste for delicacy and courtly refinement. Ivory carvers lived in the same district of Paris as painters and sculptors, with whom they shared concepts of style. Manuscript illumination may have provided the inspiration for the elaborate Gothic framing of this

portable shrine for private devotions, which probably belonged to a great noble or ecclesiastic who often traveled from one residence to another.

The shrine's central figure is the Virgin, venerated by two angels bearing candles and crowned by a third. The Virgin holds the Christ Child, to whom she offers a flower. These figures in three-quarter relief are deeply undercut so as to appear in the round, a technical feature of relatively early Gothic ivories like this one. As well, these figures and the three-arched tabernacle in which they stand, including its roof and columns, are carved from a single piece of ivory. The wings, hinged in four sections so that they can be fully closed, bear low reliefs showing events in the life of the Virgin: the

Annunciation, the Visitation, the Nativity, the Adoration of the Kings, and the Presentation in the Temple. This shrine is among the most intact surviving ivories of this complex kind, for the base and its delicate claw-and-ball feet are also original, though the pinnacles are restorations. Like most medieval sculpture, ivories were painted, and there are still traces of the polychromy and gilding that once decorated the central figures and architectural setting of this shrine.

Ivory; H 11½ in. (29.4 cm); W (open) 10½ in. (26.7 cm); Purchased with funds from the Libbey Endowment, Gift of Edward Drummond Libbey, 1950.304

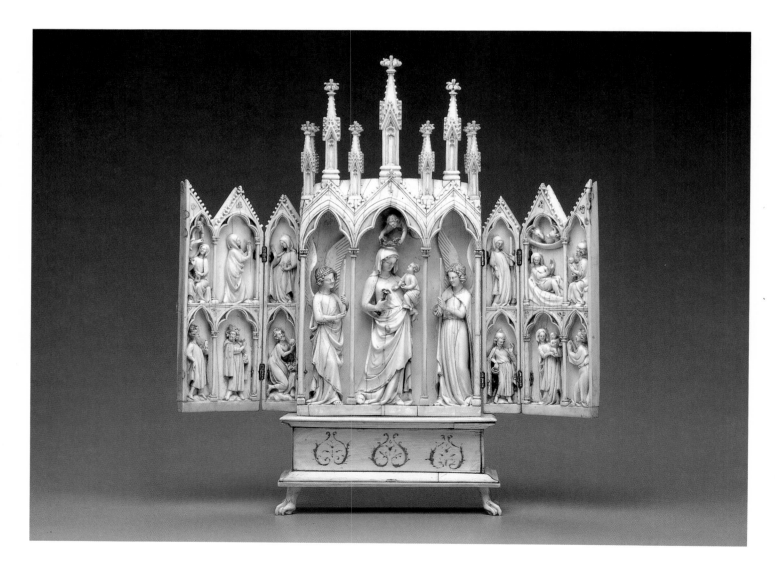

Lorenzo Monaco, Italian (Florence), about 1370–1423/24
Madonna Enthroned, about 1395

WHEN LORENZO MONACO painted the altarpiece in which this majestic figure formed the central image, he composed it, as was customary in fourteenth-century Florence, as separate painted elements framed as a unit beneath Gothic gables. When these often sizable ensembles later became liturgically obsolete, they were readily dismembered. But all ten components of this altarpiece, now scattered in seven locations, have been identified. Originally the Madonna was flanked by standing saints: Jerome, John the Baptist, Peter, and Paul. Beneath these figures were five small scenes of a principal event in each saint's life. As the male saints are known to have come from Santa Maria del Carmine in Florence, this altarpiece, now recognized as a key to understanding Lorenzo's early career, may originally have belonged to this church.

Lorenzo took his name upon entering the Florentine monastery of the Camaldolese order in 1391; "monaco," or monk, was added long after his death. Already a trained artist, he began to do manuscript illumination while also painting altarpieces and private devotional images. He became the

finest painter of his time in Florence, the most artistically conscious city in Italy, and was the last major painter there to work wholly in the late Gothic style.

This Madonna reflects the sense of sculptural form of Giotto (1266?–1337), Lorenzo's great Florentine predecessor, but the play of her robe's sinuous out-

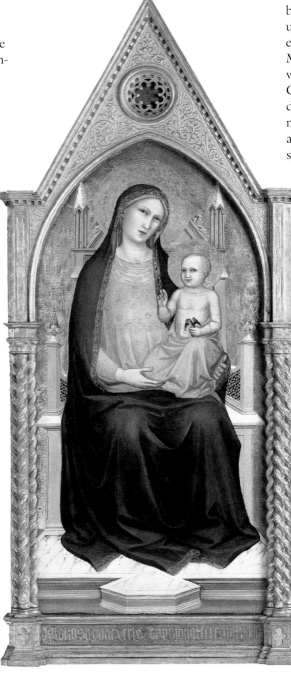

line against its elegantly patterned bottom folds and the throne's sharp angles is characteristic of Lorenzo's lyrical art. He was, above all, a consummate colorist, evident here in the striking harmony of the Madonna's lapis lazuli robe and its moss green lining with the violet gown, the crimson robe of the blessing Child, and the scarlet floor below. This panel is remarkable for its size. It is also of the greatest rarity for a fourteenth-century painting to be preserved so well that we can see unblemished the delicate craftsmanship evident in such virtuoso passages as the Madonna's halo tooled with a rose-wreath design, her transparent veil and Christ's gauze shirt, the gold embroidery of her gown, and the sparkling mosaic inlay that helps to define visually the depth of the throne, itself a symbol of the Church. The frame is substantially original, although the columns' twisted shafts and the top half of the gable are restorations.

Tempera on panel; 48 11/16 × 24 in. (123.7 × 61 cm); Purchased with funds from the Libbey Endowment, Gift of Edward Drummond Libbey, 1976.22

Iranian
Bowl, 1200–1300

FLANKED BY TWO high-ranking attendants wearing long, textured tunics beneath sleeveless surcoats, a prince sits in state on a low throne before a fishpond. He holds a ceremonial staff symbolizing authority. Overhead, beneath a draped canopy decorated with clouds and scrollwork, fly two birds; a low barrier, perhaps a striped curtain, divides the trio from the other attendants. The round-faced figures have halos for emphasis rather than to symbolize holiness. The scene, which covers the entire interior of this bowl, is similar in composition and draftsmanship to contemporaneous Persian manuscript illustrations.

Elegant calligraphy united the diverse artistic centers of the medieval Islamic world. Here, a repetitive band of the angular Arabic script called Kufic (in cobalt blue decorated with red and green foliage) encircles the inner rim. Arabesques painted in red with either turquoise or cobalt, as well as a wide, cursive Naskhi script in turquoise, enrich the exterior of the bowl. Such inscriptions — either love poetry, conventional good wishes to an unidentified owner, or merely pure decoration — generally bear no relation to the scene depicted; occasionally they give a date. Here, the combinations of letters are used purely for decorative elegance rather than to convey any information.

This type of bowl has been identified with Kashan, a city some 125 miles south of modern Teheran and an important ceramic center from the eleventh through the seventeenth centuries. Kashan workshops played an important part in producing architectural tiles. In fact, the Persian name of the town is also the word for "tiles," and pottery in general is called *kashi* there. Bowls from Kashan typically have limited subject matter — horsemen, seated figures, and princes with attendants and animals — images of the courtly life that appealed to middle-class patrons. The settings are largely gardens or outdoor scenes with pools, perhaps symbolic of the garden of heaven promised to Moslems in the Qur'an.

This bowl, called minai ware ("minai" means enamel), was created using a difficult and complicated technique involving both under- and overglaze painting. Parts of the design were painted in turquoise, red, and green on or under the raw glaze, and then fired; black outline and other supplementary colors were then added and fixed in one or more further firings at a lower temperature. As with most Islamic ceramics, the colors and lavish surface decoration take precedence over the shape.

Glazed earthenware with polychrome enamel decoration; H 3⅛ in. (7.9 cm), DIA 8³⁄₁₆ in. (20.8 cm); Purchased with funds from the Libbey Endowment, Gift of Edward Drummond Libbey, 1941.17

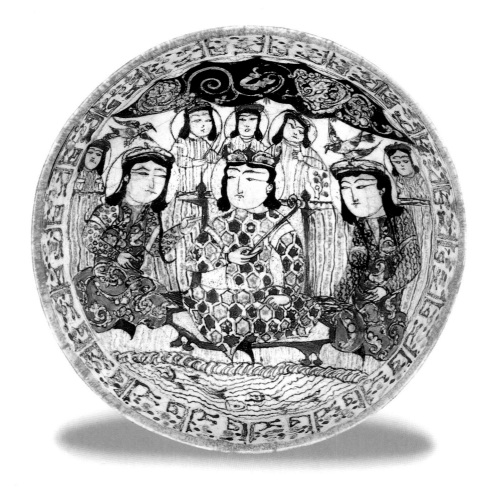

Egyptian
Lamp, 1331–35

AMONG THE LAVISH decorative arts commissioned by the courts of the Mamluk rulers of Egypt and Syria between 1250 and 1517 are examples of the most richly enamel-decorated glass vessels ever made. This lamp is remarkable because it does not bear the usual Verse of Light inscription from the Qur'an the holy book of divine revelation and the foundation of Moslem religion, law, and culture. Although such lamps were intended for use in mosques, this is one of the rare examples intended for a domestic rather than a religious setting. The owner was a minor official in the complex hierarchy of Mamluk society. His late father, Arghun, is named in the dedicatory Arabic inscription, which reads, "One of the objects made for the son of His High Excellency, our honored and well-served Lord Nasir al-Din Muhammad, son of His late High Excellency Arghun, the Dawadar of al-Malik al-Nasir. May Allah the Exalted cover them with His mercy." Thus the lamp can be dated between 1331 and 1335, the years spanning the deaths of Arghun and his son.

Although their proportions often vary, these lamps always have the same shape: a flared foot, a rotund body that curves inward to meet a flaring neck, and six applied handles through which chains were passed to suspend the lamp from the ceiling. The lamp was filled with water on top of which a layer of oil was floated; string pulled through a floating cork served as a wick. In the presence of other illuminated lamps, the gilding and enamel appeared jewellike due to the combined reflected and transmitted light.

The entire surface of these lamps was decorated with elaborate motifs,

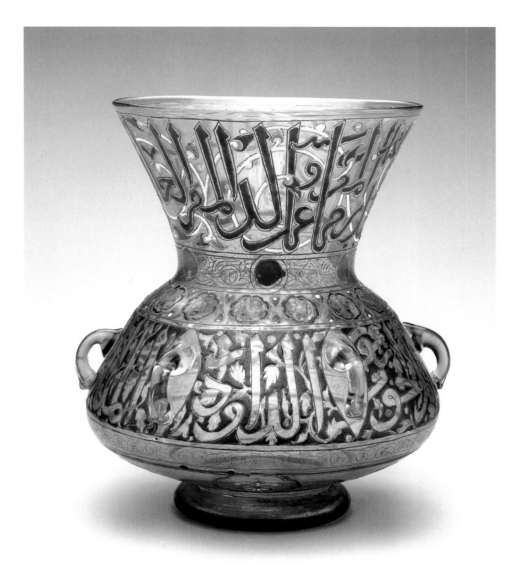

although only the lower portion would have been visible to spectators below. The designs, as on this example, often included Arabic calligraphy interspersed with intricate geometric, foliate, and floral arabesques. On the shoulder, among foliate interlacings, are six roundels, alternately enamelled red and green, which emulate rubies and emeralds. The extensive use of gilding (now worn) as a background for the intricate decoration and for the calligraphy, as

well as the use of pink, a rare enamel color, are exceptional in Mamluk glass.

Glass with enamel and gilded decoration; H 10 13/16 in. (27.5 cm), DIA 8 in. (20.3 cm); Purchased with funds from the Libbey Endowment, Gift of Edward Drummond Libbey, 1940.118

Nigerian (Yoruba People, Kingdom of Owo)
Figure of a Woman, 1500–1700

ONE OF THE MAJOR cultural centers of the Yoruba people was the Kingdom of Owo, whose traditions can be traced back to the fifteenth century or earlier. The city of Owo is located roughly equidistant from Ife and Benin City, between the Niger River and the coast of the Bight of Benin. The almost impenetrable jungle of the region still funnels travelers between Ife and Benin City through Owo, the gateway to northern and western Yorubaland. While Owo works of art have been in European collections for as long as three centuries, most have been misattributed to the better-known Yoruba centers of Ife and Benin City, with which ancient Owo traditions were entwined.

This masterfully carved female figure combines Ife and Benin elements while maintaining such Owo characteristics as the distinctive woman's cap; widely set, bulging eyes below a broad brow; tripartite nose with a central beak and flaring nostrils; mouth in high relief; cylindrical neck; necklace of squarish beads; and the melding of the breasts with shoulders and arms. On the distinctive wide skirt, the Owo talent for carving interlace is given free rein. However, the three scarification marks over each eye and those on the torso are characteristic of the Benin. This combination has led scholars to suggest that the kings of Benin commissioned works such as this from renowned Owo ivory carvers. Ivory has always been revered as a prestige commodity, reserved for kings and important officials. Figures like this belonging to important priests have been found in Benin City.

Although we do not know the details of the ritual in which such figures were used, the red-brown color and the wear on the beads of the necklace indicate repeated anointings with camwood powder. The vessel on top of the figure's head, perhaps a sacrificial, relief-decorated clay jar, may be related to the annual Igogo festival, a ceremony of sacrifice. Since this figure does not bear a baby on her back—the traditional composition for presenting women—she may be a priestess carrying out this sacrifice.

Ivory stained with camwood powder; H 7 15/16 in. (20.1 cm), DIA 3 1/4 in. (8.2 cm); Purchased with funds from the Libbey Endowment, Gift of Edward Drummond Libbey, 1976.40

Workshop of Giunto di Tugio, Italian (Florence), about 1382–1450
Pharmacy Jar, about 1430–31

PAINTED ON THE HANDLES of this sturdy jar is a crutch, the emblem of Santa Maria Nuova, the oldest and still a principal hospital of Florence. Two asterisks beneath each handle are the workshop mark of Giunto di Tugio, whose shop made this jar and nearly a thousand others of various shapes for the hospital's pharmacy in 1430–31. The twenty or so that survive may be the earliest European ceramics whose owner, maker, and date are known. The white coating that masks the natural clay color of the earthenware is glaze made opaque by the addition of tin oxide. This surface is ideally suited to receive painted decoration, as was early recognized by Near Eastern potters who in medieval times brought the technique to Spain. Because Spanish wares later reached Italy through traders on the island of Majorca, the name "maiolica" was eventually applied to tin-glazed earthenware made in Italy itself. Many centers sprang up, mostly concentrated in Tuscany and Umbria, and with growing skill maiolica painters between about 1450 and 1550 produced pictorially decorated wares that are among the distinctive achievements of the Italian Renaissance.

Within this chronology, this early jar continues late Gothic tradition. Its decoration descends from designs in Florentine textiles and other decorative arts, and also from earlier Italian and Islamic ceramics. Outlines in purple-brown were filled in with a strong blue pigment whose thick texture stands out in relief. Although "relief blue" was known in central Italy before 1400, it became especially popular in Florence about 1425–50, when Giunto di Tugio was the most important maker of maiolica there. These "oak-leaf jars" take their name from this pattern

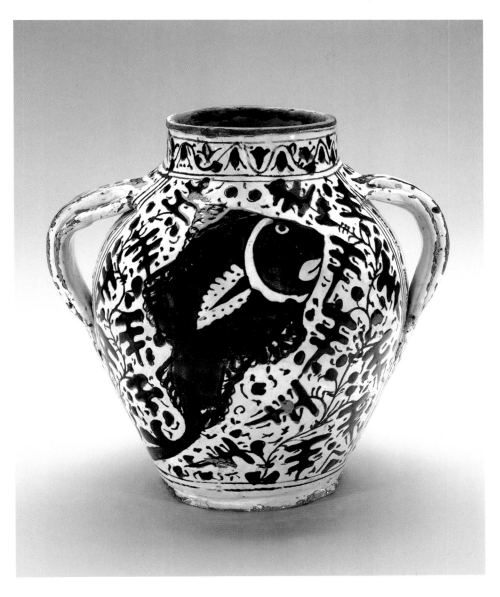

which, as here, usually surrounds more or less fantastic animals and birds. The ballooning body of this wonderfully unnatural fish (its smaller mate is on the other side) is admirably adapted to the jar's swelling shape.

Pharmacies of this time were often attached to hospitals and monastic establishments. They dispensed myriad natural substances and now-improbable compounds of traditional remedies. To some extent they were also social meeting places. There was prestige in having

handsomely decorated containers for ointments, powders, syrups, and other materials. Shelves of such vessels must have been an impressive sight.

Tin-glazed earthenware; H 12⅛ in. (30.8 cm); Museum Purchase, 1950.224

Andrea della Robbia, Italian (Florence), 1435–1525
Madonna and Child, about 1465–70

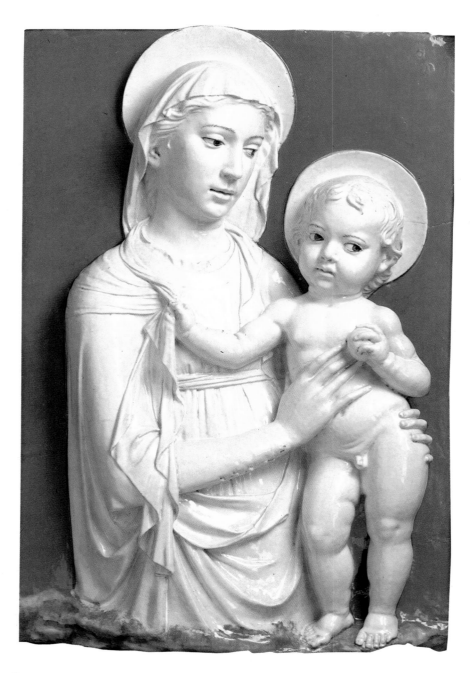

Luca first employed this material for reliefs, with the figures in white against a blue background. He also used it for free-standing sculpture and for decorative architectural elements in which other colors were introduced. Luca's sense of humanity, the serene charm of his style, and the medium's adaptability, relatively low cost compared to stone or metal, and resistance to time and weather contributed to the long-lived success of the Della Robbia workshop.

This relief is by Andrea della Robbia, Luca's nephew, chief disciple, and the man who with his five sculptor sons carried the workshop well into the following century. Andrea was precocious, and, by the time he made this relief, he had been working on his own account for some ten years. Half-length reliefs of the Madonna and Child were a staple of fifteenth-century Florentine sculpture, as they were in demand for private devotional use. This example is among Andrea's finest works on an intimate scale. The high-relief figures are deeply undercut and modeled with meticulous care, while the tremulous quality of the white glazed surfaces is of particular beauty. Although the composition is akin to ones by Luca, the figures reflect later developments of Florentine style in Andrea's own generation. The static poses of the figures, the parallel positions of their reaching arms, the elaborate treatment of the dress, and the blue glaze symbolic of heaven, mottled at the bottom to simulate clouds, are characteristics of Andrea's own work.

Tin-glazed terra cotta; H 29 in. (73.7 cm), W 20⅛ in. (51.2 cm), max depth 4½ in. (11.4 cm); Purchased with funds from the Libbey Endowment, Gift of Edward Drummond Libbey, 1938.123

DELLA ROBBIA IS among the most familiar names in Italian Renaissance art. This dynasty of sculptors was founded by Luca della Robbia (1399/1400–1482), who had an important part in the development of early Renaissance sculpture in Florence. His work in bronze and marble was esteemed by contemporaries, but his wider fame in his own time and later is based on sculpture in the medium that he was the first to use: glazed terra cotta. The ancient use of terra cotta (hard-baked earthenware) for sculpture had been revived in the fifteenth century. Luca's innovation was to cover it with glaze made opaque by the addition of tin oxide, an existing ceramic technique that he greatly refined, his formulas remaining a property of the Della Robbia family.

Albrecht Dürer, German, 1471–1528
The Nativity, 1504

WITH ITS COMPLEX, stagelike setting and carefully posed figures, Albrecht Dürer's *Nativity* theatrically portrays the story of the birth of Christ. At first glance the print may seem more a study of architecture and landscape than a religious subject, but the precise botanical and architectural details that frame the touching human vignette contribute meaning to the narrative. Mary and the Christ Child are tucked under a corner of a crumbling domestic building, while Joseph draws water from a well in a courtyard framed by both Roman and medieval arches. A shepherd looks on from a stable in the rear. Within this apparently ordinary setting, symbols emphasize themes of birth and growth. Trees sprouting from the walls of the buildings imply rejuvenation from old foundations; the pitcher, well, and water allude to the water of Paradise and the sacrament of baptism, as well as to the purity of the Virgin; and Roman arches represent the old tradition while the medieval ones symbolize the new order that has taken its place.

Well known for his originality and immense influence on other northern European artists, Dürer produced works largely of popular religious scenes in which he promoted the startling new theories of art formulated in Renaissance Italy. This print illustrates his ability to blend tradition with innovation in both form and content. Here, in one of his first attempts in printmaking to integrate southern and northern ideas, he successfully combined the complex, one-point Renaissance perspective system he had learned in Italy with the medieval narrative traditions he grew up with in Germany.

In addition to being a masterful combination of naturalistic detail, religious symbolism, and printmaking skill, *The Nativity* is also one of the first prints Dürer dated; prior to 1504 the artist had simply initialed his work, but he altered this practice upon his return from Italy. Here his initials and the date can be seen on the plaque hanging from the house.

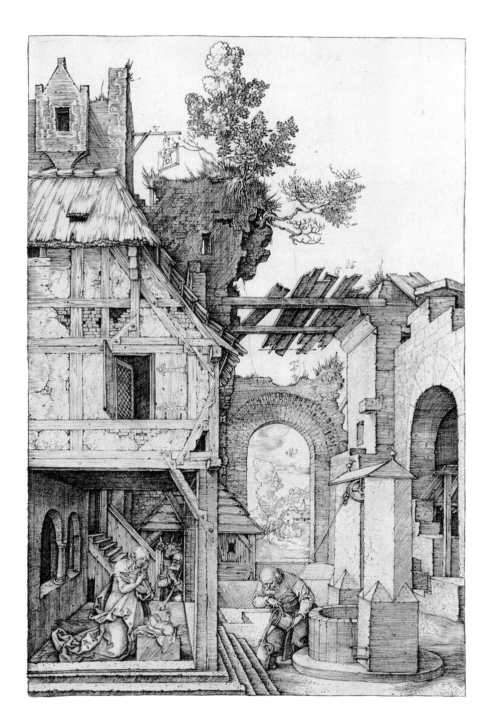

Engraving; 7¼ × 4¹¹⁄₁₆ in. (18.4 × 11.9 cm);
Purchased with funds from the Frederick B. and Kate L. Shoemaker Fund, 1959.17

Piero di Cosimo, Italian (Florence), 1462–1521
The Adoration of the Child, about 1495–1500

THE SUBJECT OF the Adoration of the Child, inspired by the fourteenth-century mystic Saint Bridget of Sweden, was popular in the Renaissance because it afforded an opportunity to express warm maternal relationships. Bridget's *Revelations* describes a vision in which the Virgin, kneeling in prayer after giving birth to Christ, began worshipping him, while Joseph slept nearby. Here the Virgin and Child are in a green meadow isolated from surrounding rough terrain by sharp ledges, an allusion to the enclosed garden symbolic of Mary's virginity. She is reading from Paul's First Epistle to the Hebrews, used on Christmas Day: "And Thou, Lord, in the beginning has laid the foundation of the earth." Christ lies on grass, a metaphor of salvation, while the flowers are a reference to both the Virgin and the Incarnation. The dandelion can refer to the Incarnation as well as to the Passion. The beautifully rendered pool is a symbol of Mary's purity, while its tadpoles may be understood as expressive of new life, and the nearby bird as a symbol of the soul. The donkey and ox, and farther off, a shepherd and grazing sheep, all associated with the Nativity, lead the eye from the richly textured foreground, past the town, to the hushed clarity of the lake's blue distance. On the other hand, the sleeping Child, the rock placed ominously above him, and the bare trees with cormorants, birds of ill omen, all seem to refer to his Passion and death.

Piero's style is not readily defined, though influences from Florentine and also Netherlandish contemporaries are apparent. He was singular in the importance he gave landscape and in the finesse with which he introduced closely observed natural details to which tradition had attached Christian significance, though it is characteristic of his art that their meanings can be variously interpreted. Piero was known for both his personal eccentricity and the fantasy of his art, most evident in strange, mythical themes that resist explanation. In religious subjects his restless originality was necessarily more restrained, though there is an uncanny sense in the way this majestic Virgin, her robe as deeply furrowed as the bizarre rocks behind her, looms over the foreground. This may be the earliest of the circular paintings of the Virgin and Child made for private devotional use that are Piero's most felicitous interpretations of sacred themes. It is among his finest and best preserved works in this format—a shape that harmonized with his penchant for placing two or three figures in compositions that emphasize the picture's front plane.

Oil on wood panel; DIA 63 in. (160 cm); Purchased with funds from the Libbey Endowment, Gift of Edward Drummond Libbey, 1937.1

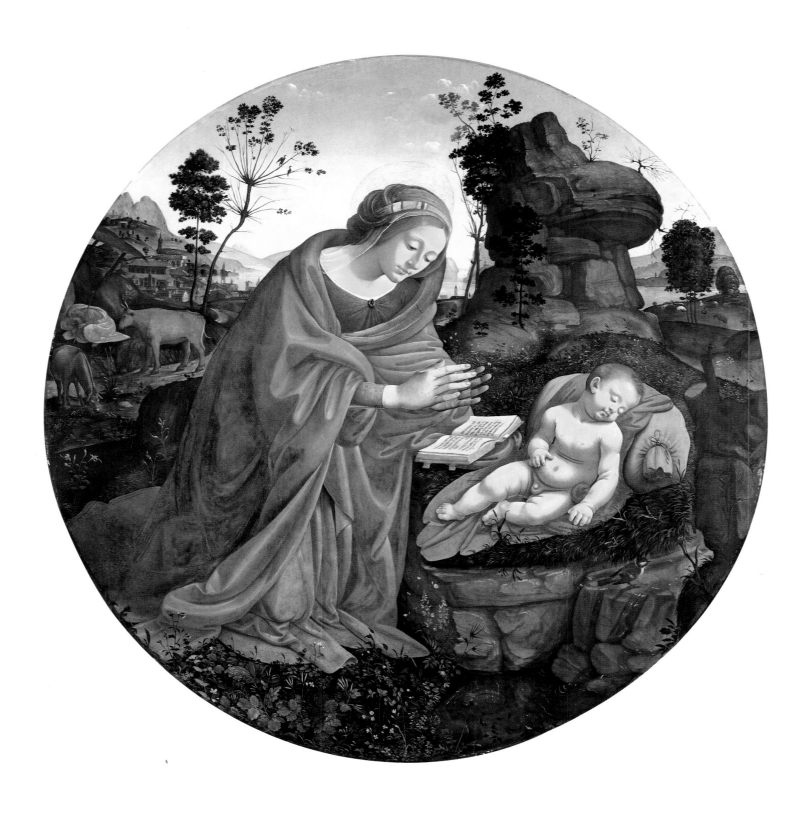

Jan Gossart (called Mabuse), Netherlandish, about 1478–1532
Wings of the Salamanca Triptych, 1521

THE TOLEDO MUSEUM'S panels by Jan Gossart admirably demonstrate the commingling of a Netherlander's artistic sensibility with the classical ideals of the Italian Renaissance. Jan Gossart, called Mabuse for his birthplace (Maubeuge in Hainaut [northern France]), traveled to Rome in 1508–9 in the entourage of his patron, Philip, the duke of Burgundy. There he acquainted himself with contemporary painting

and other arts, in addition to making a study of the ancient ruins of the Eternal City. Besides being influential on his own career, Gossart's venture south is of note for marking the commencement of a long tradition of northern artists journeying to Italy.

It is generally accepted that these panels originally functioned as the wings of a triptych, the center panel of which, *The Descent from the Cross,* today is in the Hermitage Museum, St. Petersburg. The triptych was likely

commissioned by Pedro de Salamanca, a Spanish merchant in Bruges, for his family chapel in the Augustinian church in Bruges, completed in 1516. When the wings of the triptych were closed over the *Descent,* visible on the exterior was the Annunciation, with the angel Gabriel on the left wing and the Virgin on the right. Rendered in only a monochromatic gray palette (grisaille), these figures mimic stone sculpture, a conceit

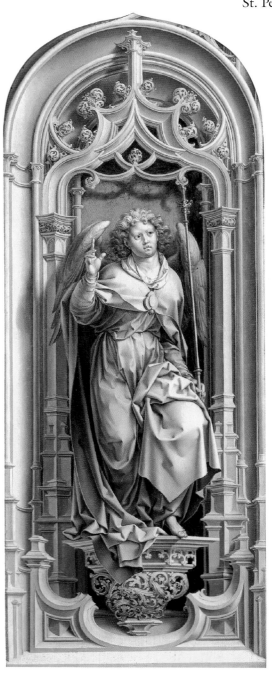
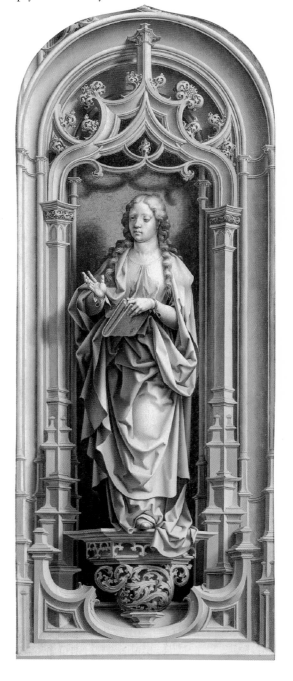

heightened by the Gothic stone tracery surrounding them as well as the purplish background that sets them off.

When opened, the interior of the wings would have been visible on either side of the *Descent*. Like the exterior wings, the interior wings display full-length figures in an architectural setting. But here the protagonists, Saint John the Baptist at the left and Saint Peter at the right, are painted in strong colors; the effect is one of sculpture come to

life. This animated quality is accentuated by the striding poses of the saints, as John points to the Lamb of God, and Peter, his key at his waist, gazes toward the Gospels. Moreover, the fantastic architecture is Italianate in character, with ornamentally encased columns and a barrel vault ending in an apse with a scallop shell half-dome. Northern realism is united with Italianate decoration, design, and figural types.

An account published in 1641 credibly observed that Gossart gave his own features to his namesake, Saint John, while the countenance of Pedro de Salamanca is recorded in the appearance of his patron saint.

Oil on wood panel; left wing 47¼ × 18½ in. (120 × 47 cm); right wing 47¼ × 18½ in. (120 × 47 cm); Purchased with funds from the Libbey Endowment, Gift of Edward Drummond Libbey, 1952.85

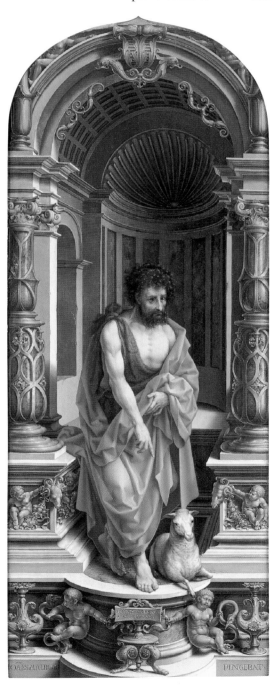

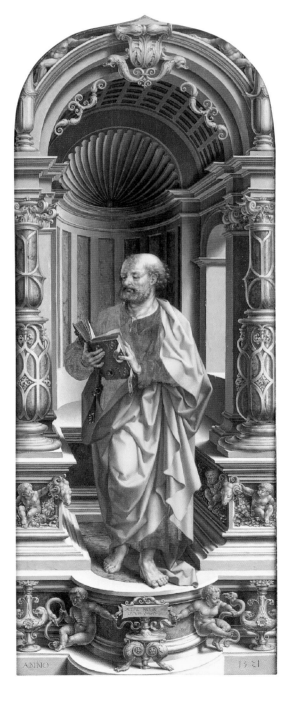

Silversmith: "BI"; Engraver: attributed to "P" over "M," German (Nuremberg)

Ewer and Basin, 1575

BEFORE FORKS came into general use in the second half of the seventeenth century, people ate with their fingers. To enable diners to wash their hands at table, a ewer (a type of pitcher) and basin were provided so that servants could pour water over the diners' hands and collect it in the basin. When not in use, such vessels were displayed on sideboards, and thus were often conceived as show pieces to reflect the owner's wealth, taste, and status. The superb condition of this set suggests that it was admired far more often than actually, if ever, used. The technical virtuosity and the remarkable integration of concept, material, form, and decoration of this ewer and basin, as well as their exceptional size and rarity, distinguish them as masterpieces of Renaissance metalwork. The maker is identified only by his initials, "BI,"

while the engraved decoration has been attributed to an engraver known only by the initials "P" over "M."

The partly gilded silver ewer and basin are engraved with sixteen episodes from the lives of Joseph and Abraham as told in the Book of Genesis. The four scenes of Joseph on the ewer are taken from an early-sixteenth-century German book with woodcuts by Virgil Solis; those on the basin are adapted from illustrations of the same cycle by Bernard Salomon in a mid-sixteenth-century French publication. These engraved scenes demonstrate the powerful influence of the graphic arts at this time, as both a source for subject matter and as models of technique for decoration.

The vase-shaped ewer is etched and engraved with arabesques, shells, rosettes, scrollwork, and a band of laurel. Its scroll handle is in the form of a serpent. Etched decoration—the

technique by which patterns are bitten into the surface of the metal with acid—is found on armor of the period, but rarely on silver.

The circular basin bears similar arabesques and laurel bands. Twelve oval panels with engraved scenes from the story of Abraham are separated by profile busts of Roman emperors. The raised central boss is engraved with the coat of arms of the German Pallandt and Von Dorth families, surrounded by a Latin inscription that translates, "The blood of Christ cleanses us of all sin," and the date, 1575. The reverse is etched with arabesques and engraved with laurel, flowers, and large rosettes; in the center is an engraved bust of a helmeted man.

Silver; ewer H 16 in. (40.5 cm), basin DIA 18⅞ in. (48 cm); Purchased with funds from the Florence Scott Libbey Bequest in Memory of her Father, Maurice A. Scott, 1983.80–81

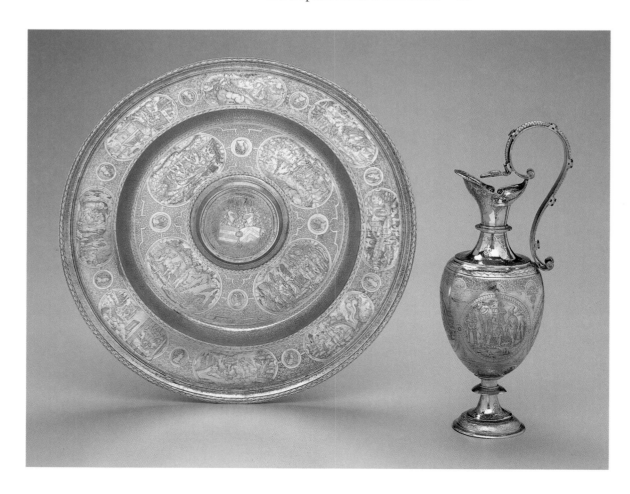

Hans Holbein the Younger, German, 1497/98–1543
Portrait of a Lady, Probably a Member of the Cromwell Family, about 1535–40

ONE OF THE MOST penetrating portraitists in Renaissance Europe, the Augsburg-born Hans Holbein the Younger (his like-named father also was a painter) was first active painting for the affluent middle class in Basel. The artist's greatest renown, however, stems in large measure from his association with the court of the English king Henry VIII. After an initial stay in London in 1526–28, Holbein returned to England in 1532, and within four or five years was named "king's painter." In this capacity, Holbein recorded in an unflinchingly realistic manner not only the likeness of Henry but also that of his many wives (and prospective ones), ministers, courtiers, court officials, and their families, as well as numerous wealthy German merchants residing in the city.

The Toledo panel dates from Holbein's years of service as the royal painter. The sitter is depicted half-length, her torso and head turned three-quarters to the left. She is rendered with her gaze averted, her hands clasped at her waist. Characteristically for Holbein, the image is one of intense objectivity as well as emotional detachment.

Thought for much of this century to represent Catherine Howard, Henry's fifth wife, this identification has been demonstrated to be untenable, as no authentic portrait of Catherine is known. Since the picture once belonged to a descendant of Thomas Cromwell, one of the king's ministers, a more plausible candidate is a member of this important family, perhaps Thomas's daughter-in-law, Elizabeth, the sister of Jane Seymour. However, this too must remain only conjecture, as no certain portrait of Elizabeth exists; nor is her date of birth recorded so as to be able to compare with the present subject's age, which is given in the inscription as twenty-one.

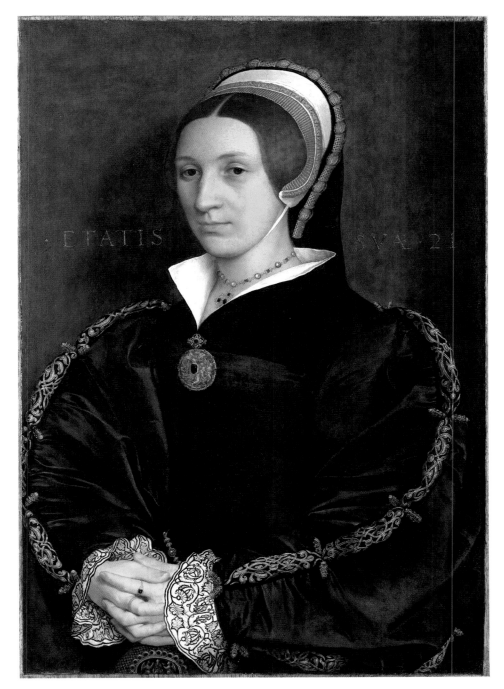

Oil on wood panel; 28⅜ × 19½ in. (72 × 49.5 cm); Gift of Edward Drummond Libbey, 1926.57

Jacopo Bassano, Italian (Venice), about 1510–1592
The Flight into Egypt, about 1542

A PAINTER OF PORTRAITS, pastoral landscapes, and bucolic genre scenes, as well as religious subjects, Jacopo (or Giacomo) dal Ponte was more commonly known as Bassano, the name of his native town in the Veneto thirty miles northwest of Venice. Though perhaps less well known today than his Venetian contemporaries of the late Italian Renaissance—Titian, Tintoretto, and Veronese—he was a celebrated artist in his own time.

Only in the Gospel of Matthew (2:13–15) does one find the story of Joseph being instructed in a dream by an angel to take Mary and the child Jesus from Bethlehem to Egypt so as to avoid Herod's murderous intentions. Bassano's brightly colored depiction of the subject is a sterling example of the artist's ability to orchestrate a complex figural arrangement while simultaneously integrating his group into a rustic landscape setting. A determined Joseph leads the ass bearing the Virgin and Jesus, both of whom have halos signifying their divine status. Behind them in this friezelike composition are three shepherds, possibly Joseph's sons, who are accompanied by a dog, two cocks, two sheep, and an ox.

A recent reassessment of this painting attributes a layer of meaning to the work beyond its biblical narrative. The stony, rugged path on which the Holy Family and the shepherds make their way contrasts sharply with the lush valley in the background, complete with peasants engaged in mundane pursuits. Bassano may have intended to suggest through this juxtaposition the theme of the pilgrimage of life. The viewer might identify with either the path leading to the City of God or that confined to the earth, raising the question, therefore, of spiritual salvation or damnation.

In the late eighteenth century, *The Flight into Egypt* was located in the church of Santissima Annunziata in Ancona. This raises the possibility that the painting was originally commissioned for the church, which was annexed to an early-sixteenth-century hospital built to assist indigent unwed mothers.

Oil on canvas; 62 × 80 in. (157.5 × 203.2 cm); Purchased with funds from the Libbey Endowment, Gift of Edward Drummond Libbey, 1977.41

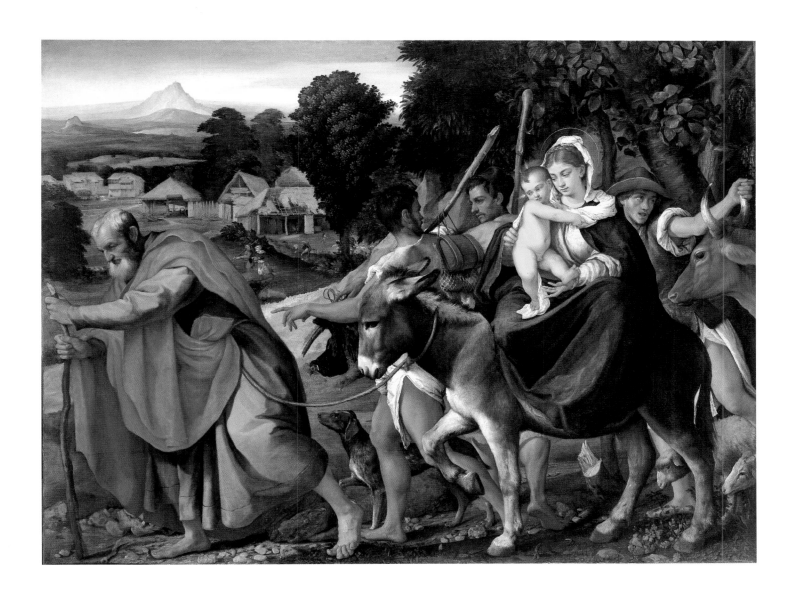

73

Léonard Limosin, French, about 1505–1575/77
Covered Bowl with an Allegory of Fortune, about 1535–40

IN THEIR BRILLIANT SPLENDOR the painted enamels of Limoges are among the most distinctive objects of the Renaissance. The enamel medium, closely related to glass, was applied to copper vessels or plaques before firing—a technique that allowed subtle chromatic and graphic effects. This bowl is among the most remarkable works by Léonard Limosin, the most famous of the Limoges enamel artists. He came to the attention of the French court about 1535, and it was probably through him that the strongly Italianate style of decoration being created for the palace of Fontainebleau at that time reached the Limoges workshops. Limosin took themes and ornamental vocabulary from Italian engravings and other graphic sources inspired by ancient Roman and Greek art, but transformed them so that the sources can seldom be identified. Here, he imagined the traditional allegory of

Fortune holding a sail and precariously balanced on a sphere as also having attributes of Venus Marina drawn over the waves by seahorses led by Cupid. The inscription can be translated, "Reason overcomes Fortune's changes." On the cover are bust medallions of Helen of Troy, Nero, Hercules, and Hercules's wife, Deianira. Three are double profiles, the only instances in the Limoges repertory, where such busts of legendary Greeks and Romans became a popular motif.

Limosin may have been the first Limoges enamel artist to make extensive aesthetic use of a white ground. Here he used it beneath the figures' pale tones and the stronger colors of the rich foliage. The luminous brilliance of this complex decorative program is set off by the black ground that sparkles with delicate gilt motifs. Limosin probably made this bowl soon after he began working in the Italianate fashion, because classical garlands and

wreaths like these are usually present on dated enamels by him from the late 1530s. It evidently had a specific personal meaning for Limosin, as his initials, conspicuously placed on Fortune's sail, are repeated ten times on the wreath around the edge of the cover. No other work by him has multiple signatures of this kind.

Enameled vessels were luxury objects for display and admiration, as the brittle enamel, though durable in itself, is easily damaged. This bowl's intact condition is due to one more singular fact: it is the only Limoges enamel known still to have its original leather case.

Enamel on copper; together H 5½ (14 cm), cover DIA 7½ in. (19 cm); Purchased with funds from the Florence Scott Libbey Bequest in Memory of her Father, Maurice A. Scott, 1980.1018

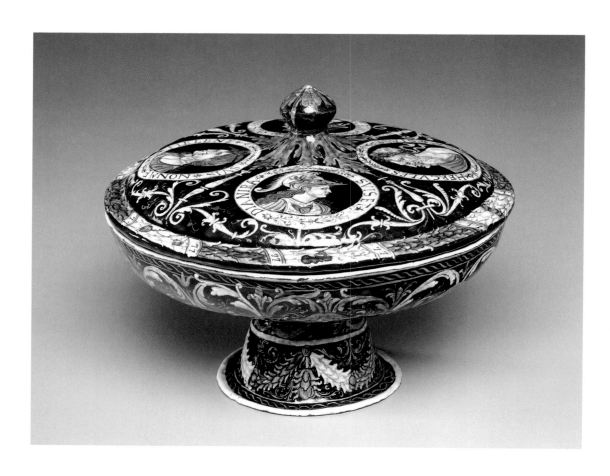

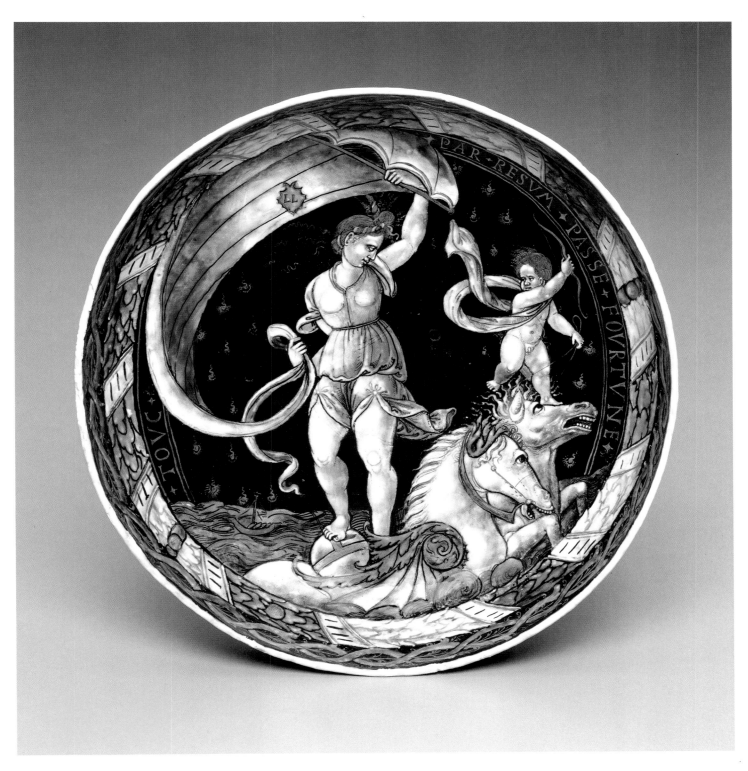

INTERIOR OF BOWL

Francesco Primaticcio, Italian, 1504–1570
Ulysses and Penelope, about 1560

RENAISSANCE ART took many of its themes from the literature of ancient Greece and Rome. Near the end of the Greek epic the *Odyssey,* Homer told how Odysseus (Ulysses to the Romans), after years of tribulations, returned at last to the arms of his wife, Penelope, the two recounting far into the night all that had befallen them. This haunting depiction of their reunion is remarkable for its touching humanity, expressed in the supremely elegant court style that had been developed at the palace of Fontainebleau. There, François I and his successors achieved a setting that became the cultural focus of sixteenth-century France, fit for kings bent on the creation of a centralized autocracy, and whose magnificence and intellectual glamour made this court the envy of Europe.

In the "universal workshop" at Fontainebleau, which adapted the later phases of Renaissance style known as Mannerism to French custom and taste, the dominant artistic personality was Francesco Primaticcio, who came there from Italy in 1532. In ten years he rose to an unprecedented position of artistic authority by virtue of his brilliance as a designer of figures and ornament, prodigious inventive powers, and administrative talent. The grace and refinement of his designs defined the official style, and his art became an exemplar for later generations of French artists.

Primaticcio's masterpiece was the palace's Gallery of Ulysses, tragically demolished in 1738 because its structure had decayed. Immensely long—some 500 feet—its walls were painted about 1556–59 by assistants following his drawings with fifty-eight episodes from the *Odyssey*. In a France disturbed by political unrest, Ulysses stood as a symbol of the wise and prudent prince who surmounted great obstacles finally to triumph over his enemies.

The frescoes were remarkable for their execution in somber earth colors—perhaps reflected in the strikingly muted tones of this oil painting which, together with the relieflike figures, raise the composition to an abstract, "ancient" realm. While this canvas is based in part on one of the frescoes, whose design is known from a later engraving, the tender gesture of Ulysses touching his wife's face is a fresh invention. The attribution to Primaticcio himself rests on the high aesthetic quality of this canvas, nearly the only one confidently attributed to him.

Oil on canvas; 47¾ × 67 in. (121.3 × 170.2 cm); Purchased with funds from the Libbey Endowment, Gift of Edward Drummond Libbey, 1964.60

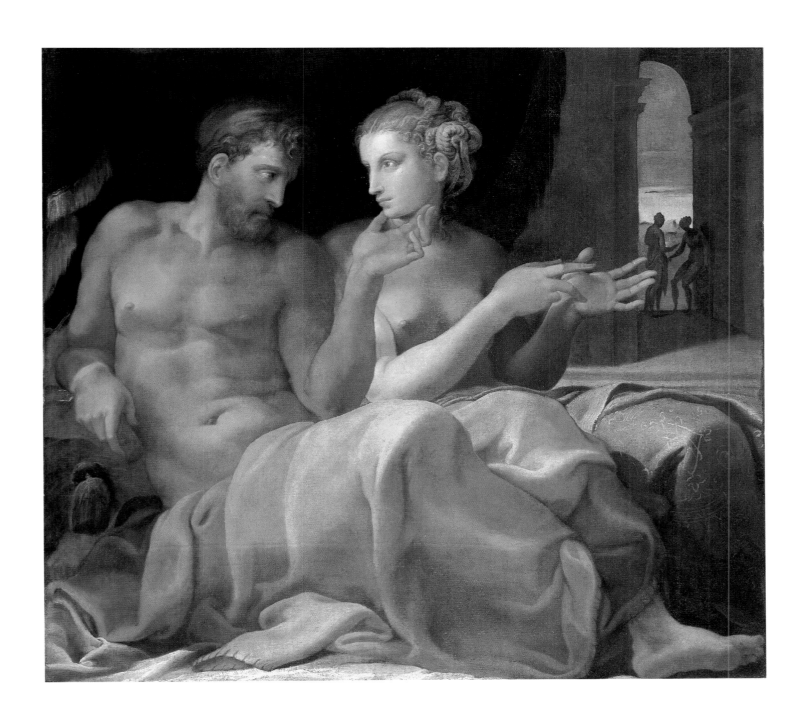

Italian (Venice)
Plate with the Arms of Pope Pius IV, 1559–65

THE SOVEREIGN MASTERY of glass achieved in the Roman Empire was filtered through successive cultures, principally Islamic ones, reaching Venice in later medieval times. During the Renaissance, Venetian glass set the standard for Europe. One famous technical achievement of Venetian glass making was the thin, nearly colorless glass called "cristallo" because it suggested the purity of rock crystal. This delicate plate blown from "cristallo" is a nearly flat disk well suited to diamond-point engraving. In this technique, a drawing instrument tipped with a small, pointed diamond is used to engrave lines into the surface. It was practiced by about 1535 in Venice, where the characteristics of diamonds were well known through trade contacts with India, then their only source.

The engraved decoration is a tour de force. Disposed around a vigorously scrolled cartouche bearing the coat of arms of Pope Pius IV beneath the papal tiara and symbolic keys are six bands of decoration separated by threads of white glass. Three bands gilded with gold leaf, which was fused to the glass by reheating, alternate with bands of engraved ornament. While like most Renaissance ornamental motifs these engraved designs can be traced back to ancient architectural and stucco decoration or metalwork, here scale and context are completely changed. Gracefully linked pairs of eagles, winged half-figures with vases, and cornucopias are symmetrically organized on the plate's vertical and horizontal axes. Their intricacy contrasts effectively with the broader treatment and larger scale of the outer border's leaf motif, and the whole complex scheme is finished off by the plate's folded edge.

This plate is one of only nine pieces engraved in this style that are known. They all either bear the arms of Pius IV or can in some way be associated with the period of his reign, from 1559 to 1565. This pope was a Medici, though his family was from Milan and not related to the great Florentine dynasty that produced two earlier sixteenth-century popes. It was under his rule that the Council of Trent, which codified the reforms of the Catholic Counter Reformation, was reconvened and finally concluded.

Glass with diamond-point-engraved decoration; DIA 10 13/16 in. (27.5 cm); Purchased with funds from the Florence Scott Libbey Bequest in Memory of her Father, Maurice A. Scott, 1982.98

Workshop of Frans Guebels, Flemish, active about 1545–1585
The Founding of Rome, about 1570–80

FROM MEDIEVAL TIMES to the eighteenth century, sets of tapestries often served as splendid decorations to be put up only for great court or religious ceremonies. Brussels, the center of the important Flemish tapestry industry, dominated sixteenth-century Europe through the richness of its designs, the perfection of its weavers' technique, and the entrepreneurial organization of its workshops. The legend of Rome's founding by Romulus and Remus, familiar to Renaissance culture from ancient literature, was a popular subject. This tapestry and another in Toledo's collection, of Romulus bringing his grandfather Numitor the head of the latter's brother, Amulius, who had overthrown Numitor as king and was then killed by Romulus, are from a set of eight on this theme. The other six are in the Kunsthistorisches Museum, Vienna. The set bears the city mark of Brussels and the shop mark of Frans Guebels, who headed one of the city's leading firms of weaver-merchants.

In this complex manufacturing system, the final product was a collaborative effort by many minds and hands. This episode shows Romulus directing the building of Rome. The figures are in the majestic style of Raphael and his followers that was current in Flanders. These Italianate designs by an unknown artist were probably developed in the 1540s, though modified in successive weavings. Compared to earlier versions, this set has a larger proportion of leafy landscape into which the figures tend to merge; this richly detailed texture is characteristic of later sixteenth-century

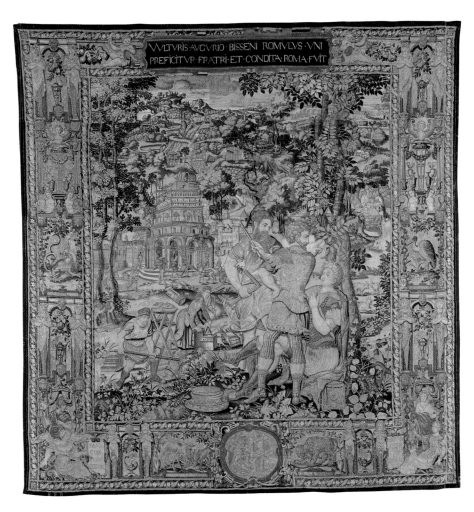

tapestries. The fantastic border of niches with bizarre half-figures, smoking vessels, garlands, masks, emblematic animals (both real and mythical), and allegories of Virtues is an ornamental scheme that Guebels often used. It ultimately derives from Raphael's borders for his *Acts of the Apostles,* woven in Brussels for the Vatican's Sistine Chapel after 1515. Distinctive to this set, however, are the medallions after Heinrich Aldegrever's *Labors of Hercules* engravings (1550), depicting another triumphant hero of antiquity.

Most spectacular in this tapestry is the large amount of gold and silver thread. These costly materials were rarely used in such profusion, but may be explained by the first owner of the set's having evidently been the Hapsburg archduke Matthias, later Holy Roman Emperor, who as governor of the Austro-Spanish Netherlands lived in its capital, Brussels, from 1577 to 1581.

Wool, silk, and gold and silver thread; 141 × 140 in. (355 × 360 cm); Purchased with funds from the Florence Scott Libbey Bequest in Memory of her Father, Maurice A. Scott, 1954.2

Domenikos Theotokopoulos (called El Greco), Spanish (born Crete), 1541–1614

The Agony in the Garden, about 1590–95

THE AGONY IN THE GARDEN depicts a moment from the mental and physical torment of Christ during the Passion, as the events of his final days are known. El Greco ("the Greek") combined elements from all four Gospels to create his own version of this event. Christ, kneeling in prayer in front of a large rock, beholds the angel who gives him strength (Luke 22:41, 43). The angel holds a cup that refers to Christ's words: "Oh my Father, if this cup may not pass away from me, except I drink it, thy will be done" (Matthew 26:42). At the right, in the distance, Judas approaches with the guards of the high priest who will take Christ captive (John 18:3). Beneath the angel, the disciples Peter, James, and John sleep (Matthew 26:37; Mark 14:33), engulfed by the cloud on which the celestial being stands. They are as unaware of Christ's vision as they are of his impending ordeal.

In *The Agony in the Garden*, El Greco blended the artistic tradition of his native Crete, the art of Italian Renaissance masters (he had spent nearly a decade in Venice and Rome), and the deep spiritualism of the late Counter Reformation, the Catholic response to the emergence of Protestantism. El Greco's career coincided with the height of this Catholic resurgence, which was particularly felt in Spain, where the artist lived from 1576 until his death. El Greco's depiction of Christ's agonizing decision to accept the chalice of sacrifice serves as an example to Christians to endure in their faith despite torments or temptations.

In keeping with the intense spirituality of the Counter Reformation, El Greco heightened the emotional impact of his paintings by various artistic means. Here, as did many Italian painters of the second half of the sixteenth century, he elongated the figures' proportions, employed acidic, dissonant colors, and manipulated scale, lighting, and spatial relationships. Rather than conveying a unified receding space, El Greco depicted the figures and scenery in individual "pockets" of ambiguous, shallow space. The beam of divine light that emanates from above the angel is based on a Byzantine icon motif from El Greco's early Greek training. It creates strange light and dark contrasts, especially on the drapery, which hangs heavily with sharply faceted folds. Equally distinctive is El Greco's treatment of rocks and clouds seemingly made of the same material and formed in the same shapes.

Oil on canvas; 40¼ × 44¾ in. (102.2 × 113.7 cm); Purchased with funds from the Libbey Endowment, Gift of Edward Drummond Libbey, 1946.5

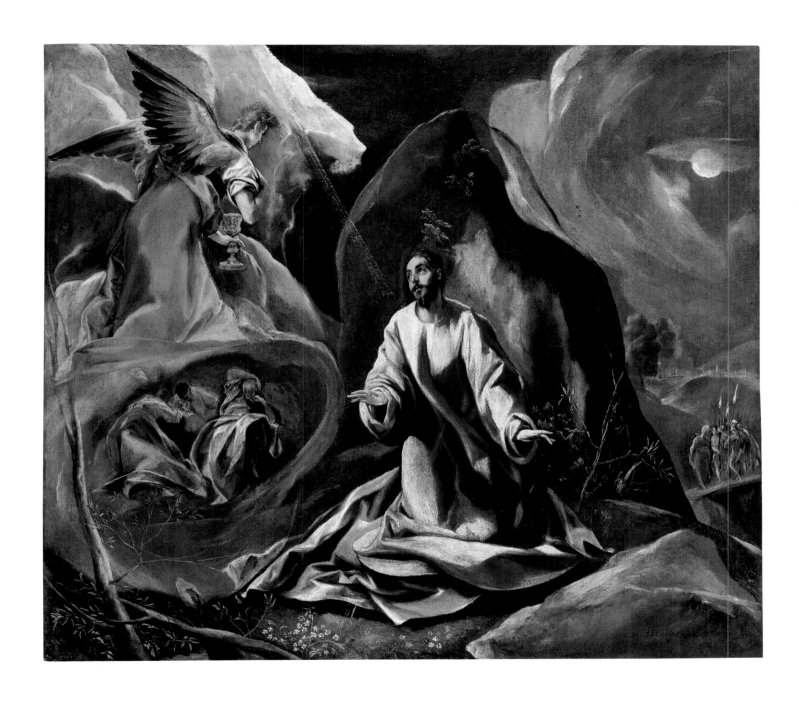

Jan Jacobsz. van Royesteyn, Dutch, about 1549–1604
Nautilus Cup, 1596

WONDERS OF NATURE, considered works of art from the Creator's hand, were avidly collected and proudly displayed in "cabinets of curiosities" during the second half of the sixteenth century. Regarded as particularly precious were exotic nautilus shells from the Indian Ocean mounted as cups in decorative gold or silver frames. The finest nautilus cups were made in the late sixteenth and early seventeenth centuries in Germany and the Netherlands. Intended for display rather than function, these opulent objects combined precious works of nature and man, demonstrating the wealth and taste of the patron as well as the technical skill of the artist. Although the basic form was generally the same and the decorative motifs usually referred to the sea, many variations exist.

This cup's gilded-silver mount masterfully combines mythical creatures, imaginative marine motifs, dramatic storytelling, and technical virtuosity. The shell, a modern replacement, is held in the raised hands of a bearded satyr (a mythical woodland creature with the pointed ears, legs, and horns of a goat), who rides a sea monster emerging from the waves on top of the domed base. The strap mounts on either side of the shell depict a Triton (a god with the head and trunk of a man and the tail of a fish) wrestling with a dolphinlike sea monster; a sea god struggling with a similar dolphinlike creature makes up the front strap mount. The cup's wide rim is engraved with a representation of a sinking ship, panicked figures, and ferocious marine creatures in a stormy sea. A large, spiky monster, its jaws open to reveal long, pointed teeth, incorporates the inner curl of the shell. A half-kneeling bearded man holding a sword and shield steadies himself on top of the monster's head, ready to conquer it.

Nautilus cups are often depicted in seventeenth-century Dutch still-life paintings. Indeed, this very cup appears with minor variations in a painting by Pieter Claesz. dated 1634 in the Landesmuseum, Münster, Germany.

Gilded silver and nautilus shell; H 11⅜ in. (28.8 cm); Purchased with funds from the Florence Scott Libbey Bequest in Memory of her Father, Maurice A. Scott, 1973.53

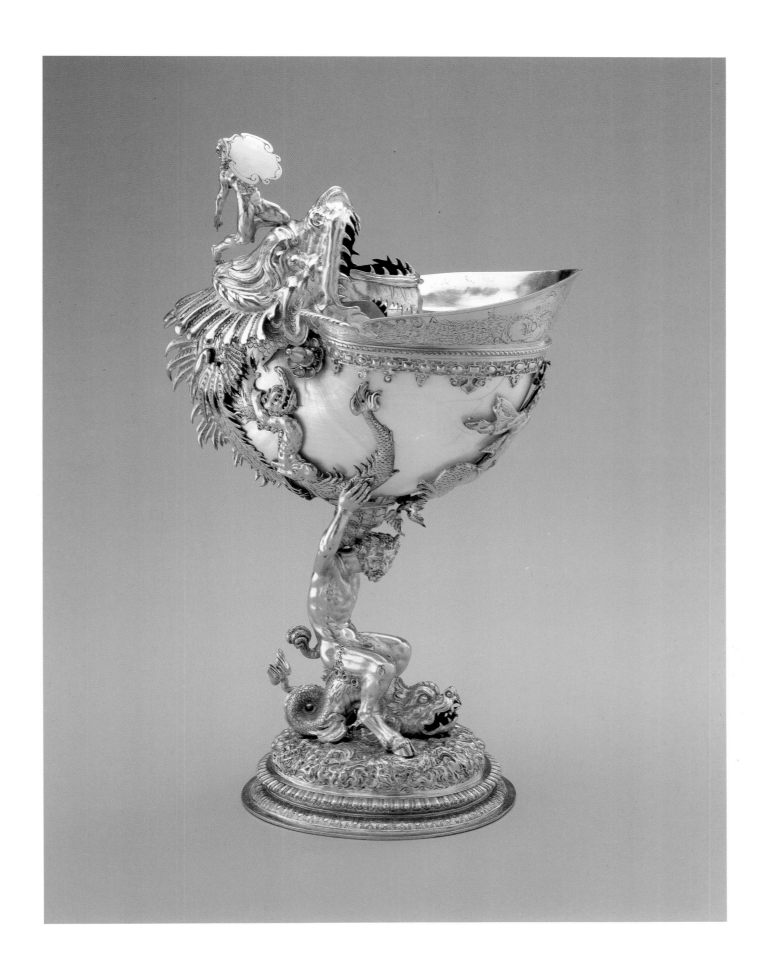

Balthasar van der Ast, Dutch, 1593/94–1657
Fruit, Flowers, and Shells, 1620s

BALTHASAR VAN DER AST's profusion of animate and inanimate objects, all rendered with extreme verisimilitude, indicates the scientific interests of his patrons as well as the painter's own creative method. On a cool gray ledge before a dark neutral background, two motifs, a basket overflowing with different kinds of fruit and a Chinese Wan-li porcelain vase crammed with a bouquet of various flowers, dominate the horizontal composition. Strewn in the immediate foreground are more fruit, a group of shells, insects (others flutter or alight above), and a lizard; a red parrot balances on a cherry branch. The brightly colored arrangement fills the pictorial surface, but most of the elements are given their own distinct space, thereby accentuating their uniqueness as things, whether inert or alive.

The still lifes of Van der Ast, here combining in a single, glorious array a variety of objects, bear testament to the contemporary fascination with the exotic. Shell collectors cherished their curiosities from the South Pacific and Indian oceans, botanists coveted their rare—and expensive—tulips, only recently introduced to Holland, while entomologists and zoologists catalogued their remarkable specimens. Amateur naturalists were obvious patrons of such images and often made their marvels available to artists to record. This documenting from the model, however, usually took the form of a drawing or a watercolor. Only afterward would a painter such as Van der Ast, employing his imagination no less than his studies, compose a carefully contrived composition such as *Fruit, Flowers, and Shells*.

Though seventeenth-century Dutch still-life painting was closely linked to concurrent trends in everyday life,

albeit as interpreted by the mind's eye of the artist, it often involved more than merely beautiful renderings of the natural world. Imbued with a didactic intent, a work like Van der Ast's might well have signified to its original audience a veiled allusion to the transience of life. Flowers in blossom soon will wither and die, insects will metamorphose and expire; indeed, all earthly possessions and experiences were to be understood as subordinate to the realm of the spiritual. Paradoxical as it therefore may seem to a modern viewer, *Fruit, Flowers, and Shells*, at least on a symbolic level, may initially have brought to mind the notion of human mortality.

Oil on wood panel; 21¾ × 35⅛ in. (55.2 × 89.2 cm); Purchased with funds from the Libbey Endowment, Gift of Edward Drummond Libbey, 1951.381

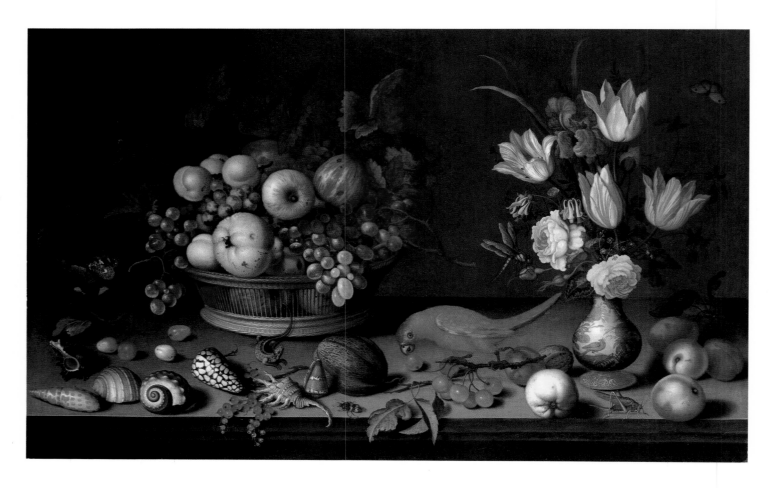

Thomas de Keyser, Dutch, 1596/97–1667
The Syndics of the Amsterdam Goldsmiths Guild, 1627

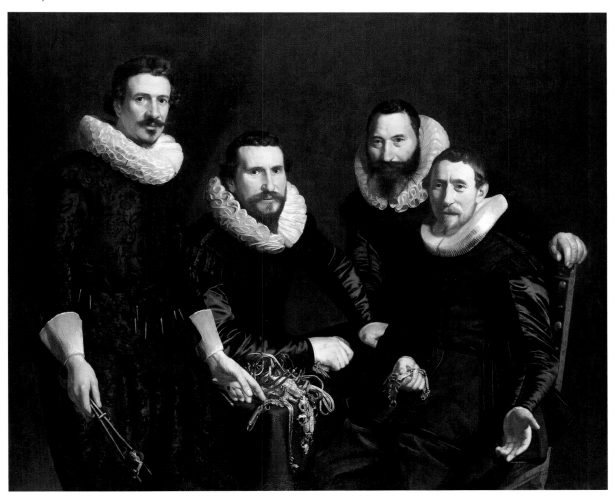

PSYCHOLOGICAL UNITY and compositional structure are purposefully integrated in this group portrait. Thomas de Keyser, the leading Amsterdam portrait painter until Rembrandt's arrival in the city in 1631, positions four men, two seated and two standing, around a table. Each looks directly at us, with no single head claiming prominence over another. As a counterpoint to the rhythm established by the placement of the strongly characterized faces, the painter deliberately distributed across the canvas the hands of the four individuals. Three of the men hold items associated with their profession, while the outside figures are also represented with one hand in a "speaking" gesture. With a strong light bathing the scene from the right, the image dynamically engages our attention.

The pronounced emphasis on the interaction between those portrayed looking out and us as viewers looking on has its explanation in the painting's original context and function. The men, three of whose identities are known, were syndics (wardens) of the Amsterdam goldsmiths guild. As officers of their organization, they were charged with ensuring that standards of materials and craftsmanship were maintained. It was for this reason that De Keyser included at the left in the tongs clasped by Loeff Vredericx a *cupel* (a porous cup used in assaying precious ores), and in one hand of Jacob le Merchier, the second from the left, a set of touch needles employed to ascertain silver and gold content. So too, Jacob Everts Wolff, seated at the right, clasps a silver belt, and other items produced by the guild membership occupy the center of the composition.

Governing boards of a guild commonly commissioned artists to paint their collective portrait, often doing so annually as officers rotated positions. A series of these paintings, or perhaps only the portrait of the current syndics, would be displayed in the guild's chamber, hanging above a fireplace or a piece of furniture. The symbolic importance of the image would have been apparent to all. *The Syndics of the Amsterdam Goldsmiths Guild* is one of the rare instances of such a group portrait to be seen today outside the Netherlands.

Oil on canvas; 50⅛ × 60 in. (127.2 × 152.4 cm); Museum Purchase, 1960.11

French
Room from the Château de Chenailles,
about 1633–35

THE CHÂTEAU DE CHENAILLES lies east of Orléans in the valley of the Loire River, whose idyllic countryside was favored by medieval and Renaissance kings and nobles as a site for splendid dwellings. Construction of this moderately sized house began before 1550 and continued over the next two centuries. This room was decorated in the 1630s for François Vallée, a descendant of the original builders, who held important government financial posts under Louis XIII.

This chamber was a "cabinet," the owner's retreat for work, displaying works of art, and receiving intimate friends. In its ambitious decoration, that both looks back to the Renaissance and contains elements of a new French classicism, it was fully current with Parisian fashion. The prime architectural feature is the towering chimney-piece, for which dated drawings survive, flanked by doors whose painted panels maintain the room's decorative unity. The masks with drapery and fruit festoons were a fashionable motif, but the ambiguous organic scrolls of the circular frame and tablet beneath are a rare occurrence in France of a fantastic style that originated in the Low Countries. Characteristic of French interior design at this time, a ledge halfway up divides the walls. The walls and ceiling are otherwise dominated by paintings designed to fit the paneling. The principal series narrates the dramatic romance of Rinaldo and Armida from the Italian poet Torquato Tasso's popular epic *Jerusalem Delivered* (1575). This cycle and allegories of Virtues (Prudence and Justice are seen here on the doors) may be by the painter Jean Mosnier (1600–about 1656), who lived in Italy and Paris before settling on the Loire in his native Blois. Their style reflects that of Simon Vouet, who in 1627 returned from Rome to become principal painter at the French court, bringing a fluent and decorative Baroque manner that deeply influenced French painting. Mosnier probably also did the smaller-scale, monochrome panels of Mars and Venus under the windows and allegories of the Elements and Seasons on the ceiling. The idealized landscape paintings are by another hand, perhaps one of the Flemish specialists in this subject.

This room was removed from Chenailles about 1900. Its reconfigured installation within the Museum is the reason why the windows, their shutters carved with the monogram of Vallée and his wife and arranged in tiers as was customary in the century's first half, are placed facing each other.

Painted and gilded paneling with oil on canvas and wood panel paintings; Gift of Mr. and Mrs. Marvin S. Kobacker, 1964.34

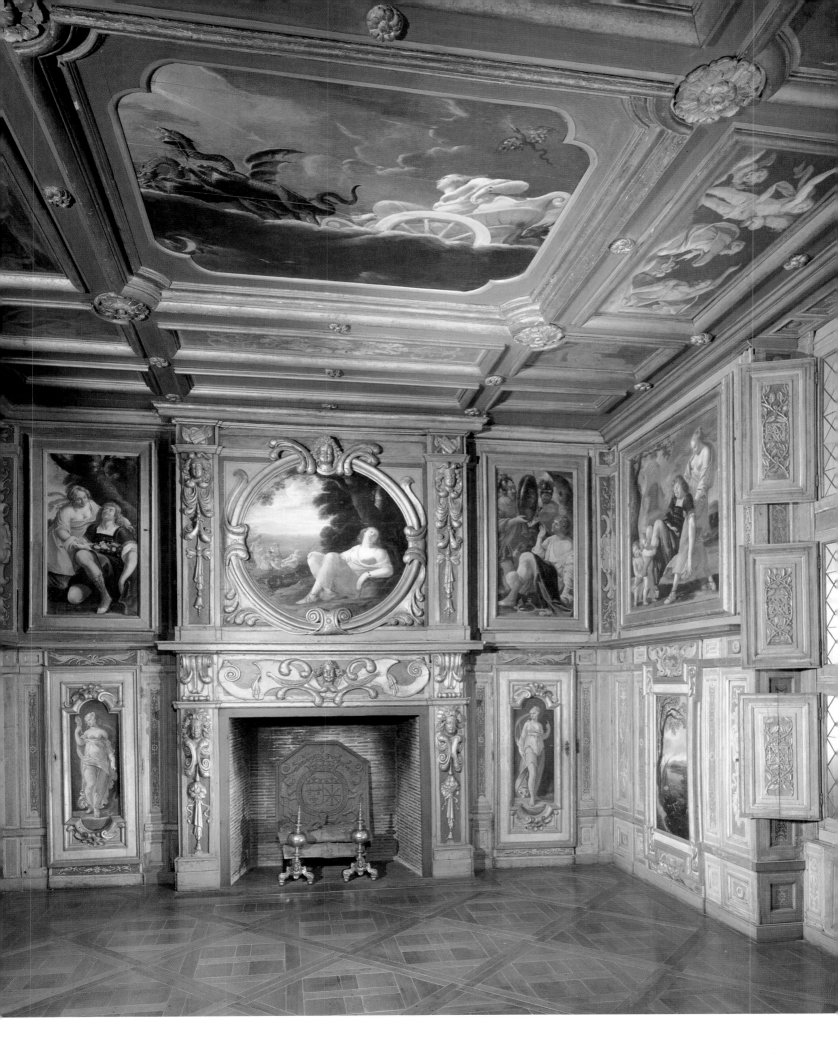

Rembrandt Harmensz. van Rijn, Dutch, 1606–1669
Young Man with Plumed Hat, 1631

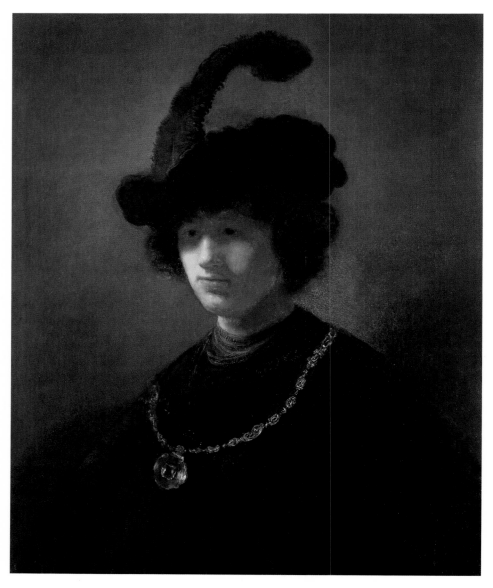

covered by a heavier wool cape, held together by elaborate hooks. The dark red velvet cap is crowned by a large, majestic, gray feather.

The young man in his finery has just turned his body at an oblique angle with his left shoulder forward. The width of the shoulder is cleverly indicated by a turn in the gold chain. The body's movement forward is balanced by the cap's oblique angle backward into space. Between these two vectors are the man's mouth and chin, bathed in warm light; the mouth appears about to open.

Above the red cap a dark shape is clearly visible under the gray paint of the background. Through examination with X ray, Rembrandt's original composition, masked by the surface layer of paint, becomes clear. Initially the cap was higher and shorter at the right, which allowed more hair to be seen. The feather was also a later development. The final cap is both more elegant and more dramatic, since it causes a shadow to fall across the upper part of the face, thus veiling the eyes in semidarkness and creating an air of mystery.

Oil on wood panel; 32 × 26 in. (81.2 × 66 cm); Gift of Edward Drummond Libbey, 1926.64

REMBRANDT AT THE AGE of twenty-five was continually experimenting in his paintings. In the preceding few years, he had painted a number of heads of men in which he explored properties of light and color, the textures of objects, and psychological states. These studies are often of unknown models dressed up by the artist in picturesque or exotic costumes. The Toledo Museum's *Young Man with Plumed Hat* is one of the first large-scale busts Rembrandt painted in the months following his move from his native Leiden to Amsterdam, the most flourishing city in the Dutch Republic. The artist soon became the leading portraitist in Amsterdam, displacing Thomas de Keyser (see p. 51).

In this painting Rembrandt seems to have been most interested in capturing both a sense of opulence and the feeling of a person seen in a specific but transitory moment of time. The light that comes from the upper left highlights the sitter's gold chain and pendant with its large jewel. There is gold embroidery around the neck of the tunic, which is

Jusepe de Ribera, Spanish, 1591–1652
Portrait of a Musician, 1638

IN THIS PORTRAIT Jusepe de Ribera employed his characteristic rugged naturalism to capture the grace and intelligence of his sitter. Though Spanish by birth, Ribera spent his entire professional career in Italy, mostly in Naples, then a dominion of Spain. He specialized predominantly in religious and mythological imagery, painting for the churches of his adopted city and the Spanish viceroys in power there, as well as for institutions and patrons in Spain, including the king himself. Indeed, Ribera, popularly known in Naples as Lo Spagnoletto ("the little Spaniard"), can be said to have been the first Spanish artist to gain international stature.

Portraits count for but a small fraction of Ribera's total output, but they are rightly considered to be among the most expressive likenesses in all of seventeenth-century Italian painting. Here Ribera depicted in bust-length a man with two attributes, a roll of paper bearing musical notation and a baton used to beat time. The sitter's profession clearly involved music, and he may well have been known to the artist through mutual court contacts in Naples. A recent attempt to establish his identity as Giovanni Maria Trabaci,

organist and choirmaster of the Cappella Reale in Naples at the time of this work, seems improbable, since in 1638 Trabaci was already in his sixties, whereas the individual represented here presumably is at most in his forties.

Ribera is known to have painted from the model, as had the influential Michelangelo Merisi da Caravaggio before him. The vibrancy of this picture suggests that it is the result of the painter's having worked directly from his subject and not from drawings. Hand and head are rendered with

an immediacy of touch—a highlight on the tip of the nose, the wrinkles on the fingers—that conveys a sense of the tactile and lends a directness to the portrait.

Oil on canvas; 30 3/8 × 24 5/8 in. (77.2 × 62.5 cm); Gift of Edward Drummond Libbey, 1926.61

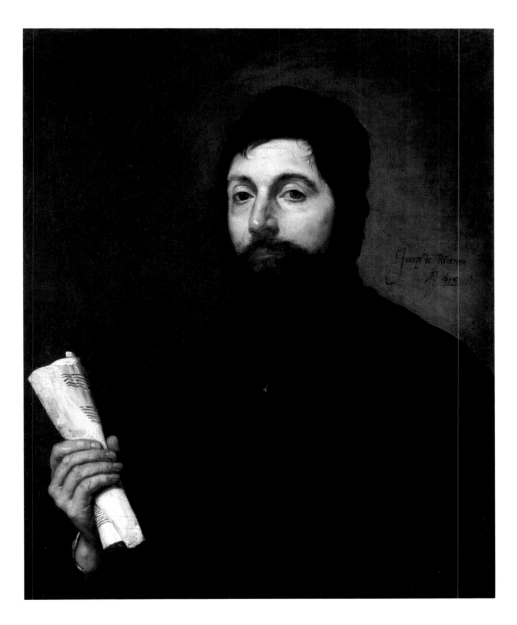

Peter Paul Rubens, Flemish, 1577–1640
The Crowning of Saint Catherine, 1631 (1633?)

WIDELY ACKNOWLEDGED as the most beautifully painted religious picture by Peter Paul Rubens in the United States, *The Crowning of Saint Catherine* originally served as an altarpiece in the church of the Augustinians in Mechelen (Malines), near Antwerp. Seated on a foliated throne, the Virgin Mary gently holds on her lap the Infant Christ. He is shown placing a laurel crown on the head of the kneeling Saint Catherine of Alexandria, who clutches a palm branch, symbol of martyrdom. At the left stands Saint Apollonia, a third-century virgin martyr from the same city. She too bears a palm branch and in her right hand her identifying attribute: pincers, signifying the torture she endured by having her teeth extracted. Saint Margaret, holding a demonic dragon on a leash, looks on at the right. For refusing a marriage proposal from Olybrius, governor of Antioch, Margaret was imprisoned and devoured by Satan in the form of a dragon. Her cross induced the beast to burst, releasing her unscathed, though subsequently she too was martyred. Three putti flutter above, strewing flowers, offering a floral crown, and holding aloft a palm branch. A fourth putto appears between Saints Catherine and Margaret with lightning bolts and flames, an allusion to the destruction of Catherine's wheel of torture.

The visionary scene Rubens portrayed has no exact literary foundation. Rather, it is an instance of creative genius taking liberty with a text to create a new iconographic program. The source from which Rubens drew inspiration is Jacobus de Voragine's popular *Golden Legend,* written about 1275, which states that in Alexandria in about 300, Catherine, the erudite young Egyptian queen converted to Christianity, was baptized; later, she experienced a mystical vision in which the Christ Child married her and "in token of this set a ring on her finger." Because she subsequently refused the advances of the pagan emperor Maxentius, Catherine was tortured on a set of four spiked wheels that was miraculously destroyed by a thunderbolt; later she was decapitated for her faith.

Rubens's invention of the crowning of Saint Catherine conveys the metaphor of divine matrimony to God usually depicted by the bestowal of the ring, thus evoking the theological concepts inherent in the traditional iconography of the Mystic Marriage. This unprecedented iconography, however, places greater significance on Catherine's martyrdom, indeed martyrdom in general, a not uncommon concept within Rubens's oeuvre and Counter Reformation imagery as a whole.

Oil on canvas; 104⅝ × 84⅜ in. (265.8 × 214.3 cm); Purchased with funds from the Libbey Endowment, Gift of Edward Drummond Libbey, 1950.272

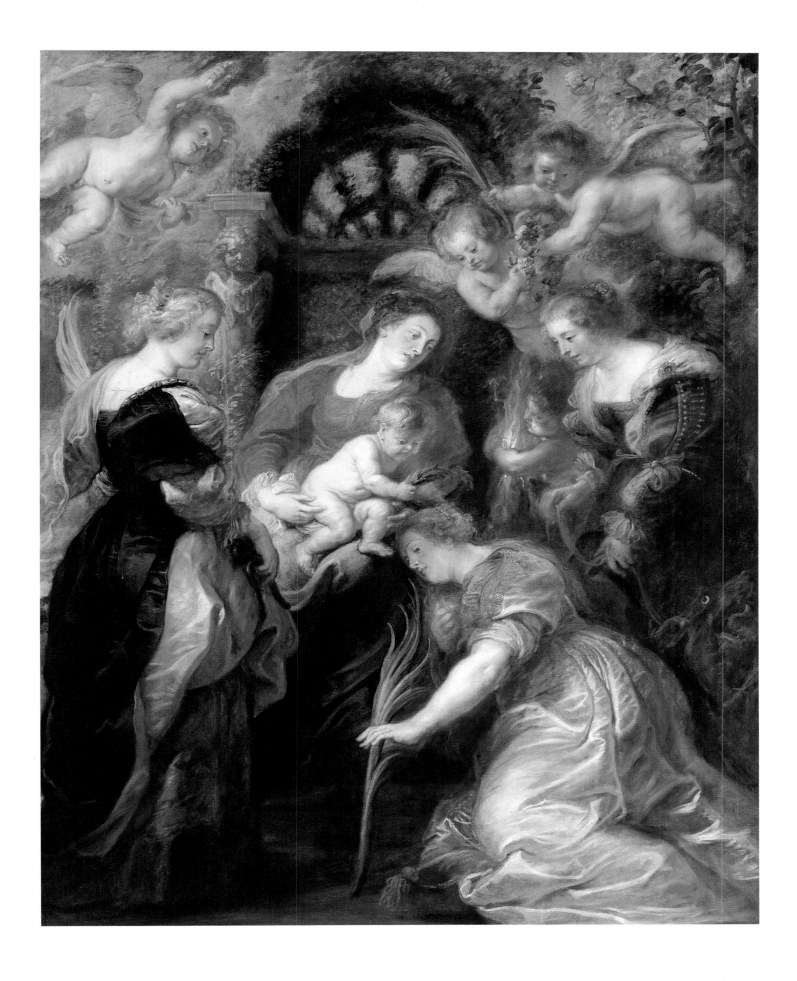

Nicolas Poussin, French, 1594–1665
Mars and Venus, about 1634–35

FASCINATED BY THE ART and literature of antiquity, Renaissance and Baroque artists found ever-new ways of depicting themes such as warlike Mars tamed by his passion for Venus, the goddess of love. This noble canvas presents Venus at her toilet attended by the Three Graces. Mars, his helmet, sword, and spear cast aside, stands enraptured by the sight. He holds his shield as Venus's mirror. Its oval with her reflected image ingeniously links the two principals and marks the change in pictorial key from the quiet, coolly lit group of women composed in profile-like relief sculpture to the warmer tones of Mars's shadowed figure and the flickering movement and lighting of the two cupids. The landscape sustains this shift, the stately trees and constricted foreground opening out to a spacious vista toward snowcapped mountains.

By the time he painted *Mars and Venus,* Poussin had lived some ten years in Rome since arriving there from France in 1624. It was to be his permanent home. Poussin's clients were cultivated men who shared his intellectual interests and valued the harmony he achieved in mythological and religious subjects between poetic content and rigorous clarity. Poussin absorbed ideas from many sources, including the monuments of earlier art. For instance, in *Mars and Venus,* the nudes recall not only ancient sculpture but also those by the Renaissance painters Raphael and Giulio Romano. On the other hand, the landscape setting was inspired by Poussin's study of the Venetian Renaissance, especially the art of Titian. But from the force of Poussin's artistic personality and his astonishing ability to invent solutions appropriate to each subject's mood came an artistic language, both incisive and sensuous, that broke new ground.

Although he worked in Rome when the Baroque style reached its climax, Poussin maintained an increasingly independent and austere direction. In the last half of the century his art attained the supreme status in French painting that it has since retained.

Oil on canvas; 62 × 74¾ in. (157.5 × 189.8 cm); Purchased with funds from the Libbey Endowment, Gift of Edward Drummond Libbey, 1954.87

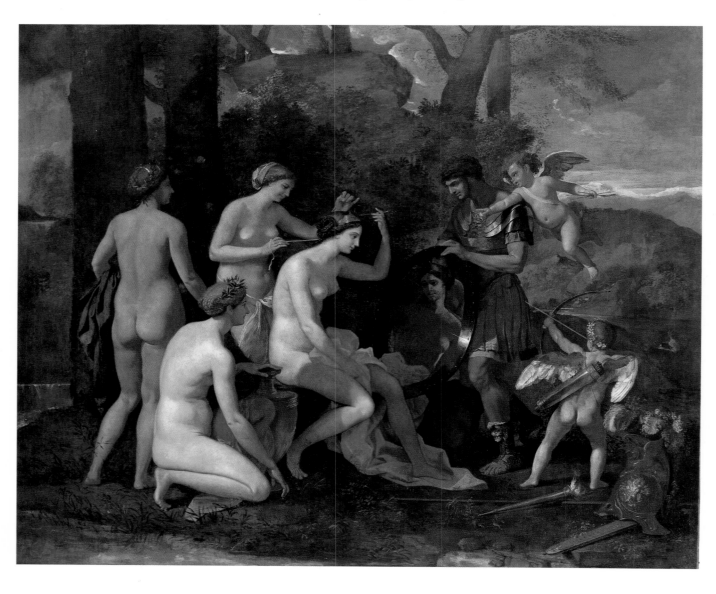

Claude Lorrain, French, 1600–1682
Landscape with Nymph and Satyr Dancing, about 1641

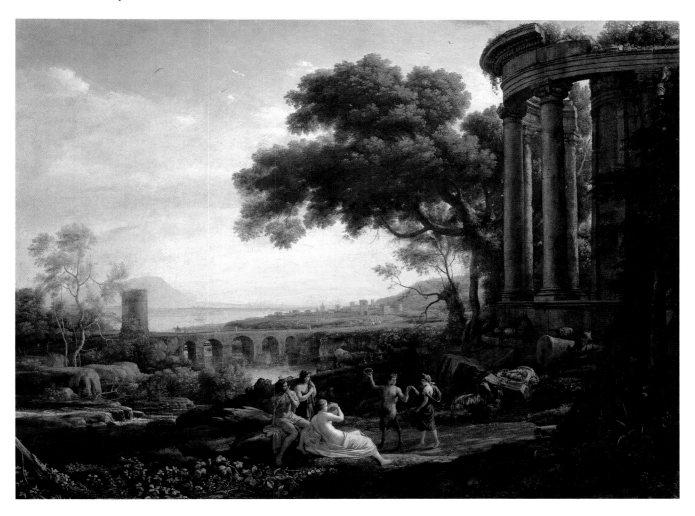

THERE IS NO MORE ELOQUENT evidence of Rome's status as the artistic center of Europe than the decision by the two greatest French artists of the seventeenth century, Nicolas Poussin and Claude Lorrain, to live there. Claude Gellée, born in Lorraine (thus the name by which he became known), went as a boy to Rome, where he apprenticed with painters specializing in landscape at the time it was just becoming recognized as an independent pictorial subject. By the 1630s he was the leading landscapist in Italy, with commissions from the pope and the king of Spain, and he remained a sought-after artist for the rest of his life.

Claude's figures and settings are intertwined. Here the pastoral realm and references to classical architecture and mythology mingle to evoke the ancient Roman poet Virgil, whose poetry first captured the charm of rural life in the Italian countryside. Near a majestic temple ruin, a flute-playing shepherd and his companion make music with some nature spirits. One nymph beats a tambourine while the other dances with a satyr—rather warily, in view of the latter's leer and lustful nature. Claude's own record notes that this painting was sent to Venice, and he evidently felt that a Bacchic theme like those often seen in Venetian paintings would be appreciated there. The light that streams through the columns, leaving most of the foreground in shadow, sets this enchanted glade apart from the sunlit country beyond the river. Beyond, where water, land, and sky melt into infinite distance, the light grows radiant. It is the clarity of this light, the exactitude with which Claude rendered how it falls differently on each object in nature, and its unifying effect that ultimately accounts for the aesthetic beauty of his work.

If the figures evoke a poetic Golden Age, and the ruined temple recalls time's decay and the passing of antique grandeur, the imaginative power of Claude's landscapes was grounded in an intense study of nature, as evidenced by the many drawings he made. This painting was done at the point in his career when he turned to a type of composition that is clearer and more classically balanced than earlier scenes; it evokes an ideal, imagined order.

Oil on canvas; 39¼ × 52⅜ in. (99.6 × 133 cm); Purchased with funds from the Libbey Endowment, Gift of Edward Drummond Libbey, 1949.170

Mattia Preti, Italian, 1613–1699
The Feast of Herod, 1656–61

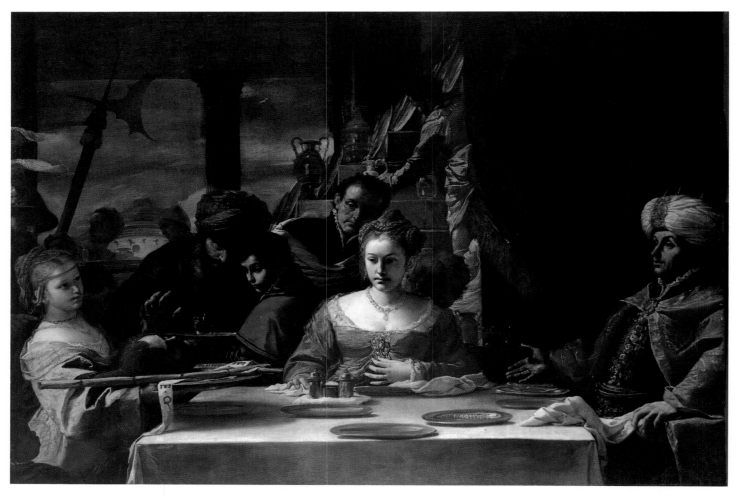

A HAUNTING SILENCE pervades Mattia Preti's horrific scene of John the Baptist's end. The story of the gruesome death of the forerunner of Christ is recounted in the Gospels of Matthew and Mark (and alluded to in Luke's). For rebuking Herod Antipas, tetrarch of Galilee, for having married his brother's wife, Herodias, John the Baptist was imprisoned on the instigation of the conspiring woman. Thereafter, during a banquet marking Herod's birthday, Herodias's daughter, Salome, danced for her stepfather. Herod was so enthralled that he pledged to grant her whatever she desired. Prodded by Herodias, Salome requested the head of John brought on a charger. The ruler, though distressed, made good

on the oath he had sworn and ordered the deed done, whereupon John's head was delivered to Salome, who in turn presented it to Herodias.

The work is likely from a narrative cycle the artist is known to have completed for a member of the Neapolitan nobility. Though the biblical commentary does not relate in further detail the circumstances of the heinous episode's conclusion, Preti followed pictorial tradition in having the head of John the Baptist served up while the birthday festivity was still in full swing. The somber moment was used by Preti as an opportunity to delve into the emotional responses of the protagonists of this theatrical account of retribution and honor ill-served. With the compositional structure of the portico setting reinforcing the triad of principal characters, Salome enters at left, bearing the severed head, the halberd above a

reminder of the shocking action just taken. Across from her Herod recoils and gesticulates, aghast at the grisly outcome of his promise. Primacy of place is reserved for Herodias. As she nervously fingers her garment, the ashen tonality of her face and neck contrasts starkly with that of the head resting on the platter. Around and behind them some twelve other guests and servants are portrayed in various degrees of awareness of what is transpiring. The whole effect is that of a magnificent, mute opera, with pathos the poignant theme.

Oil on canvas; 70 × 99¼ in. (177.8 × 252.1 cm); Purchased with funds from the Libbey Endowment, Gift of Edward Drummond Libbey, 1961.30

French
Table Centerpiece, about 1710

TABLE CENTERPIECES ("surtouts de table") were an innovation introduced at Versailles in the 1690s and quickly adopted at other European courts. Designed as platforms on which containers for condiments, spices, or fruit were conveniently arranged, and with a principal higher element, which might be candlesticks, a figure, or a basket for fruit, these centerpieces remained standard items on grand dining tables well into the nineteenth century.

In this example, an eight-branched candelabrum with four busts of young women and satyrs with animal feet rests on a raised platform. At the corners of the platform are removable sugar casters; shell-shaped boxes for salt or spices are attached to its edges. Thin marble slabs forming the platform's lower section are later additions, for empty holes show where other elements, probably further condiment holders, were originally attached. The platform is decorated with a geometric meander border enclosing shells, lilies, and palmettes, and interspersed with pendant irises and tassels. The overall composition is pyramidal, with each horizontal level being a variation on the circle, square, or octagon. The architectural rigor of the structure serves as a foil for the naturalistic sculptural elements. The dolphin rider and busts are in themselves beautifully modeled sculptures of remarkable quality.

Certain motifs suggest this centerpiece may have been made for a member of the royal family. "Dauphin" (dolphin) was the title of the heir apparent to the French throne. Moreover, the lilies, though naturalistic, may allude to the stylized fleurs de lis, the French coat of arms and royal emblem.

French silver was melted down periodically to finance the hard-pressed government in the period from 1689 to 1815. In 1700 sumptuary laws prohibiting the use of silver were severely enforced, and in 1709 there was another great melting of existing silver. This bronze centerpiece evidently was made to replace a silver version by the royal silversmith Nicolas Delaunay (about 1655–1727). A painting of 1704 by Robert Tournières (1667–1752), in the Musée des Beaux-Arts, Caen, shows Delaunay, surrounded by his family, proudly pointing to the silver centerpiece, no doubt his greatest creation.

Gilded bronze and marble veneer; H 22¾ in. (57.8 cm), W 21½ in. (54.6 cm); Gift of Mr. and Mrs. Edward H. Alexander, 1971.178a–i

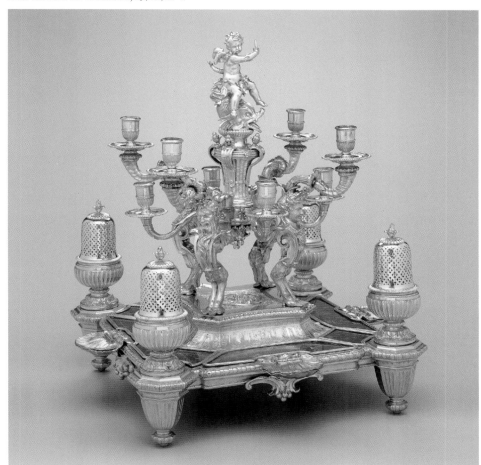

Meyndert Hobbema, Dutch, 1638–1709
The Water Mill, 1664

How to make a flat landscape interesting and dramatic was the central problem for seventeenth-century Dutch painters who lived in a country with no hills and no inherently picturesque scenery. Painters worked out surprisingly different solutions. Jan van Goyen kept his colors almost monochromatic, relying on lively drawing to inject energy into his scenes. Jacob van Ruisdael frequently concentrated on a single dramatic motif, such as ruined tombs or heroic trees. Meyndert Hobbema, on the other hand, was a master of subtle contrasts. In *The Water*

Mill two separate areas, each different in subject and in tone, contrast to infuse the scene with life. At the center large trees arch like canopies over the watermill and pond at the right and the open field at the left. The mill pond and the two figure groups of fishermen and strollers form an intimate scene centered around the water cascading from the buckets into the calm water. The bright green fields and the village dominated by a church steeple seem, on the other hand, part of a larger, more open world. Above, dramatic clouds full of energy and movement are a counterpoint to the relative stillness of the landscape below.

Hobbema studied with Jacob van Ruisdael in the late 1650s, and even in the next decade his work reflected Ruisdael's influence. The mill as a subject was first used by Ruisdael in a painting of 1661 in Amsterdam, but Hobbema quickly became the master of this motif.

Oil on canvas; 37 3/8 × 51 13/16 in. (94.9 × 131.7 cm); Purchased with funds from the Libbey Endowment, Gift of Edward Drummond Libbey, 1967.157

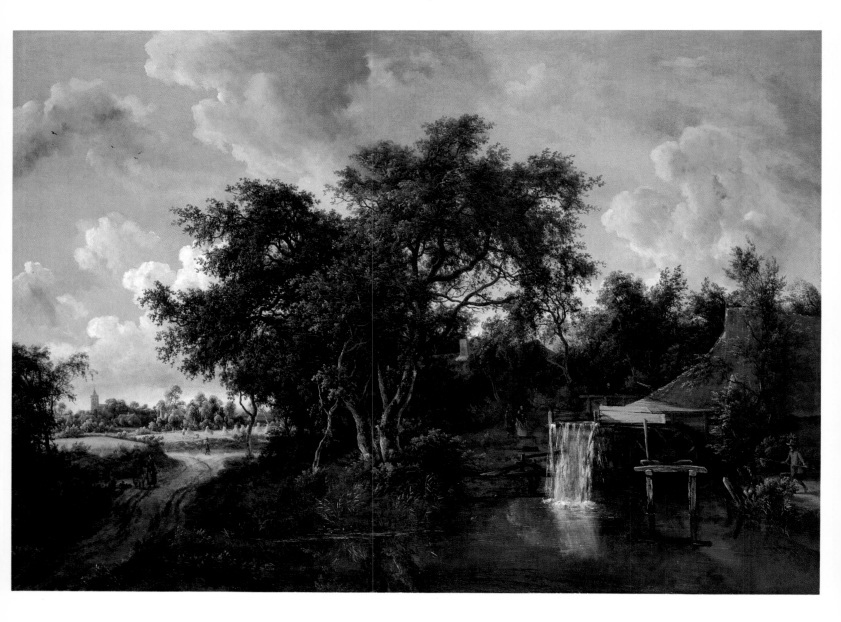

Aelbert Cuyp, Dutch, 1620–1691
Landscape with Horse Trainers, about 1655

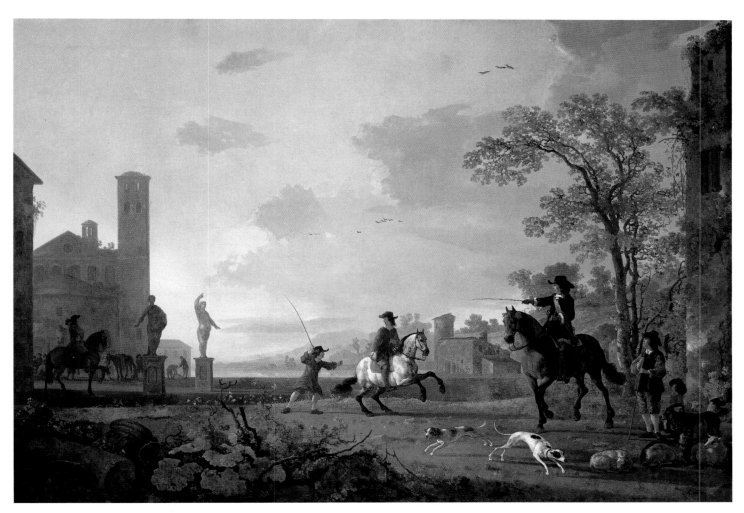

REFINED HORSEMANSHIP was a traditional aristocratic accomplishment, and during the seventeenth century specific formal movements became codified. Such advanced equitation is called dressage. Although this is Aelbert Cuyp's only picture with a dressage theme, patrician families in the town of Dordrecht, where he worked, valued fine horses and on occasion commissioned Cuyp to paint them on horseback.

In this scene an elegantly dressed and mounted man directs two grooms training a horse to perform the "levade," a movement in which the horse rises on its hind legs while keeping the forelegs tucked in, though the latter has not yet been achieved here. The artifice of this training is in harmony with the setting, for this enchantingly improbable land features elements of both Holland and Italy. Cuyp framed his prospect with high side wings, and in the shadowed foreground are fragments of ancient columns—a note of nostalgia for faraway times and lands. The shepherd looking up deferentially at the riding master has stepped out of the fashionable pastoral poetry of the time; his flock seems oblivious to the bounding hunting dogs. Farther off, beyond two robust statues, is a building generally inspired by the Romanesque Mariakerk in Utrecht. Beyond a lake are hills like those Cuyp saw where the Rhine passes into Germany. Nevertheless, however skillful with details, Cuyp is most celebrated for his mastery of light: here, the sun streaming in from the side casts long shadows that organize recession into space. It warms all it touches, including the splendid clouds glowing at their edges.

While the local subjects and low-keyed tones of Cuyp's earlier work reflect the influential style of Jan van Goyen, by the late 1640s Cuyp adopted the golden light and compositional motifs of the important group of Dutch painters working in Italianate styles inspired by the work of men such as Claude Lorrain (see p. 93). Cuyp himself never went to Italy, but as his family had connections with Utrecht, long the center of Italianate art in the northern Netherlands, he clearly learned from the example of Utrecht painters who had returned there from Italy.

Oil on canvas; 46¾ × 67 in. (118.7 × 170.2 cm); Purchased with funds from the Libbey Endowment, Gift of Edward Drummond Libbey, 1960.2

Lucas Dræf, Dutch, 1615–1679
One of a Pair of Sconces, 1670

MOST LIKELY MADE for a small private chapel in Amsterdam, this sconce, one of a pair of wall-bracket candlesticks in the Museum's collection, is an exuberant expression of the Baroque floral style: extravagantly winged putto, broad leaf-scrolled arm projecting almost two feet from the wall, and a candle socket in the form of a tulip. Baroque characteristics found in the architectural sculpture of the period are observed in the sconce's dynamic balance, luxuriant forms, emphasis on the dramatic, and richly worked surfaces. Much of this last effect was accomplished by a technique known as repoussé, produced by hammering from the underside to create three-dimensional decoration. The Baroque

spirit of this sconce, however, is best captured in the wall plate, with a boldly winged putto, its full cheeks puffed like a personification of wind, blowing out the arm of the sconce to its full length in a whirl of scrolled foliage.

At the end of the arm sits the candle socket in the form of a tulip. While the tulip could symbolize human mortality, certainly an appropriate theme for chapel furnishings, this flower had specific associations with the Netherlands. Just several decades before this sconce was made, "tulip mania" swept the country. The competition for the rarest varieties of tulip, with its seemingly unlimited possibilities of petal shapes, sizes, and colors, turned this fashionable flower into a speculative commodity. Prices rose to extraordinary levels, but in 1637 the market collapsed, leaving thousands of speculators devastated. In spite of this history, the tulip remains Holland's national flower.

The seventeenth-century interior in which this sconce and its mate once hung would have had low light levels. The flickering candlelight on the reflecting wall plates and along the arms would have glowed to great effect, fulfilling an important aesthetic role in that interior, while also serving the function of illumination. Though details of the original commission and intended location are unknown, an eighteenth-century inscription on copper plates attached to the backs of the wall plates indicates that in 1788 these sconces were probably presented upon the occasion of a wedding anniversary or a marriage.

Silver; H 16⅛ in. (41 cm), W 15¾ in. (40 cm), DIA 23¼ in. (59 cm); Purchased with funds from the Florence Scott Libbey Bequest in Memory of her Father, Maurice A. Scott, 1982.2

Willem van de Velde the Younger, Dutch, 1633–1707
Ships in a Stormy Sea, 1671–72

THE EMERGING DUTCH REPUBLIC in the seventeenth century had a close and ambivalent relationship with the sea. On the one hand, its land had constantly to be reclaimed and protected from the water through the construction of dikes; on the other, merchant ships were being sent to trade all over the world. The Dutch East India Company was a highly successful mercantile empire, and the Dutch navy was the equal of England's. Thus it is not surprising that the Dutch invented seascapes to celebrate an essential part of their lives and fortunes.

Willem van de Velde the Elder specialized in recording naval battles with skilled "portraits" of actual ships, based on drawings he made from a rowboat during the fight. His son, whom he first taught as a painter, was of a different sensibility and talent, although both men shared a great passion for boats and the excitement of the forces of nature.

In *Ships in a Stormy Sea*, Willem van de Velde the Younger both captured the thrill of boats in dramatic weather and accurately depicted different types of vessels and sailing techniques. At the right a ship used for coastal trade is seen close-hauled on the starboard tack with the sea breaking over her bow. Close on her leeward bow and only partly seen is a small ship. In the left background is a ship at anchor with her mizzen topsail and a driver hoisted. There is a boat pulling toward her; other vessels are in the distance. The striped masthead vane of the ketch is that of the North Sea islands of Terschelling and Vlieland. The clouds seem to be moving fast, propelled by a wind that is also creating the choppy seas. Sunlight breaks through the clouds; all nature seems charged with a sense of movement and change. Van de Velde has captured both the power of the wind and waves and the reassuring skill of the sailors.

This canvas was painted shortly before the Van de Veldes, father and son, moved permanently to England in 1672. In 1802 the painting was in the collection of the third duke of Bridgewater, who commissioned the English artist J. M. W. Turner to paint a companion painting, now on loan to the National Gallery, London.

Oil on canvas; 52 1/16 × 75 9/16 in. (132.2 × 191.9 cm); Purchased with funds from the Libbey Endowment, Gift of Edward Drummond Libbey, 1977.62

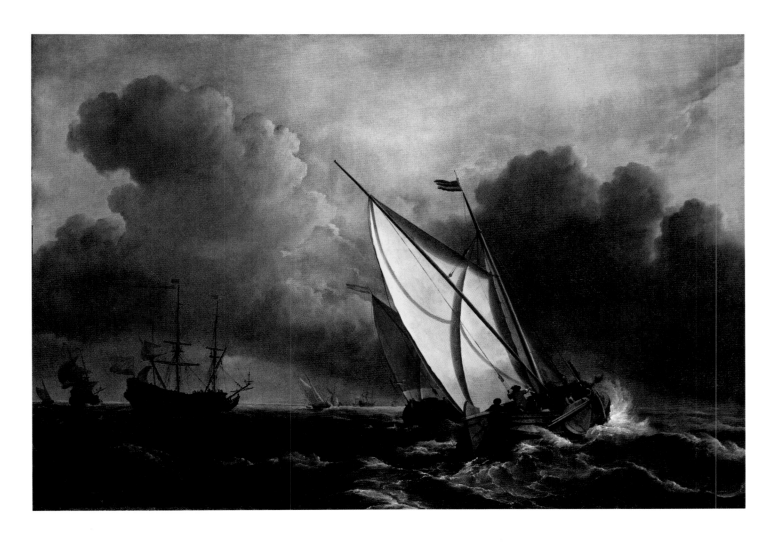

French
Commode, about 1715–20

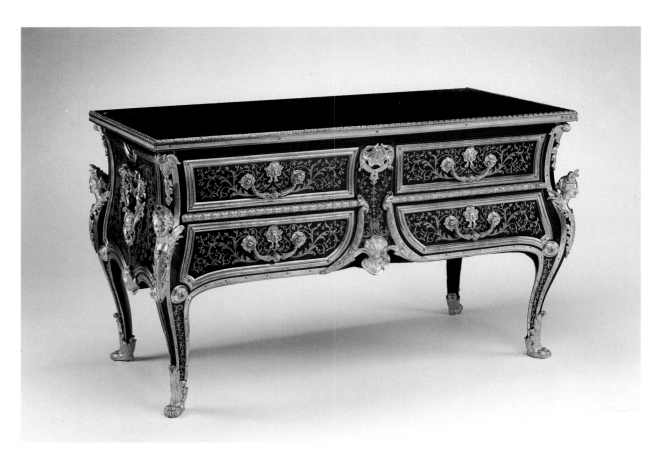

FOLLOWING THE DEATH of Louis XIV in 1715, France was ruled by Philippe, duc d'Orléans, as regent until 1723, when Louis XV came of age. This transition period, known as the Régence, saw in the decorative arts a gradual lessening of the solemn, rigid formality of the Louis XIV style, though its sense of grandeur was retained. Magnificent furniture, such as this commode, or chest of drawers, was intended to celebrate and display the wealth, taste, and power of its owner. The commode as a type of furniture experienced a similar lightening. The fairly massive, cumbersome structure first appeared around 1700, although by 1715–20 it was beginning to be developed in a somewhat less heavy form. This lightening is evident here not only in the structure of the longer legs but also in the animated expressions on the gilded bronze masks at both ends of the commode.

Marquetry was introduced to France in the sixteenth century by Italian craftsmen working for François I at the palace of Fontainebleau. André-Charles Boulle (1642–1732), cabinet-maker to Louis XIV, is celebrated for perfecting this lavish version of the technique that is often referred to by his name, although a number of contemporary cabinetmakers in Paris practiced the technique of combining thin sheets of luxurious tortoiseshell and brass into veneers that were attached to a strong, but less expensive, carcass. When tortoiseshell is inlaid with brass and serves as the ground, the veneer is referred to as *première partie*, or first part, allowing for a complementary piece of furniture using brass as the ground and known as *contre partie*. In this piece the brass inlays have been engraved, adding to the richness of the overall effect of the tortoiseshell, brass, black marble, and gilded bronze, while also mediating the dramatic light and

dark colors. The veneers are enhanced and also protected by gilded bronze mounts, which vary from relatively simple moldings to bold, highly sculptural conceptions, such as the women crowned with laurel wreaths, probably symbolizing Victory, on each of the four corners, and in the inventive, heart-shaped forms with female masks sporting plumed headdresses on both ends of this commode. The individual elements are not only beautifully executed but carefully complementary, giving this splendid commode an especially well-defined unity.

Carcass of oak and pine; drawers of walnut and oak, veneered with tortoiseshell and brass; gilded bronze mounts; marble top; H 34¼ in. (87 cm), L 57 in. (144.7 cm), D 28 in. (71.2 cm); Purchased with funds from the Florence Scott Libbey Bequest in Memory of her Father, Maurice A. Scott, 1965.167

After Martin Desjardins, French, 1637–1694
Equestrian Monument to Louis XIV,
modeled about 1688–91, this cast made about 1700

CIVIC HOMAGE TO LOUIS XIV was expressed by grandiose monuments conceived within a program of political propaganda. In 1688 the city of Lyons commissioned the sculptor Martin Desjardins to make an over-life-size bronze equestrian statue of the king for the new Place Bellecour. Desjardins, Dutch by birth, had achieved professional eminence in France. His great figure, cast in Paris shortly before he died in 1694, became celebrated after it was finally installed in 1713. Destroyed during the Revolution as a symbol of tyranny—as were all public royal images—it is now known by various small-scale versions, the largest and finest of which is the Museum's bronze.

The equestrian ruler as the ultimate image of temporal power, which reaches back to the life-size bronze statue in Rome of the second-century emperor Marcus Aurelius, accorded with the powerfully classicizing thrust of official art under Louis XIV, which established specific prototypes for royal portraits. Following ancient precedent, the king is shown riding without saddle or stirrups, wearing Roman military dress and the imperial cloak, and holding a commander's baton. On his breastplate is the Gallic cock overcoming a lion emblematic of Holland or Spain. The shoulder guard and leg wraps allude to Hercules's triumph over the Nemean lion. The magnificent horse treads upon a sword and barbarian shield bearing an Amazon's head that symbolize enemies defeated. A concession to current fashion is the flowing wig, which had the advantage of making the king's head seem larger.

In 1755 a description of the château of Villeroi south of Paris singled out a bronze after the Lyons equestrian Louis XIV. This was the residence of the maréchal duc de Villeroi, a favorite of the king who, as governor of Lyons, was close to the monument project. No other surviving bronze can be as plausibly associated with him as can this princely work, which speaks so eloquently of those ideals and ambitions by which France defined monarchic grandeur.

Bronze; H 39 in. (99 cm); Purchased with funds from the Florence Scott Libbey Bequest in Memory of her Father, Maurice A. Scott, 1980.1330

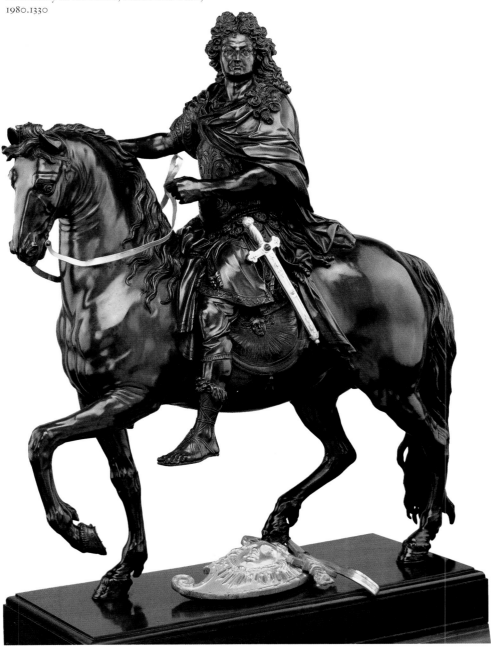

Francesco Solimena, Italian (Naples), 1657–1747

The Expulsion of Heliodorus from the Temple, 1722–23

THE INCONGRUOUS APPEARANCE of a rearing horse and rider in the midst of a crowded architectural setting can be accounted for by the fact that Francesco Solimena's painting is a representation of the divine commingling with the mortal. The Expulsion of Heliodorus from the Temple in Jerusalem is recorded in the Second Book of the Maccabees (ch. 3), one of the Apocryphal books of the Bible. During the reign of Seleucus Philopator, king of Syria (186–175 B.C.), the ruler sent Heliodorus to collect revenue from Solomon's Temple that reputedly was being withheld. As the funds in question, according to the text, had actually been set aside for widows and orphans, the high priest

Onias prayed for God's intervention to stop the plunder. What ensued was the miraculous emergence of "a magnificently caparisoned horse, with a rider of frightening mien, and it rushed furiously at Heliodorus and struck at him with its front hoofs."

As Onias kneels in supplication before an altar in the painting's upper right, a stunned Heliodorus is pummeled in the center of the composition. Nearby, members of his band and their loot litter the steps of the sanctuary, while the distressed but grateful faithful look on in amazement at the turmoil. With the aplomb of an impresario, Solimena has choreographed a scene of wondrous, sacred theater, managing a cast of some seventy-five figures in a grand, architectural panorama.

Solimena's canvas is generally regarded as the preparatory model for the artist's immense fresco positioned above the entrance door in the church of the Gesù Nuovo in Naples. One of the most famous works of art in that city, it and others made Solimena the leading Neapolitan artistic force in the first half of the eighteenth century. Characteristic of his style, this painting demonstrates Solimena's intense chiaroscuro, which results in a flickering pattern of light across the picture's surface.

Oil on canvas; 60 × 80¼ in. (152.4 × 203.8 cm); Purchased with funds from the Libbey Endowment, Gift of Edward Drummond Libbey, 1973.44

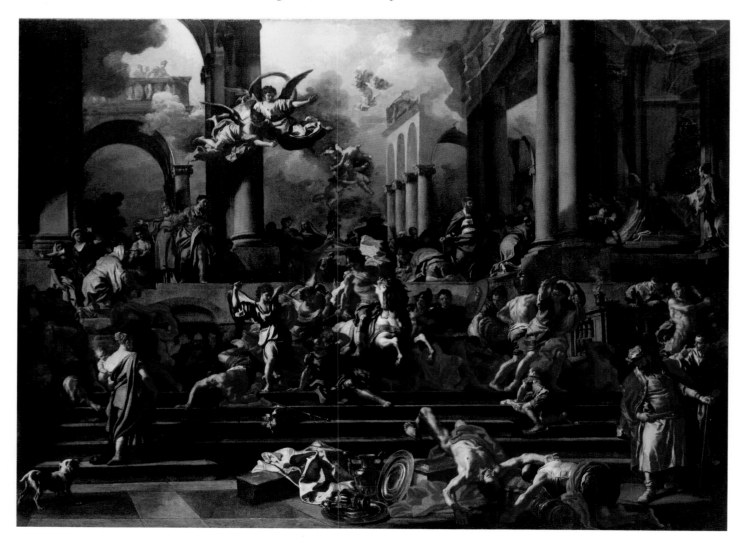

Bernardo Bellotto, Italian, 1721–1780
The Tiber with the Church of San Giovanni dei Fiorentini, Rome, about 1742–44

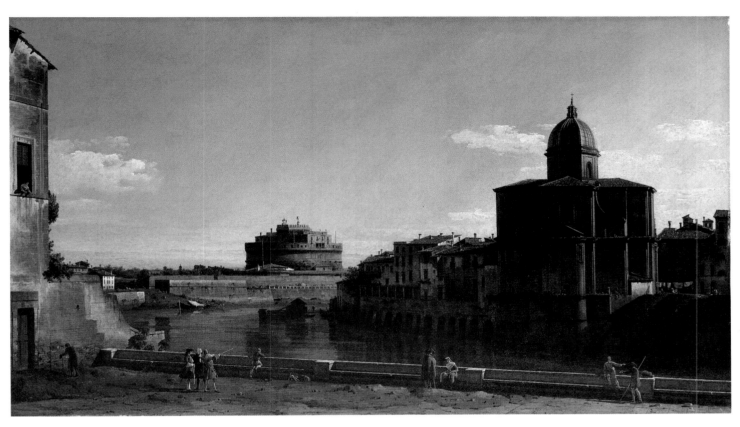

IN MORNING LIGHT, two fashionable visitors with their tutor or guide take stock of a solemn prospect. On the skyline is the massive tomb of the ancient Roman emperor Hadrian. Transformed into the papal fortress Castel Sant'Angelo, it became a symbol of Christianity triumphant over pagan antiquity. To the right, looming above its surroundings, is the church of the Florentine community in Rome, San Giovanni dei Fiorentini. Seen from the back in deep shadow, its angular Renaissance bulk contrasts piquantly with hanging laundry, foreground idlers, and the stained plaster wall that frames the view on the left.

These privileged youths are surely on the Grand Tour, that experience of Continental culture and life then seen as indispensable for cosmopolitan polish. Whatever the itinerary, the ultimate goal was Italy, and its climax, Rome, where countless monuments of

ancient grandeur and modern splendor formed the setting for an international mingling of artists, musicians, writers, and potential patrons.

As a tourist magnet, Rome was rivaled only by Venice, and in both cities the demand for evocations of their famous sights was met by specialist painters. In Venice, Bernardo Bellotto at about fifteen became the pupil of his uncle, Giovanni Antonio Canale, called Canaletto, the most celebrated view painter in Europe. Bellotto's own highly individual talent was already evident by the time his uncle, probably in 1742, advised the experience of Rome as essential for an aspiring topographical artist. Bellotto made a spirited drawing of this view on location; whether the painting was done in his Roman studio or a year or two later in Venice remains uncertain. Views were often made in sets, and Toledo's canvas was originally paired with one of Castel Sant'Angelo seen

from the opposite direction in warm, late-afternoon light (now in The Detroit Institute of Arts).

In 1747 Bellotto went to Dresden, where as court painter he created a series of great townscapes of the Saxon capital and its countryside. Interrupted by war, he worked in Vienna and Munich. Then, after another five years in Dresden, in 1767 he settled in Warsaw to paint for the Polish king. While Bellotto's views of these cities are among the most impressive works of their kind, this early canvas already shows his mastery of strikingly contrasted lights and darks and his use of grayed greens and browns to create the mood of austere gravity that is a markedly personal constant of his art.

Oil on canvas; 33½ × 57½ in. (85 × 146 cm); Purchased with funds from the Libbey Endowment, Gift of Edward Drummond Libbey, 1977.3

Meissen Manufactory, German
Chinoiserie Sweetmeat Stand, 1735

FROM THE SIXTEENTH CENTURY onward, the West was fascinated by porcelain brought from China, and later Japan, though the mysterious, brilliant white, hard, and translucent substance long baffled intensive attempts to duplicate it. The breakthrough finally came in 1709 in Dresden, the capital of Saxony, whose ruler had backed the scientific research and empirical talents that discovered the essential combination of raw materials and techniques. The next year the first porcelain factory in Europe was founded at neighboring Meissen; it was to become one of Saxony's greatest assets.

Spurred by exacting patronage, a succession of remarkable artistic, technical, and organizational talents made Meissen the creator of porcelain art in Europe, and for fifty years its unquestioned leader (see p. 106). Augustus II, elector of Saxony and king of Poland, had grandiose ambitions for his factory. One was to make life-size animals and birds for the Japanese Palace housing his vast porcelain collections. In 1731 he found in the young sculptor Johann Joachim Kaendler the man who could not only realize this project, but whose versatility and inventive energy would soon make him the factory's dominant artistic force. Kaendler saw unlimited new possibilities for porcelain, including his virtual invention of the small porcelain figure as an art form.

In this stand for sweetmeats such as candied fruit and confectionery, a Chinese figure holding shells on his head and lap is seated in an openwork arbor where giant flowers serve as further dishes. Created by Kaendler in 1735, the year he first turned to modeling small figures, it is an example of

chinoiseries, the original and amusingly exotic fantasies of oriental life, as seen through European eyes, that enjoyed a great vogue in eighteenth-century Europe. Since the mid-1720s chinoiseries had already formed a large part of Meissen's brilliant repertory of painted decoration. The arbor in this piece harks back to a Chinese type that Kaendler enlarged and modified, but the figure, with its play of sharply opposed angles, has an incisive tension and pungency that show Kaendler working in a vigorous late Baroque

style. The bizarre fancy and wit of the whole concept is heightened by the astringent discord of the colors, largely concentrated on the flowers, but elsewhere boldly dappled to set off the glittering white of the porcelain itself.

Model by Johann Joachim Kaendler (1706–1775); Porcelain with enamel and luster colors and gilding; H 17⅞ in. (45.4 cm); Purchased with funds from the Florence Scott Libbey Bequest in Memory of her Father, Maurice A. Scott, 1983.47

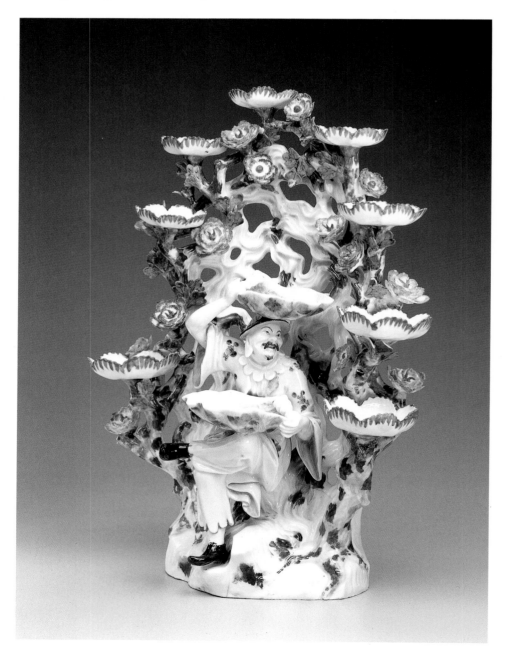

Jean-Honoré Fragonard, French, 1732–1806
Blind-Man's Buff, about 1750–52

LOVE AND COURTSHIP—sometimes chaste, often erotic—were favorite themes of eighteenth-century French art. Elegant young women and men enjoying themselves in outdoor settings were painted with great delicacy early in the century by Antoine Watteau. François Boucher, the favorite painter of Louis XV's mistress, Madame de Pompadour, continued the tradition with broader strokes, both literally and figuratively (see p. 109). Jean-Honoré Fragonard's *Blind-Man's Buff* is close to Boucher in both the way it is painted and the treatment of the subject.

In the sixteenth and seventeenth centuries, blind-man's buff was used by artists as a symbol of the folly of marriage, where one took one's chances in choosing a mate. In Fragonard's portrayal, however, because only one pair of adults plays the game, neither the ultimate partner nor the final outcome is in doubt. As in earlier examples by Boucher, the figures are beautifully dressed in rustic but freshly ironed clothes; the woman's shoes even have bows on them. The setting for this courtship game is a terrace surrounded by a low wall. The limbs of a large tree hang over the terrace like a canopy, and a garden structure is behind its thick trunk. Leaning against the wall is a gate that has fallen off its posts. The sexual symbolism of the enclosed garden and of the gate—not only open but broken off—would have been obvious to eighteenth-century viewers.

When Fragonard painted this scene, he was a very young artist just beginning to be successful. He had come to Paris from the town of Grasse in his early teens. He was apprenticed for a short time to a lawyer, who urged him to pursue the arts. Fragonard worked

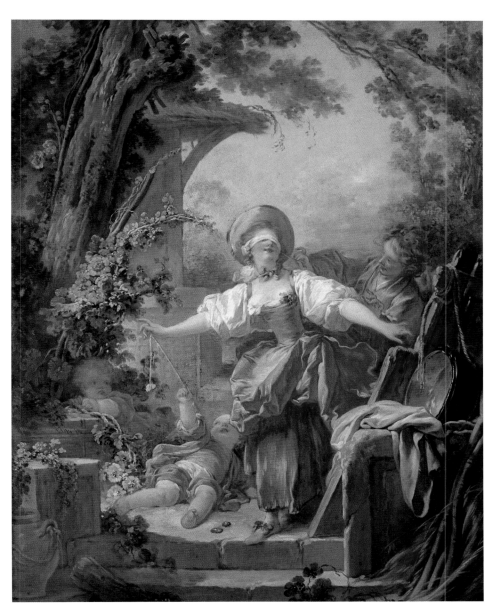

briefly for the still-life painter Jean-Baptiste-Siméon Chardin, but soon was accepted into Boucher's studio. The older artist urged Fragonard to compete for the prestigious prix de Rome, which he won in 1752. During the following nine years, he lived and studied in Paris and in Rome. Fragonard also painted a companion painting, the *See-Saw*, now in the Thyssen-Bornemisza Collection, Madrid. Both paintings may have originally been as much as a foot higher at the top, if we accept the accuracy of eighteenth-century engravings.

Oil on canvas; 46 × 36 in. (116.8 × 91.4 cm); Purchased with funds from the Libbey Endowment, Gift of Edward Drummond Libbey, 1954.43

Meissen Manufactory, German
Nereid Sweetmeat Stand, 1737

THE PRESENCE in the Toledo collection of two fine and rare, yet so different, Meissen objects (see also p. 104) conceived for the same purpose at nearly the same time is a striking illustration of the Meissen manufactory's inventiveness during its great period. After its founding patron, Augustus II of Saxony-Poland, died in 1733, the factory's guiding spirit and supervisor became Count Heinrich von Brühl. Later the chief political force in Saxony and its prime minister, Brühl set himself up in princely state as an instrument of policy as well as to satisfy his own luxurious tastes. He had a genuine understanding of the arts and recognized the worth of Johann Joachim Kaendler, the Meissen factory's chief modeler. As Brühl could take unlimited porcelain at no cost, he encouraged increasingly ambitious projects as his power base became secure. Eclipsing all others was the Swan Service, so-called for the swans in relief on the plates (the Museum has two) and formed as vessels. The service's underlying theme, however, was a grandiose Baroque allegory of the element of water, and Kaendler exploited all the realms of nature and mythology for motifs. There were dozens of specialized pieces, including tureens of five different designs. In the end—the service was in design and production from 1737 to 1741—it could serve a hundred guests and numbered some 2,200 pieces. One of Meissen's greatest accomplishments, it stands as the largest and most astonishing porcelain service in history.

This Nereid, or mermaid, bearing a dish for sweetmeats is among the masterpieces of figure modeling in porcelain. Because Kaendler conceived her as a major element in the formal arrangement around the service's monumental centerpiece, the scale is exceptionally

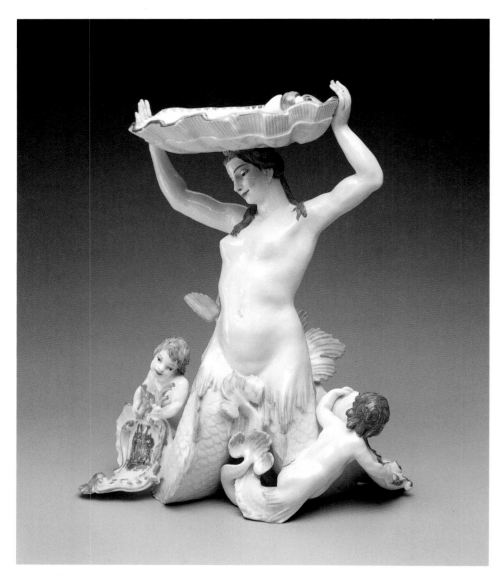

large. Additionally, since this figure and its companions would be seen from many viewpoints, it has a sculptural integrity rarely equaled among porcelain figures. The play of entwined fish tails and young tritons holding shields bearing the coats of arms of Brühl and his wife forms a powerful, rhythmic base for the long, slanting lines of the torso and arms rising to the delicately molded shell dish. Kaendler's design was worked out by Johann Friedrich Eberlein, his principal assistant, whose own gracious, pensive manner remains evident despite Kaendler's final revision. Here, as in the entire service, color is

used with great discretion, a few delicate, naturalistic details and touches of gold setting off the beauty of the porcelain itself.

Model by Johann Joachim Kaendler (1706–1775) and Johann Friedrich Eberlein (1696–1749); Porcelain with enamel colors and gilding; H 14¾ in. (37.5 cm); Purchased with funds from the Florence Scott Libbey Bequest in Memory of her Father, Maurice A. Scott, 1956.60

Lorenzo de Ferrari, Italian (Genoa), 1680–1744
One of a Pair of Console Tables, about 1742–44

ORIGINALLY MADE for the Galleria Dorata (Golden Gallery) in the Palazzo Carrega-Cataldi, now home to the Genoa Chamber of Commerce, this table, one of a pair in the Museum's collection, is a splendid example of the opulent furniture commissioned by wealthy Italians in the eighteenth century. This Renaissance palace, built in the sixteenth century, was purchased in 1704 by the Carrega family, who later added five rooms, including the Golden Gallery.

The interior of the new wing, designed by Lorenzo de Ferrari about 1742–44, featured mythological themes. The Golden Gallery served as a formal, public state-room. The decorative theme refers to Virgil's *Aeneid*, the story of the Trojan warrior Aeneas who escaped the sack of Troy and wandered for seven years before founding Rome. This particular theme was chosen to glorify the Carrega family, which

claimed the hero as an ancestor. Moreover, the classical theme—broadly conveyed here by the table's frolicking putti and maenads (woodland nymphs with the legs of a goat)—suited the era's desire to create a vision of Arcadia, the ideal of rural simplicity and contentment.

This table combines elements of the Baroque and Rococo styles in a manner that also sets up a tension between them, adding to the sense of movement and sculptural vigor typical of Italian furniture of this period. The front legs are female maenads grasping two precariously balanced putti carved in the round. These frolicking children flank an elaborately carved urn of flowers and clutch ribbons that flutter from a winged mask on the center frieze. The table was originally placed against a wall beneath a mirror; the shape of the marble top indicates that the table also was designed to fit into a recess. Mirrors were used to create an atmosphere of lightness and spaciousness and

to unify the room's decorative scheme. The furnishings beneath them were linked in form and decoration to the mirror's frame which, in turn, was related to other decoration in the room. The multiplicity of gilding and forms reflected in the mirrors would further increase the room's overall impact. The scrolling legs, elegant curvilinear shapes, and rich decoration of this table indicate how spectacular this effect must have been when the table was in its original setting.

Gilded gesso over wood; marble top; H 34½ in. (87.5 cm), L 48 in. (121.9 cm), D 20 in. (50.8 cm); Purchased with funds from the Florence Scott Libbey Bequest in Memory of her Father, Maurice A. Scott, 1978.31

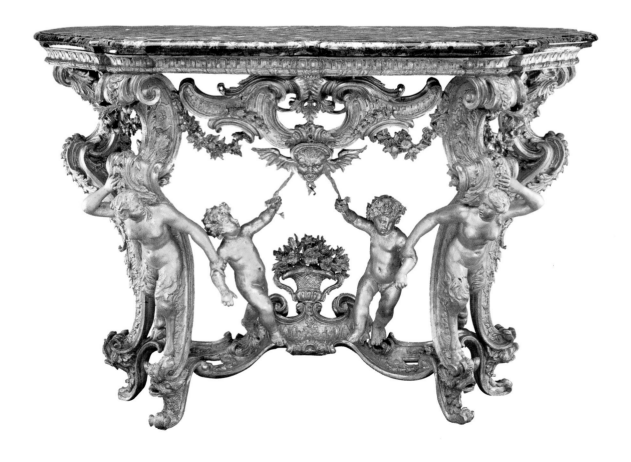

Paul Crespin, English, 1694–1770
Tureen with Stand and Liner, 1740

THIS EXCEPTIONAL SOUP TUREEN is a noted example of English Rococo silver. The Rococo style emerged in France in the 1720s and was introduced in silver to English patrons shortly thereafter through prints and drawings and by French Huguenot silversmiths who had left their native land after the Revocation of the Edict of Nantes in 1685 forbade them to practice Protestantism. Rococo is a delicately elegant style characterized by harmonious naturalistic motifs, asymmetry of decoration, and a taste for lively movement that compels the viewer's eye to move from part to part rather than focus on any one element.

The tureen's function is almost completely hidden by its elaborate sculptural components. A shallow oval bowl rests on two recumbent figures of goats or hinds (female red deer). Its sides are festooned with flowers, foliage, and a band of shallow flutes. Held in place by screws, life-size fruits and a finial of two apples with cherries and leaves decorate the cover. On each side of the base, an orange or lemon is set between the reclining animals. Both the bowl and the platterlike base terminate in scroll ends above the animals' heads and below their feet. The asymmetry and diversity of decoration provide great liveliness to this extravagant but well-balanced object. The tureen's liner is engraved with a ducal coronet and the crest of the Seymour family, suggesting that this impressive work was made for or at one time belonged to Charles Seymour, sixth duke of Somerset (1662–1748).

An English silversmith of French extraction, Paul Crespin was making remarkable silver in the French Rococo style by the 1730s for such prestigious patrons as the king of Portugal and Empress Catherine of Russia. This elaborate creation may have been inspired by a design circulating among London goldsmiths. It has also been suggested that, despite Crespin's mark, the tureen may have been made by Nicholas Sprimont, another leading silversmith of the Rococo style in England and a contemporary of Crespin. The design has many affinities with work in both silver and porcelain by Sprimont. As Sprimont was not a member of the London Goldsmiths' Company until 1742, and the tureen is dated 1740, it is possible that Crespin submitted it to the Goldsmiths' Company in his colleague's behalf.

Silver; H 13 in. (33 cm), W 21¾ in. (55.2 cm), WT 524 oz. (16.29 kg); Purchased with funds from the Florence Scott Libbey Bequest in Memory of her Father, Maurice A. Scott, 1964.51a–d

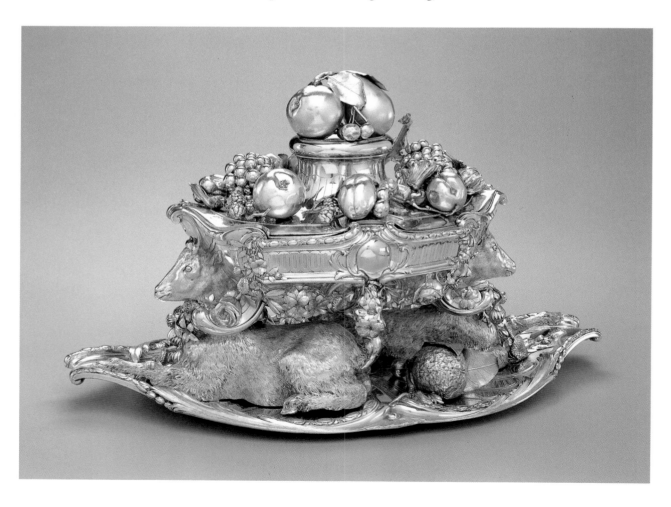

François Boucher, French, 1703–1770
The Mill at Charenton, 1758

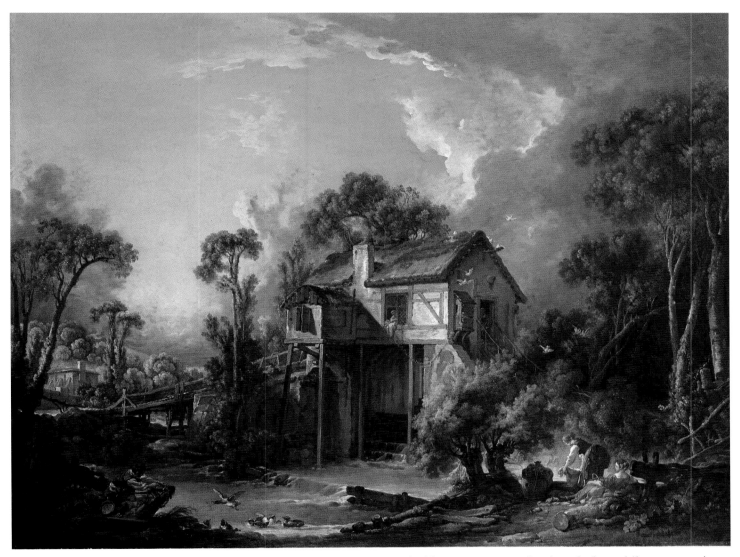

EUROPEANS IN THE EIGHTEENTH century appreciated paintings in which reality was mixed with fantasy. They enjoyed, for example, views in which ruined buildings from different parts of Rome were united in one scene or views of currently extant buildings like the Louvre shown as ruins. François Boucher demonstrated such an adroit mixture of fact and fancy in *The Mill at Charenton*.

The village of Charenton lies east of Paris at the meeting of the Seine and Marne rivers. The area, a favorite location for excursions from Paris, had a number of picturesque mills. Although the building in this painting does not appear in other paintings or drawings,

it would have been recognizable as a Charenton mill, albeit a decidedly superior one with its expensive glass windows and decorative swags of greenery. The elements in the painting emphasize the verticality of the mill. Tall trees contain the view at either side and frame the mill itself. Four thin supporting poles carry our eyes to the sunlit upper floor of the structure. The trees are covered with foliage; the stream is banked with bushes. Sparkling white highlights on the foliage, mill, and bridge enliven the lush summer scene. It is as if the air is filled with dancing light. A multitude of white doves flies around the mill. The inhabitants of this idyllic world are healthy, handsome, and immaculately dressed. At the right, a woman

washes her clothes while a companion lounges elegantly beside her. A fisherman moors his boat filled with nets. Across the stream, women look out of the open window and door and a child leans over the bridge, his small dog beside him.

When Boucher painted *The Mill at Charenton*, he had been working for Louis XV and his mistress Madame de Pompadour for thirty-two years. He had been appointed director of the Gobelins tapestry manufactory and in a few years was to be named "first painter" to the king.

Oil on canvas; 44½ × 57½ in. (113 × 146 cm); Purchased with funds from the Libbey Endowment, Gift of Edward Drummond Libbey, 1954.18

Paul Revere, American, 1735–1818
Tankard, 1769

PAUL REVERE, the most famous name in American silver, is renowned for both his patriotism and his outstanding proficiency as a silversmith and engraver. Thoughtfully composed and skillfully executed, this tankard represents one of his most innovative interpretations of the restrained Rococo style that flourished in Boston prior to the American Revolution. Recorded on August 25, 1769, in Revere's daybook, the tankard was commissioned by Captain Joseph Goodwin. Goodwin was apparently an affluent patron, as his name appears frequently in Revere's daybooks. Here, his richly engraved coat of arms and crest, while usually found opposite the handle, have been placed on the side for his pleasure as he drank.

As colonists prospered, it was not unusual to take an accumulation of silver coins or out-of-fashion objects to a silversmith to be melted down and made into a tankard, porringer, or teapot. A client thus converted spare capital into an intrinsically valuable object, a visible symbol of material success. Tankards, popular for centuries for beer and cider, are tall, one-handled drinking vessels. Notable for the sculptural qualities of its rare double-scrolled handle, open thumbpiece, and domed cover, this example is the inventive result of Revere's approach to a standard form in order to meet the challenge of its exceptional weight. At its original weight of 44 oz. 10 dwt., it was almost twice as heavy as many tankards of the day and is the heaviest tankard listed between 1761 and 1797 in Revere's ledgers. The double-scrolled handle

strongly balances the mass, while the open thumbpiece provides lightness and the plain domed cover without finial, which is in an earlier style of the second quarter of the century, simplifies and crowns this carefully controlled form.

Silver; H 8⅝ in. (21.9 cm), DIA BASE 6 1/16 in. (15.4 cm), WT 43 OZ. 10 dwt. (1.23 kg); Purchased with funds from Mr. and Mrs. Robert J. Barber; Dr. and Mrs. Edward A. Kern; Mr. and Mrs. Stanley K. Levison; Mr. and Mrs. George P. MacNichol, Jr.; and the Florence Scott Libbey Bequest in Memory of her Father, Maurice A. Scott, 1988.43

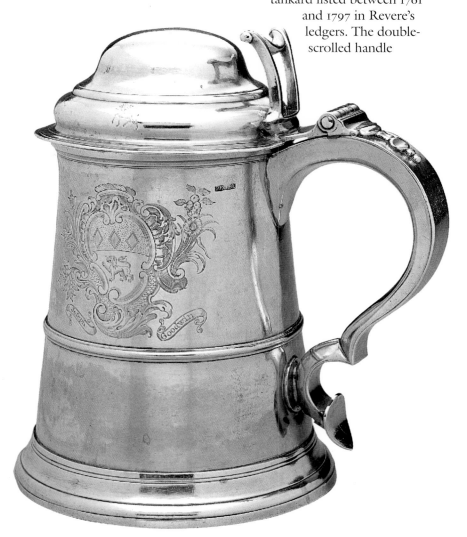

Thomas Gainsborough, British, 1727–1788
The Road from Market, 1767–68

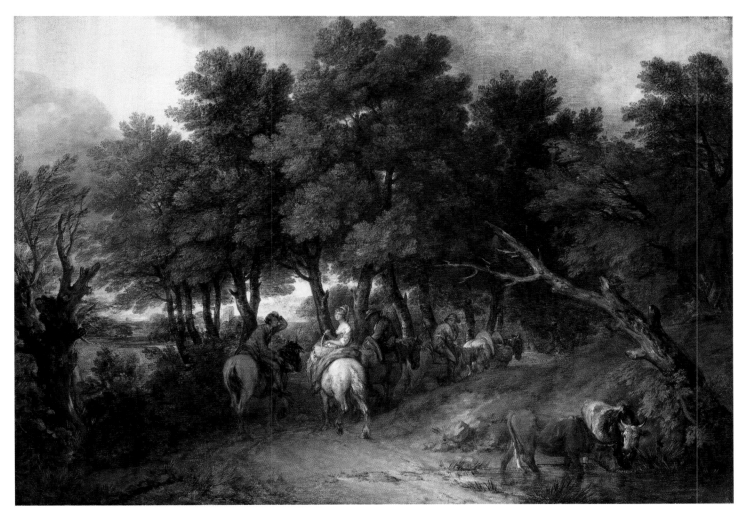

THOMAS GAINSBOROUGH'S HEART never left the Suffolk countryside where he grew up. Even after he established himself, first in the resort town of Bath, then in London, as one of England's most fashionable portrait painters, he continued to produce a great number of sketched and painted landscapes.

Gainsborough's earlier landscapes had been heavily influenced by the grave mood of Dutch seventeenth-century landscape painting. *The Road from Market* is considered a pivotal work of Gainsborough's new landscape style of around 1767, inspired by Peter Paul Rubens's broad, vigorous, high-keyed landscapes of the 1630s. The late-afternoon landscape almost glows as it is touched by pinks and yellows of the lowering sun. Three men and a woman ride home on a tree-shaded road, following the lead of the riderless horse clearly making its way back to the barn. Two cows drink at a pond at the left. There is a view into the distance punctuated by a church steeple glimpsed through the trees. Arcing prominently above the cows is a dead tree, but at its base springs new growth.

Almost in the center of the canvas, a pretty young woman carries a basket of eggs purchased at the market. The young man at her left, his hand to his head, speaks to her as their two companions turn to watch this interchange. The flirtatious sentiment that pervades this figure group is totally in harmony with the vitality of the landscape. Both are painted with verve and permeated with a rhythmic vitality that captures the almost palpable fecundity of a summer day.

Gainsborough was commissioned by the earl of Shelburne (later the first marquess of Lansdowne) to paint *The Road from Market* for the drawing room at Bowood, his country house near Bath. He instructed Gainsborough and other painters to produce masterpieces, as their paintings were "intended to lay the foundation of a school of British landscapes." Few paintings indeed have distilled the essence of a nation's countryside as has *The Road from Market*.

Oil on canvas; 47¾ × 67 in. (121.3 × 170.2 cm); Purchased with funds from the Libbey Endowment, Gift of Edward Drummond Libbey, 1955.221

Jacques-Charles Mongenot, French, active 1751–1790
Tureen and Stand, 1783

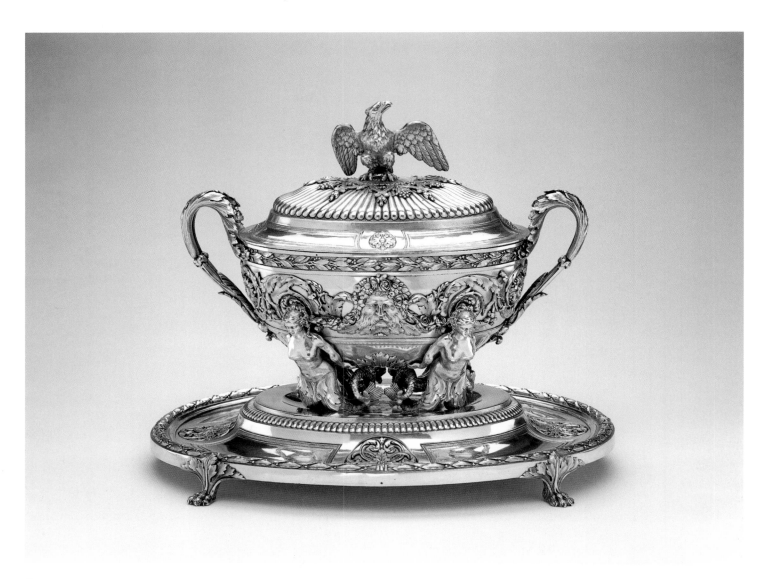

FRENCH SILVER made before 1789 is relatively scarce, for much of it was melted down to allay financial crises and the costs of war. Most often preserved are pieces that found their way abroad. This tureen for serving soup or stew was originally part of an elaborate dinner service, including at least four tureens, made for an Italian noble family, the Pignatellis of Naples.

Stylistic elements in silver frequently persisted long after the official style was theoretically outmoded. Although this tureen was made during the Neoclassical period, it has features

from the earlier Rococo style as well. The tureen's body is decorated in relief on each side with a flower-crowned mask, perhaps of Neptune, and scrolling garlands of acanthus, as well as an elaborate border of bay leaves. It rests on four sculptured Nereids, who possibly symbolize and extol Naples as an important seaport. The handles are formed by high, curling leaves with stalks. An eagle surmounting the cover, perhaps a Pignatelli emblem, serves as its handle. The stand, decorated with four circular clusters of foliage and an applied border of pointed leaves along its edge, is supported by four short, leafed legs terminating in paw feet.

The eagle, leaf ornament, masks, and symmetry of the tureen indicate its classical inspiration, while the treatment of the handles, the enriched surfaces, and the lively decoration evoking the sea and nature suggest a continuing Rococo spirit. The overall decorative effect is a harmonious combination of both naturalistic motifs and nonrepresentational ornament.

Silver; H 15½ in. (39.4 cm), W 17 5/16 in. (44 cm), DIA 15 in. (38.1 cm), WT 256 oz. (7.96 kg); Purchased with funds from the Florence Scott Libbey Bequest in Memory of her Father, Maurice A. Scott, 1967.13a–c

Jacques-Louis David, French, 1748–1825
The Oath of the Horatii, 1786

ACCORDING TO THE LEGENDARY history of Rome, the city declared war on its neighbor, Alba Longa, but since both cities traced their descent from the hero Aeneas, war between Romans and Albans would be impious, and an alternative was proposed. In each army there were three brothers, all equally young and strong. The Roman Horatii and Alban Curiatii were cousins, married and betrothed to each other's sisters. The young men agreed to serve as champions, fighting three against three; the city of the victors would rule over the vanquished. The youngest Horatius alone survived. This painting illustrates the Roman brothers swearing an oath before their father to fight to the death.

Inspired by the classical art he had studied in Italy, Jacques-Louis David composed the scene as a shallow frieze, with the figures in statuelike relief, strongly reminiscent of Roman sarcophagi and of the wall paintings being discovered in the buried cities of Herculaneum and Pompeii. The four men raise arms and weapons in salute to their unswerving allegiance to Rome. Their tense muscles and angular rhythms divide them from the fluid contours of the slumped, grieving women and children.

This reduced replica of David's life-size original painting, commissioned by Louis XVI and now in the Musée du Louvre, Paris, was ordered by the comte de Vaudreuil, a friend of Marie Antoinette. It is closely similar to the original, except that it includes a distaff on the floor near the feet of the women. David reportedly was assisted in making this version by his pupil and assistant Anne-Louis Girodet (1767–1824). In signing the replica and dating it 1786, David followed the standard practice of all great European artists operating a large studio with assistants.

David's powerful composition created a sensation when it was first exhibited at the Paris Salon in 1785. Viewers admired the archaeologically exact setting and were exhilarated by this icon of patriotic duty. In the light of history, *The Oath of the Horatii* seems a harbinger of the French Revolution. The severe composition and dramatic subject combined to create what was probably the most famous image of its generation.

Oil on canvas; 51¼ × 65⅝ in. (130.2 × 166.7 cm); Purchased with funds from the Libbey Endowment, Gift of Edward Drummond Libbey, 1950.308

Bertel Thorvaldsen, Danish, 1770–1844

Count Artur Potocki, modeled 1829, made 1830–33

WHEN HE MADE this noble portrait, the Danish sculptor Bertel Thorvaldsen was perhaps the most celebrated artist alive. Resident in Rome since 1797, he had become a leading exponent of Neoclassicism, the powerful impulse born there from radical new interpretations of those Greek and Roman ideals that had inspired Western art since the Renaissance. His studio, with its full-size original models for mythological, religious, and historical figures and bas-reliefs, was one of the compulsory

sights of Rome for tourists and residents—aspiring artists, literary notables, the powerful and the rich. The pope himself visited Thorvaldsen, a Protestant, for both his art and personal character were seen as transcending sectarian limits. Thorvaldsen was also a remarkable portraitist. While this bust shows close study of Graeco-Roman sculpture, the tousled hair and sideburns reflect current fashion. The finely textured finish of the marble—"to catch

the light," as he said—was a personal technique of Thorvaldsen's that was widely emulated by younger sculptors on both sides of the Atlantic.

Count Potocki (1787–1832) belonged to a great aristocratic family for whose seat at Łańcut, in southeastern Poland, this bust was made. The mantle and sword strap were devices adapted from ancient Roman portraits to symbolize his early military service under Józef Poniatowski, a national hero and leader of Napoleon's Polish troops, and also under Alexander I of Russia. Both men were also portrayed by Thorvaldsen, who was particularly revered in northern Europe.

For most of his life, though, Potocki was a much admired member of international society. While contemporaries affectionately recalled him as a dashingly romantic and elegant youth, by the time Potocki sat for this portrait in Rome he had become a corpulent landmark of the good life. But his charm, wit, and generosity still shone, and Thorvaldsen assessed those qualities in a portrait that serenely mediates the requirements of actuality, Potocki's rank, and the idealization inherent in his own art.

Marble; H with base 28⅝ in. (72.6 cm); Purchased with funds from the Libbey Endowment, Gift of Edward Drummond Libbey, 1991.64

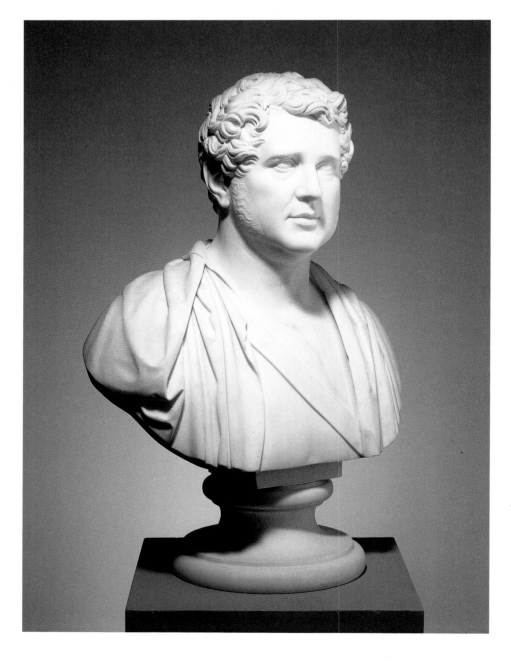

Antoine-Jean Gros, French, 1771–1835
Napoleon on the Battlefield of Eylau, 1807

AT EYLAU IN EAST PRUSSIA (now part of Poland), the French under Napoleon fought Russian and Prussian armies in snow and bitter cold on February 7 and 8, 1807. The armies were dead-locked until the Russians retreated during the night, leaving the French as bloodied victors. The next day Napoleon inspected the battlefield amid scenes of appalling carnage. The staggering losses on both sides—some 50,000 out of 150,000—made this one of the most devastating battles to date. It was set as the subject of an official government competition announced on April 2, less than two months after the event. The twenty-six artists who entered were required to consult a detailed "explanatory notice" and a drawing that stipulated what was to be represented. Antoine-Jean Gros, a favorite pupil of Jacques-Louis David, entered this *Napoleon on the Battlefield of Eylau* in the competition and won the commission to execute an immense

painting of the subject now in the Musée du Louvre, Paris.

Painting competitions were unusual in France during the Empire, since government commissions were usually awarded directly. The Eylau competi-tion was part of a broad campaign directed by Napoleon to secure the perception of this battle as a significant French victory. Such a perception was crucial to sustaining Napoleon's power and legitimacy, both of which rested on his capacity to defend France against external threats, both real and illusory, through decisive military triumphs.

In Gros's painting, Napoleon appears surrounded by his commanders, among them marshals Berthier, Bessières, and Caulaincourt to the left, Soult, Davout, and Murat (on a rearing horse) to the right, with chief surgeon Dominique Larrey prominent in the right fore-ground. The precise subject—the emperor's visit to the battlefield—responded to rumors of enormous French casualties by representing

mostly Russian dead and wounded in the care of French medical officers. Like other imperial propaganda, the painting also represented Napoleon as the humane and compassionate leader whose destiny was to bring peace and a new order to France and to Europe, but who—to his immense sorrow—was compelled to cause death and destruction to attain this goal. As one critic remarked in 1807, of all the competition paintings, it was Gros's that truly conveyed the "noble sorrow which the victor feels at the sight of so much destruction and suffering caused by war . . . with his gesture, he expresses his resolve to put an end to these disasters."

Oil on canvas; 41¼ × 57⅛ in. (104.9 × 145.1 cm); Purchased with funds from the Libbey Endowment, Gift of Edward Drummond Libbey, 1988.54

Francisco Goya, Spanish, 1746–1828
The Famous American Mariano Ceballos, 1825

El famoso Americano, Mariano Ceballos.

CAPTURING THE DRAMA and brutality of bullfighting, *The Famous American Mariano Ceballos* depicts a matador who went to Europe from South America around 1775. Known in Spain as "The Indian," he was noted for his skill in fighting on horseback or, as illustrated in this image, mounted on another bull. It was said that he learned his technique while hunting wild cattle in Argentina. His extraordinary agility and strength amazed all who saw him, including the painter, printmaker, and bullfight aficionado Francisco Goya. Ceballos was not agile enough, however, to escape the horns of every bull. He died in the ring in 1784. Forty years later, Goya, then seventy-eight years old, deaf, and nearly blind, re-created one of the flamboyant matador's adventures in this print, one of four lithographs of bullfights called *The Bulls of Bordeaux* after the city in which they were printed.

Although official painter to the court of Spain, Goya left that country in 1824 ostensibly for health reasons, but in fact to escape the repressive regime of Ferdinand VII. He settled in Bordeaux in the south of France, home to many Spanish émigrés fleeing political tyranny. Bordeaux was also the location of one of the finest lithographic print shops outside Paris and Munich. Working with the master printer Gaulon, Goya created prints that have the same strength and immediacy as his drawings and paintings. *The Famous American* and the other three images in the set were all inspired by the artist's memories of bullfights

he had attended regularly in Madrid. Fascinated by both the theater and the brutality of the spectacle, Goya successfully captured both aspects here. Frequently, as in this image, the bull is given greater dignity than the people, who seem to be moronic if not demonic. This lithograph and its companions, among the last prints Goya made before his death in 1828, are masterpieces in this medium. The Museum is fortunate to have a rare complete set of these celebrated lithographs.

Lithograph; sheet 15½ × 17⅝ in. (39.4 × 44.8 cm), image 12¼ × 16⅛ in. (31.1 × 40.9 cm); Museum Purchase, 1954.23A

Eugène Delacroix, French, 1798–1863
Botzaris Surprises the Turkish Camp and Falls Fatally Wounded, 1860–62

ON THE NIGHT OF AUGUST 21–22, 1823, a band of only 240 Greek freedom fighters of Albanian descent besieged some 4,000 Turkish soldiers encamped in a valley near Karpenissi in the western part of mainland Greece. The surprise attack overwhelmed the army of Djelaleddin Bey, which was making its way to lay siege to the critical city of Missolonghi. Though the battle, a notable one in the Greek War of Independence (1821–27), was a stunning victory for the Greek cause, Marcos Botzaris, leader of the daring assault, was mortally wounded during the struggle and died shortly after his removal from the fray. The circumstances of his heroic death were widely known in France and proved a rallying point for the Philhellenic movement, which supported the Greek cause.

Already in April 1824, Eugène Delacroix, the leading protagonist of French Romanticism, recorded in his diary his desire to portray the event—an intention substantiated by a watercolor and a number of his drawing studies from around this time. Yet it was not until the very end of his life that Delacroix returned to the composition initiated more than thirty-five years earlier. On the commission of a Greek patrician named Rodocanachi residing in Marseilles, Delacroix set to work on a canvas exceeding six feet in width. Never fully completed because of the death of the artist, the unfinished work exists today only in fragments. Delacroix's dazzling preparatory oil study for this endeavor, however, is now in the Toledo Museum.

The design shows the wounded Botzaris in the center, dramatically falling while his loyal comrades valiantly come to his assistance. As dawn breaks over the distant mountains, the pitched conflict rages around Botzaris: a cannon is hurriedly prepared, the stunned occupants of a tent are felled by sword, and unattended horses bolt aimlessly. Delacroix's dynamic handling of the brush demonstrates his phenomenal prowess both as a colorist and as a composer of form. This rapidly painted canvas, which for the artist was but a means to an end, admirably makes evident the remarkable genius of a creative mind in the very process of translating an idea into visual form.

Oil on canvas; 23 11/16 × 28 15/16 in. (60.2 × 73.5 cm); Purchased with funds from the Libbey Endowment, Gift of Edward Drummond Libbey, and with funds from the Florence Scott Libbey Bequest in Memory of her Father, Maurice A. Scott, 1994.36

Raphaelle Peale, American, 1774–1825
Still Life with Oranges, about 1818

A MEMBER OF THE PEALE FAMILY whose three generations of talented artists helped shape American painting, Raphaelle Peale is regarded as the country's first professional still-life artist and the founder of the American still-life tradition. *Still Life with Oranges* typifies Peale's subject matter and compositional design: a sparse selection of commonplace objects arranged simply. The artist depicted each object with such care that any could stand on its own, but together they create a coherent, balanced composition. The arrangement of fruit and nuts and the full wineglass are sensuous delights and suggest abundance, albeit sensibly moderated. A soft but direct light accents the different surface textures and reflective qualities of the glass, ceramic glaze, waxy leaves, and orange rinds. By setting the objects against a partially lit background, Peale enhanced their three-dimensionality and volume. The diagonal thrust of the twig and the various directions of the curling leaves also suggest depth. The realism recalls similar details found in seventeenth-century Dutch still lifes, examples of which Peale certainly saw exhibited in his native Philadelphia. The spiraling orange peel is perhaps a visual pun on his name.

An inscription on the painting, "Painted for the Collection of John A. Alston, Esqr./The Patron of Living American Artists," indicates that it was made for John Ashe Alston, a plantation owner near Georgetown, South Carolina, and in this period, one of the few Southern collectors of both American and European art. While there is no record of Peale's having been in South Carolina at this time, the picture may have been a gift to Alston or a work commissioned by him.

Oil on wood panel; 18 5/8 × 22 15/16 in. (47.4 × 58.3 cm); Purchased with funds from the Florence Scott Libbey Bequest in Memory of her Father, Maurice A. Scott, 1951.498

Redwood Glass Works, American
Footed Pitcher, 1831–50

DURING THE EARLY NINETEENTH century, American glasshouses focused on the production of window glass and utilitarian vessels. With extensive forests for fuel, abundant lime and sand for raw materials, and easy access to the port of Philadelphia, southern New Jersey became a glass-making center. A type of functional, highly individualistic, blown-glass hollow ware emerged. Varying in size, form, color, and decoration, these wares were characterized by thick walls, often plain but sometimes decorated with applied hot glass in the form of trailed threads, blobs with impressed patterns, leaf-shaped swirls, or crimped feet and handles. The movement of glass workers, many of them German immigrants, from one employer to another quickly brought these forms and related techniques to glasshouses in New York State and New England. In the 1920s such glassware (most of which was made from 1800 to 1850) was named the "South Jersey" style or tradition, although no examples can be firmly attributed to glasshouses from that locale.

Believed to be the largest example of its kind known, this rotund pitcher of aquamarine nonleaded glass represents the culmination of the "South Jersey" aesthetic. With its heavy walls adorned with a superimposed layer of similar colored glass tooled into broad, energetic swirls and loops resembling lily pads, it captures the sense of immediacy inherent in this tradition of glass blowing. Once owned by a family who carried it by prairie schooner from New York to Illinois, this pitcher is believed to have been made in New York State, probably at the Redwood Glass Works in Redwood, because the pattern of its superimposed decoration is distinctive of glasshouses of that region.

Glass; H 9 7/32 in. (23.4 cm), DIA RIM 6 3/8 in. (16.2 cm); Purchased with funds from the Libbey Endowment, Gift of Edward Drummond Libbey, 1959.86

Thomas Cole, American (born England), 1801–1848
The Architect's Dream, 1840

THE ARCHITECT'S DREAM portrays an ideal realm imagined by the architect, who reclines in the foreground with his eyes closed. The odd combination of buildings, stagelike setting, and exaggerated contrasts of scale indicates that the scene is a fantasy. The series of buildings also represents the history of Western civilization and exemplifies particular cultures. Arranged in historical order, the Egyptian pyramid and temple in the background give way to Greek and Roman temples, and to the left, a Gothic cathedral. Cole used light and setting to distinguish between the clarity of Mediterranean architecture bathed in southern sunlight and the mystery of a tree-surrounded Gothic church cast in northern shadow.

The painting was commissioned in 1839 from Cole by the architect Ithiel Town, who owned the largest architectural library in America. In fact, Town made part of his payment to Cole in books. Cole, whose own architectural accomplishments included the design for the Ohio State Capitol, was allowed to choose the specific subject of the painting within the broad guidelines of a view of Athens. Although Town liked "the mixture of different ages and styles in the same imaginary picture," he more than likely had wanted the landscape to dominate the architecture. He rejected the completed painting.

The painting's varied buildings may reflect the mid-nineteenth century's aesthetic of combining elements from different styles of architecture in near proximity, and may refer specifically to Town's designs in both Greek and Gothic Revival styles. The dreamer who rests atop a pile of books and portfolios may be an allegorical portrait of either Town or Cole. As references to the past and inspiration for the future, the books and architectural styles, combined with the dreaming architect, may signify the power of the human mind to envision and the human hand to construct creations of incredible variety, splendor, and enduring aesthetic appeal.

Cole was the founder of the Hudson River School, a group of American landscape painters who were strongly nationalistic both in their choice of subject matter and in their desire to become independent of European themes. Cole raised the stature of American landscape painting by transforming specific sites into celebrations of nature and emphasizing the heroic human associations, such as Beauty and Divinity, that could be found in the wilderness. He increasingly imbued these monumental works with religious, allegorical, and literary references, moving toward moralizing compositions that could display his intellect.

Oil on canvas; 53 × 84 1/16 in. (134.7 × 213.6 cm); Purchased with funds from the Florence Scott Libbey Bequest in Memory of her Father, Maurice A. Scott, 1949.162

William Henry Fox Talbot, British, 1800–1877
Articles of Glass, about 1844

WHAT SUBJECT could be better than glass, a material that shimmers in light, to demonstrate photography, a medium invented to capture reflected light? William Henry Fox Talbot, a scientist and an inventor of photography, created the first photograph of glass objects, featuring decanters and cups from his own household arranged on shelves in the courtyard of his home at Lacock Abbey, England. Talbot's early photographic process required long exposures in sunlight, so he frequently set up still lifes outdoors to demonstrate the new medium. Many of the objects Talbot photographed were still being used at Lacock by the family in the 1960s. Unfortunately, the exquisite glass in this photograph has not been found.

Articles of Glass was one of four photographs published by Talbot in 1844 as the first part, or fascicle, of *The Pencil of Nature,* published from 1844 to 1846, the first book illustrated with photographs. Each photograph was accompanied by text describing the variety of practical and aesthetic uses of photography. Talbot's text for this image notes that it represents "the beginning of a new art." The medium was new to the visual arts. Still life was, in fact, the medium's first genre to be adopted by artists to rival painting. The photographic artist's interpretation and aesthetic judgment were more readily evident in a still life than in a landscape or cityscape.

Talbot invented a means of fixing an image on paper by capturing a negative of the subject that could be used to print unlimited positive images. We take this invention for granted every time we snap the shutter of our compact, hand-held cameras.

Calotype; sheet 7½ × 9¹⁄₁₆ in. (19.1 × 23 cm), image 5 × 6 in. (12.8 × 15.2 cm); Gift of Harold Boeschenstein, Jr.; Frederic P. and Amy McCombs Currier; William and Pamela Davis; Mary and Thomas Field; Mr. and Mrs. O. Lee Henry; Mr. and Mrs. Harry Kaminer III; The Reva and David Logan Foundation; Dr. and Mrs. James Ravin; Mark and Rubena Schaffer; and Mr. and Mrs. Spencer D. Stone in honor of the 150th anniversary of the invention of photography, 1989.32

Joseph Mallord William Turner, British, 1775–1851
The Campo Santo, Venice, 1842

VENICE CAME TO HAVE special significance for J. M.W. Turner. He made his first brief visit in 1819 and returned in 1833 and again in 1840. Here the view depicted is north across Venice's lagoon, with the city to the left and the cemetery island of San Michele (the Campo Santo of Turner's title) in the distance on the right. This unimposing locale was not often depicted, as it lacked impressive monuments or other reminders of the city's grand and powerful past. The cemetery itself was recent, dating from the time of the extinction of the Venetian Republic by Napoleon, and for Turner it may have stood as a fitting symbol of the death of this great imperial city. There are subtle intimations of decline and death in the picturesque yet lowly vessels and floating debris in the foreground. The twin-masted felucca has

tall, brilliant white sails, further elongated by their reflections; their resemblance to angel's wings stresses the theme of mortality.

Such historical and poetic associations may have been even clearer when Turner showed this painting in 1842 with its pendant, a view of prosperous Venice, its cargo-laden boats arrayed before the Customs House (now in the Tate Gallery, London). Such a contrast of Venice's glorious past and debased present was common in literature and travel books, but Turner's vision was closest perhaps to that of Lord Byron, a poet Turner read and much admired, in *Childe Harold's Pilgrimage*. Turner, like Byron, experienced sadness and regret along with delight and wonder at the city's transcendent beauty: "Perchance even dearer in her day of woe, Than when she was a boast, a marvel and a show."

In *The Campo Santo, Venice*, the city is splendid even in decay. The colors are brilliant yet delicate, the whites radiant, the whole made more luminous by the paint's washlike translucency over a white ground. In the overall brightness and soft painterliness, solid forms are fused with their reflections and absorbed into light. Venice appears shimmering and ethereal. Even in its death Turner celebrates Venice's enduring loveliness and asserts the eternal glory of nature, giving visual expression to Byron's words: "Those days are gone—but Beauty still is here. States fall, arts fade—but Nature doth not die."

Oil on canvas; 24 ½ × 36 ½ in. (62.2 × 92.7 cm); Gift of Edward Drummond Libbey, 1926.63

Albert-Ernest Carrier-Belleuse, French, 1824–1887
Console Table, about 1864

THE MARQUISE DE PAÏVA, a celebrated Parisian courtesan, commissioned this splendid console table for her residence, the hôtel de Païva, one of the most luxurious town houses on the Champs Elysées built during the reign of Napoleon III. Born Esther Lachmann in Russia, she arrived in Paris as the companion of the musician Henri Herz, but in 1851 married the marquis de Païva, a Portuguese nobleman with little money. Desiring to build an artistic marvel and financed by the immense fortune of her German lover, Count Henckel von Donnersmarck, she hired the architect Pierre Manguin to design a house in the Renaissance style and to assemble, supervise, and direct artists of great distinction to decorate and furnish the lavish interior.

The chief public room, the Grand Salon, was remarkable for its extensive gilding, ornate moldings, walls hung with rose satin, and elaborate furniture. This console table, one of four of the same design made as the principal features of the Grand Salon, was designed by Albert-Ernest Carrier-Belleuse, a leading figure in the revival of Renaissance and eighteenth-century styles, who was inspired by the elongated proportions and complex poses favored by sixteenth-century French Renaissance sculptors.

This table has an inlaid marble and onyx top supported by two half-life-size bronze youths crouching on a gilded bronze base. The ring in the center of the base was to site a large vase, most likely of Chinese porcelain. The table's massiveness and strong color contrasts are characteristic of the eclectic taste of the Second Empire, the dominant style during Napoleon III's reign. Male caryatids bearing a table or cabinet are a Renaissance motif that was continued during the seventeenth century, particularly in Italy. Here, the figures' large scale gives them a prominent role. Elegantly elongated, their graceful silhouettes are emphasized,

their hair is delicately incised, and repeated folds detail their draped tunics, underscoring Carrier-Belleuse's versatility as a sculptor and designer of decorative arts. Placed against the walls of the Grand Salon, the four tables would have been closely integrated with other sculptural and decorative elements.

The hôtel Païva became a brilliant gathering place for politicians, writers, and artists. The marquise, however, occupied her extraordinary house for only nine years. Ostracized for their complicity with the Prussians during the 1870 war, she and Donnersmarck (her husband after 1871) left Paris in 1875, never to return.

Bronze and gilded bronze; breccolito marble and onyx top; H 42⅞ in. (109 cm), W 63 in. (160 cm), D 22¾ in. (57.8 cm); Purchased with funds from the Florence Scott Libbey Bequest in Memory of her Father, Maurice A. Scott, 1960.32

Gustave Courbet, French, 1819–1877
The Trellis, or Young Girl Arranging Flowers, 1862

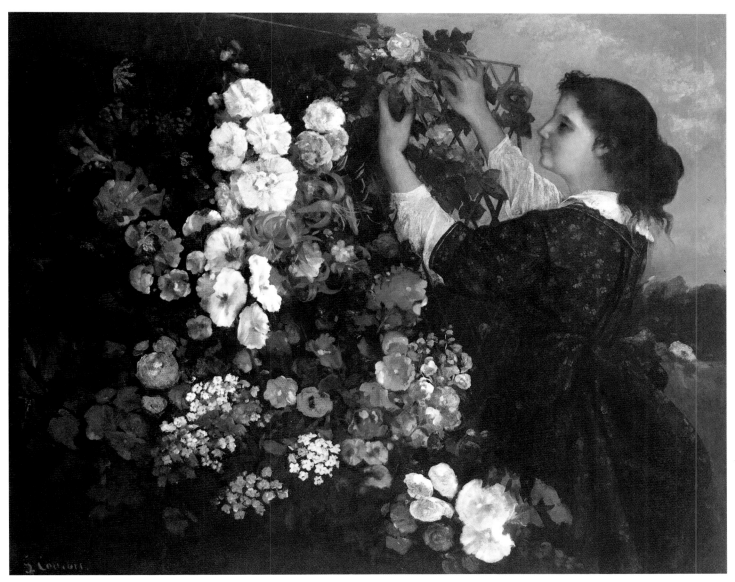

GUSTAVE COURBET led a personal campaign to reform art, declaring brashly that artists must represent contemporary life, not imitate the past. This painting of a young woman arranging cut flowers on an outdoor trellis reflects Courbet's realist manifesto, since it shows the subject not as an antique nymph or goddess, but as a pretty model.

In 1862 Courbet, already famous for his confrontational images of peasant life and dramatic landscapes, was invited for a two-week stay at Saintes, in southwestern France, by Etienne Baudry, a wealthy young art patron. Courbet remained almost a year. He completed nearly a hundred canvases, including two dozen flower paintings, inspired in part by Baudry, whose passion was scientific botany, and by a neighbor, the lawyer Phoedora Gaudin, who was fascinated with the history of floral symbolism.

Summer flowers are the heart of this painting. Full-blown, they surge across the surface, engulfing the young woman whose dress is even printed with demure miniature flowers. Intense colors and sweeping strokes of the palette knife evoke the hues and textures of individual blooms. Instead of a formal bouquet, armfuls of blossoms spill across a tabletop, a casual type of floral composition that became popular during the nineteenth century. In the allegorical language of the period, day lilies symbolize coquetry; hollyhocks, ambition; hydrangeas, heartlessness; and morning glories, eternal love and admiration. Courbet may have intended this sly subtext to supply a hint of narrative. Below the vivid surface of the young woman as a flower amid flowers, Courbet evoked a lighthearted sensuality as she adorns herself and the world around her in pleasurable anticipation.

Oil on canvas; 43¼ × 53¼ in. (109.8 × 135.2 cm); Purchased with funds from the Libbey Endowment, Gift of Edward Drummond Libbey, 1950.309

Herter Brothers, American
Center Table, about 1865–70

DURING THE YEARS following the Civil War, Americans were feeling a great exuberance, optimism, and enterprise. At the same time, this relatively new country was looking to the past for inspiration and for symbols of a new prosperity. The finest decorative arts, and particularly furniture, of this period, known as the Renaissance Revival, are characterized by both eclecticism and exceptional craftsmanship. Renaissance Revival furniture did not imitate past styles, but rather synthesized in a new way motifs and forms from a variety of European countries and historical periods from the fifteenth to the eighteenth centuries, which well suited the economic and social circumstances of the time. The millionaires of the era sought great elegance, opulence, and cosmopolitan glamour, choosing furniture often grand in scale and thus appropriate

to the spacious homes of post–Civil War America.

One of the foremost New York decorating firms of the time was Herter Brothers, founded by the German immigrants Gustave Herter (1830–1898) and his half-brother Christian (1840–1883), and in business from about 1865 to 1906. Herter Brothers produced the structure supporting the top of this table. A typical Herter frieze with geometric and foliate wood inlay is punctuated on each side by carved classical female masks. The table's legs, with carved winged lion's heads, end in trumpet feet and are joined by a complex, pierced, strap-work stretcher, centered with an urn.

The marquetry top, on the other hand, inlaid with an elaborate central medallion of flowers and birds and surrounded by interlacing vines and scrolls, was possibly imported from

Joseph Cremer, a leading Parisian marqueteur. Added to the great variety of exotic woods comprising the intricate marquetry are mother-of-pearl and lacquer, the latter to imitate the lapis lazuli often found in miniature hard-stone mosaics of the seventeenth century.

The combination of historical influences thus seen in the marquetry top is reminiscent of work from the late seventeenth and early eighteenth centuries in the Netherlands and France, the classically inspired urn and masks, and the overall Renaissance form. The table is a tour de force of design and craftsmanship.

Ebony, rosewood, sycamore, kingwood, tulipwood, amboina, mother-of-pearl, and lacquer; H 30 in. (76.2 cm), W 48 in. (121.9 cm), D 30 in. (76.2 cm); Gift of Dr. and Mrs. Edward A. Kern, 1986.65

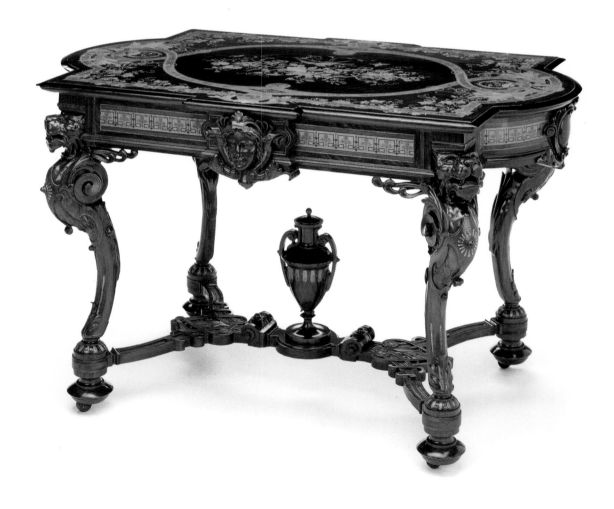

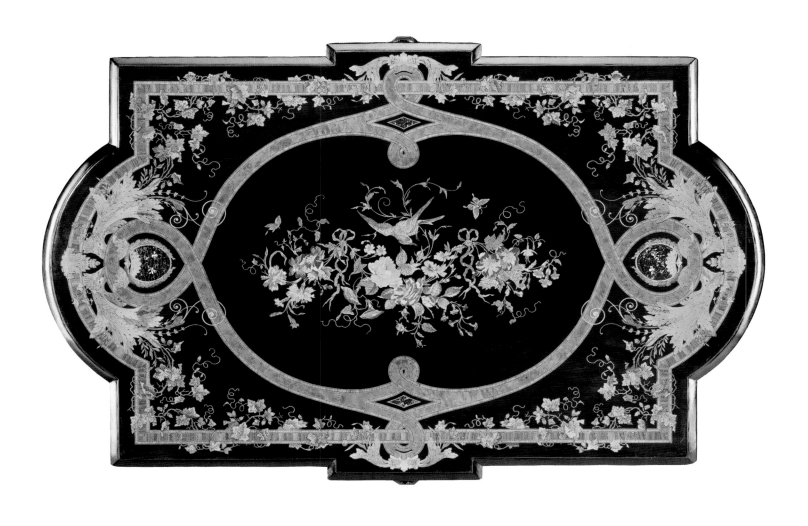

Jasper Francis Cropsey, American, 1823–1900
Starrucca Viaduct, Pennsylvania, 1865

STARRUCCA VIADUCT, PENNSYLVANIA is a celebration of both American nature and industry. Built in northeastern Pennsylvania by the New York and Erie Railroad in 1847–48, the viaduct was among the great American engineering feats of its time. Its scale dwarfs the old-fashioned wooden bridge in the middle distance that leads to the village of Lanesboro. In nineteenth-century landscape painting, the railroad was often seen as a symbol either of industrial progress and change or of man's destruction and exploitation of nature. In this painting Jasper Francis Cropsey seems to suggest, through the reflective attitude of the figures gazing over the valley toward the train, by the nestling of technology within the landscape, and by the dominance of the undisturbed foreground wilderness, that

nature can absorb the effects of technology without adverse consequences. The composition's overall emphasis, however, is not on the narrative but on the beauty and serenity of the Susquehanna River Valley. Industry remains a small, romanticized counterpoint to the brilliant autumn foliage.

Cropsey was a member of the Hudson River School, an important nineteenth-century group of landscape painters, and was strongly influenced stylistically and thematically by the work of its founder, Thomas Cole (see pp. 120–21). Like Cole, Cropsey sketched extensively in nature, primarily in upstate New York and in New England, and compiled his direct observations of nature into ideal landscapes. Cropsey too saw painting as a moral enterprise meant to evoke appropriately elevated thoughts and feelings, but in order to emphasize the serenity of nature he

reduced the narrative and symbolic details in his work. The emphasis on nature's tranquility and the penchant for fall's brilliant colors in *Starrucca Viaduct* are hallmarks of Cropsey's late landscapes.

Oil on canvas; 22 ⅜ × 36 ⅜ in. (56.8 × 92.4 cm); Purchased with funds from the Florence Scott Libbey Bequest in Memory of her Father, Maurice A. Scott, 1947.58

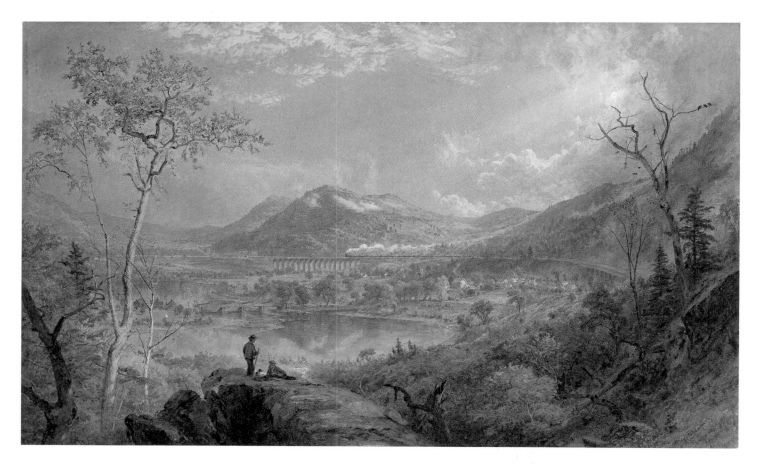

William Holman Hunt, British, 1827–1910
Fanny Waugh Hunt, 1866–68

PERSONAL TRAGEDY suffuses this portrait. William Holman Hunt and Fanny Waugh married in December 1865. In August 1866 the couple set out for the Holy Land, where the artist planned to paint scenes of the life of Christ in the most authentic setting possible. They were delayed in Florence, where day after day in intense heat Fanny posed for Hunt behind a chair that concealed her pregnancy. Their son was born in October; Fanny died two months later.

The grieving Hunt returned to London, where, with the aid of a photograph, he continued this painting. Insistent on accurate backgrounds and props, he retrieved Fanny's peacock shawl, dress, and cameo brooch from Florence. The rich interior evokes upper-class "artistic" taste. But the Chinese porcelain vase and mirror frame, Venetian glass bowl and chandelier, Persian pottery dish, and elegantly framed watercolors are also poignant with Hunt's sorrow, contrasting the evanescence of life with the eternal natures of love and art. Multiple reflections in the mirror, for example, seem to mingle a traditional wry comment on the vanity of this world's treasures with a biblical observation on the dimming of memory, as the departed recedes in time "through a glass darkly."

Hunt was a cofounder (with Dante Gabriel Rossetti and John Everett Millais) of the Pre-Raphaelite Brotherhood, a youthfully iconoclastic society formed in 1848. Viewing contemporary art in England as trivial and vulgar, the members dedicated themselves to revitalizing art with the purity, elevated feeling, and realism they thought it had possessed before the advent of Raphael and the High Renaissance. Although it dissolved in 1853, the group remained an important influence on late-nineteenth-century English art. Hunt alone remained faithful to the brotherhood's goals, combining painstaking

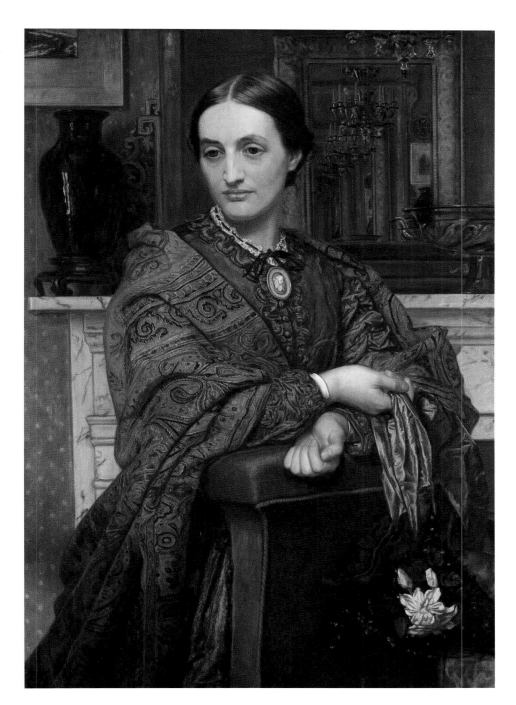

realism with personal imagery to symbolize moral ideas. He also studied the effects of light and was admired for the purity and intensity of color he achieved with transparent glazes of oil paint.

Oil on canvas; 40¹⁵⁄₁₆ × 28¾ in. (104 × 73 cm); Purchased with funds from the Libbey Endowment, Gift of Edward Drummond Libbey, 1977.34

J. & L. Lobmeyr, Austrian
Plate, 1888

JOSEF LOBMEYR, founder of the renowned Viennese glass firm J. & L. Lobmeyr, did not believe that the Austrian glass factories of the nineteenth century had the most up-to-date knowledge of glass making and enameling. Therefore, to fabricate the designs for luxury goods like this plate, Lobmeyr began to make use of the glass factories in Bohemia, once an independent kingdom but today a part of the Czech Republic. The firm's glassware, which is still being produced today, became internationally recognized for its high quality and rich decoration.

This plate belongs to a line of luxury display glass known as the "Flower Series," which included one-handled jugs, tall slender beakers, and wine-glasses with varying insect and floral decoration. The series was inaugurated in 1888, but because of the high cost of its production, little was made after the first year. In fact, this plate is the only known example of its kind.

The gilding and enameling on the Lobmeyr plate illustrate the tendency during the second half of the nineteenth century to interpret freely earlier artistic styles, techniques, and forms. Although it is difficult to pinpoint exact antecedents, this plate's decoration was inspired more by motifs found on Pompeian, Graeco-Roman, Renaissance, and eighteenth-century Neoclassical sources than by Asian or Islamic models. The juxtaposition of the opaque and transparent enameled surfaces with the gilded areas gives a richness to the swirling acanthus leaves and twisting snakes, as well as to the delicate butterflies and insects in the center roundel. The central motifs were inspired by decoration on eighteenth-century German porcelain and exemplify the insect forms popular at that time. The impressive size of the plate and the skillful incorporation of both naturalistic and stylized motifs attest to the talent, expertise, and ability of the Lobmeyr firm.

Glass with enamel and gilt decoration; DIA 17¾ in. (45 cm); Purchased with funds from the Florence Scott Libbey Bequest in Memory of her Father, Maurice A. Scott, 1983.9

Henri Fantin-Latour, French, 1836–1904
Flowers and Fruit, 1866

UNTIL THE LATER NINETEENTH century, still-life painting was often denigrated as merely decorative, but art critics pointed to canvases by Henri Fantin-Latour to prove that in the hands of a master, still life could be bold and vital. Fantin became renowned for his precise rendering of nature, in part a reflection of the fascination with photography and the depiction of modern life rather than history, allegory, and exotic places.

Like his sometime teacher Courbet (p. 125), and even his Impressionist friends Manet (pp. 134–35) and Degas (p. 147), Fantin painted in the studio where he could control the conditions. His characteristic, diffuse light envelops forms with a brightness that is at once realistic and visionary. The dominant colors of this still life, painted in June when hydrangeas, ranunculus, and roses are in bloom, range from rich pink, red, orange, yellow, and the plum-brown of the tablecloth in the lower half of the composition to the fragile pastels of the bouquet in the upper half. Flowers, glass vase, and porcelain bowl are composed of numerous brushstrokes that vary in thickness and hue to evoke texture and volume. For example, thick strokes that depict the white membrane of the orange wedges give way to thinner strokes for their sides, veiling the strong orange pigment beneath.

Fantin painted three distinct subjects: portraits, imaginary compositions reflecting his love of the music of his contemporaries Berlioz and Wagner, and still lifes. Only the still lifes were widely successful, and between 1864 and 1896 Fantin painted more than

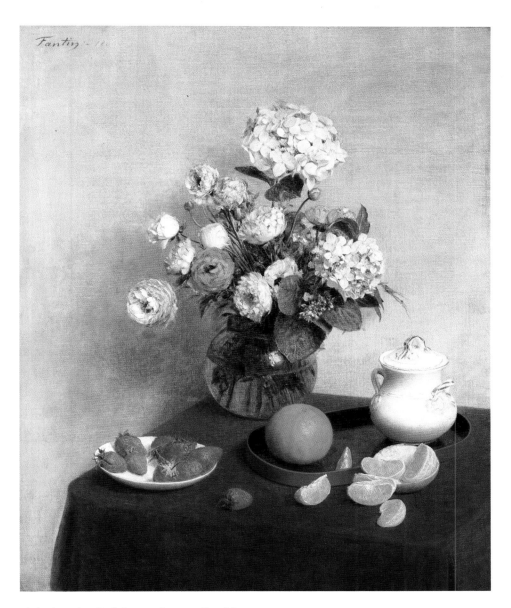

eight hundred of them, almost all sold to English clients. Shown in 1867 at the annual Royal Academy exhibition in London, this painting is one of an early series of canvases using the same fruit basket, red-and-black lacquer tray, and porcelain sugar bowl to accent seasonal flowers.

Oil on canvas; 28¾ × 23½ in. (73 × 59.6 cm); Purchased with funds from the Libbey Endowment, Gift of Edward Drummond Libbey, 1951.363

James Tissot, French, 1836–1902
London Visitors, 1874

IN 1872 JAMES (born Jacques-Joseph) Tissot, a French artist of the Impressionist generation, settled in London. In *London Visitors*, painted two years later, Tissot represented tourists standing on the steps of the National Gallery with a view eastward to the eighteenth-century church of Saint Martin-in-the-Fields. The three adults, in typical Tissot fashion, are stylishly and meticulously dressed. The distinctive uniform of the two boys identifies them as students at Christ's Hospital, established in the sixteenth century for the education of London's poor. By the nineteenth century, Christ's Hospital was an elite school, but some of the less well off boys earned pocket money serving as guides, as they do here. One gestures toward Trafalgar Square, while the other, looking bored and distracted, has apparently not been engaged. The couple behind him relies instead on their guidebook, as the woman points

imperiously with her umbrella in the direction of the Nelson Column.

The viewpoint, quite low and angled, suggests that of another tourist coming up the steps. The figures seem randomly dispersed, and provocative prominence is given to a discarded cigar butt. The seemingly accidental character of the composition expresses the fugitive and contingent nature of vision and experience in the modern urban world.

Tissot's contemporary subject, his detachment, and his pictorial strategies recall those of his French friends Edgar Degas and Edouard Manet. Their common interests even led Degas, in the year of *London Visitors,* to invite Tissot to participate in what was to become the first Impressionist group exhibition. Tissot chose instead to show the painting in that year's exhibition of the Royal Academy in London, where it was greeted with critical incomprehension at its compositional peculiarities, its sooty color, and its apparent absence of a coherent narrative, engaging sentiment, or edifying moral.

A mood, rather than a story, is created. Underlying tension and disquiet are

hinted at beneath an air of what one critic described as "arctic frigidity," most striking in the woman atop the barrier of steps, who fixes the viewer with a chilly, blue-eyed gaze full of restlessness and impatience. A sort of triangular relationship is intimated with the (conventionally male) viewer, insinuating a subtle note of sexual innuendo into Tissot's understated, complex, and ambiguous picture of contemporary social life.

Oil on canvas; 63 × 45 in. (160 × 114.2 cm); Purchased with funds from the Libbey Endowment, Gift of Edward Drummond Libbey, 1951.409

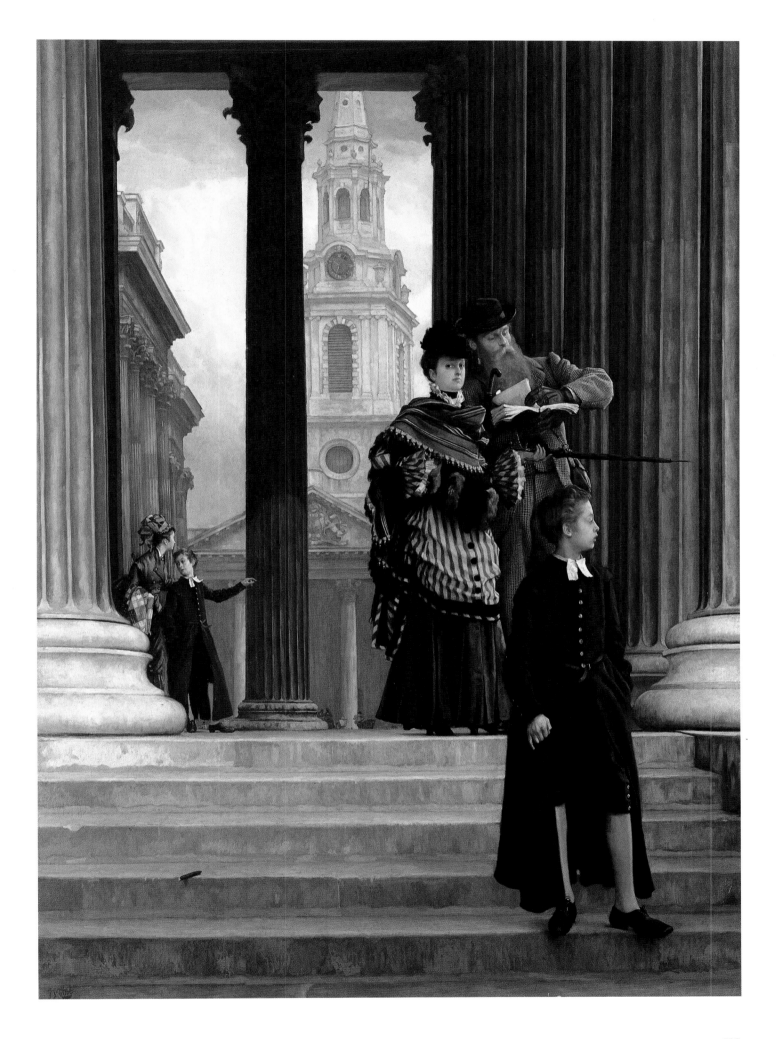

Edouard Manet, French, 1832–1883

Antonin Proust, 1880

ANTONIN PROUST (1832–1905) and Edouard Manet were friends from childhood. Proust followed a career as a journalist and politician, and at the time of this portrait was a rapidly rising leftist legislator active in arts issues. During his brief tenure as Minister of Fine Arts (1881–82), he arranged for Manet to be awarded the Legion of Honor. After Manet's death, Proust published a biography of the artist.

In 1879, as Proust later recounted, "Manet was obsessed with two 'idées fixes': to do a 'plein-air' painting . . . and to paint my portrait on unprepared white canvas, in a single sitting." The type of portrait featured here—a half-to full-length figure posed against a flat, neutral-colored background—and this particular pose were commonplace in Manet's time. What distinguished Manet's *Proust* was what one critic called his "bold and decisive brush-work," and another his "supple and spirited execution." This appearance of improvisatory freedom and immediacy of response was for Manet hard won. Proust recalled: "After using up seven or eight canvases, the portrait came all at once."

Traces of Manet's extended struggle with spontaneity are still evident in the canvas's extensive surface crackle, a sign of considerable reworking. The artist generally dispensed with preliminary studies and preparatory underpainting, instead developing his compositions in clean, clear tones directly on the light ground. He would revise, scrape away, repaint, and sometimes even discard a canvas so as to begin afresh, but the final result was the accumulated experience of the different versions.

While Manet's *Proust* is a discerning yet flattering likeness of his friend, it also embodies something of the essential traits of the dandy, a modern Parisian type. Elegantly urbane and impeccably dressed, Proust is posed in an attitude of carefully studied relaxation. Yet Manet may have had even more in mind. In a passage in his biography, Proust recalled Manet telling him:

There is one thing I have always wanted to do. I would like to paint a Crucifixion . . . While I was painting your portrait, this idea haunted me. It was an obsession. I painted you as Christ dressed in a hat and frockcoat with a rose in your lapel—as Christ going to visit the Magdalen.

But this ironical and mocking equation of Proust with Christ and the Magdalen with a modern courtesan may finally be less in evidence here than Manet's respect and affection for his lifelong friend.

Oil on canvas; 51 × 37¾ in. (129.5 × 95.9 cm); Gift of Edward Drummond Libbey, 1925.108

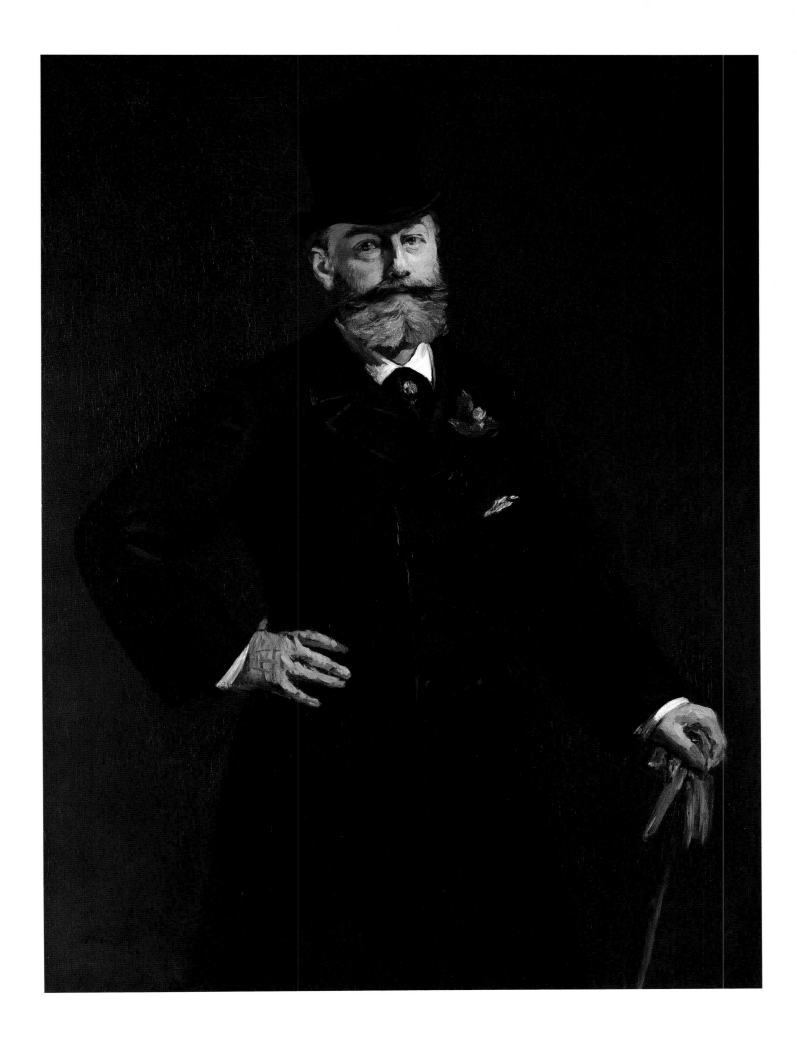

Childe Hassam, American, 1859–1935
Rainy Day, Boston, 1885

PAINTED AT A TIME when urban landscapes were still a novel subject in America, *Rainy Day, Boston* depicts the intersection of Columbus Avenue and Appleton Street in Boston's South End. When Childe Hassam painted this picture, he and his wife lived at 282 Columbus Avenue. According to the artist, "I lived in Columbus Avenue in Boston. The street was all paved in asphalt, and I used to think it very pretty when it was wet and shining, and caught the reflections of passing people and vehicles." In this view seen through the atmospheric filter of rain, Hassam accentuated the pictorial effects produced by the light and weather conditions. Rain causes the broad expanse of pavement to glisten with reflections and casts a soft rosy tone onto the damp red bricks. The overcast sky and pearly light produce a misty atmosphere that enshrouds buildings and pedestrians alike and, combined with the muted palette of dull pinks, grays, and blacks, unifies the composition.

Rainy Day, Boston also celebrates Boston's fashionable, clean, and spacious cityscape. Hassam had been to Europe in 1883 and had seen the new appearance of Paris created by Baron Haussmann for Napoleon III. This painting's wide angle of vision, uncluttered setting, and deep perspective recall Haussmann's municipal improvements, which had inspired Boston's own concurrent developments in the 1860s and 1870s, and suggest that Hassam here, in his first major oil painting, was trying out this popular French urban theme.

Soon to be a leading American exponent of Impressionist painting, Hassam painted *Rainy Day, Boston* before he adopted the style for which he is best known, characterized by an increased use of saturated light, diverse intense colors, and broken brushwork. Here, he was responding to the stimuli of life around him primarily as a realist painter, applying the pigment smoothly and generously, but without the bravura and characteristic broken brushstrokes of Impressionism.

Oil on canvas; 26⅛ × 48 in. (66.3 × 122 cm); Purchased with funds from the Florence Scott Libbey Bequest in Memory of her Father, Maurice A. Scott, 1956.53

William Merritt Chase, American, 1849–1916
The Open Air Breakfast, about 1888

THE OPEN AIR BREAKFAST captures a moment of domestic pleasure in the leisure life of a contented family. The scene is set in the Chases' backyard in a fashionable section of Brooklyn, the neighborhood Chase had moved to in 1886, and had begun to paint in a series of pictures that combine spirited brushwork with a fondness for painting outdoors. The figures are members of the artist's family, his favorite models for many pictures. His wife is seated at the table next to their oldest child, Alice, in the high chair. Chase's sister, Hattie, stands behind them wearing a seventeenth-century Dutch-style hat and holding a paddle used in battledore, an early form of badminton. Chase's sister-in-law, Virginia Gerson, lounges in a hammock, while one of his favorite Russian wolfhounds naps by the fence. Although the figures seem to be the focal point of the painting,

they are really just part of the decorative array of unrelated objects Chase assembled to create a pleasing effect. Stylishly dressed in shades of white, the women are sheltered from the outside world by a high wooden fence and lush summer vegetation. The variety of accessories—a Japanese screen, a Spanish shawl, Dutch hat, oriental porcelains, and a potted palm—exemplifies Chase's well-known taste for exotic objects (many of which decorated his famous Tenth Street studio in Manhattan) as well as his role as a fashion setter and cosmopolitan artist.

This appealing presentation of an idyllic, backyard repast not only celebrates Chase's own private domain, but also by its technical virtuosity reveals his sheer joy in painting. A leading figure in New York's artistic institutions, Chase believed that it was not *what* was painted that mattered but *how* it was painted. Although he never

considered himself an Impressionist, he did adopt some of the movement's practices, particularly in painting outdoors and capturing a fleeting moment. Also, like the Impressionists, he portrayed scenes from contemporary life; this one was adapted from the popular French motif of figures in a garden. Chase painted the scene with the bravura brushwork he had developed while a student in Munich in the 1870s, but his palette remained relatively tonal, with brilliant hues reserved primarily for highlights or accents. Unlike in the work of the Impressionists, the figures and the deep perspective take precedence over atmospheric effects.

Oil on canvas; 37⁷⁄₁₆ × 56¾ in. (95.1 × 144.3 cm); Purchased with funds from the Florence Scott Libbey Bequest in Memory of her Father, Maurice A. Scott, 1953.136

William Michael Harnett, American (born Ireland), 1848–1892
Still Life with the *Toledo Blade*, 1886

PAINTED FOR ISAAC N. REED, a Toledo druggist, *Still Life with the "Toledo Blade"* features the domestic bric-a-brac—books, pipe, violin, and folded newspaper—that William Harnett often used to evoke the modest pleasures of leisure activities and gentlemanly commerce. The folded newspaper is the September 17, 1886, issue of the *Toledo Blade;* renamed *The Blade,* it is still Toledo's daily paper. Reed probably asked Harnett to include the paper to indicate his hometown; in addition, a member of Reed's family

may have been its managing editor. The reference was also a declaration of civic and regional pride, as the *Toledo Blade* was a publication of national reputation.

The pyramidal arrangement of objects, dark earth-toned palette, and thinly applied, uniform brushwork are characteristic of Harnett's late work. Most of Harnett's admirers, however, were fascinated by his highly illusionistic painting style, called trompe l'oeil (literally "fool the eye"), which intrigued, challenged, and sometimes boggled their perception of reality. A

Toledo Blade article aptly expressed this admiration soon after Harnett painted the picture: "The highest triumph of artistic genius is in approaching the actual—in the perfect reproduction of the subject represented. This is a picture well worth seeing, and those who appreciate the true and the good will no doubt find pleasure in looking upon it."

One of the chief practitioners of still life in the nineteenth-century, Harnett expanded upon the artistic tradition founded fifty years earlier by the Peale family (p. 118) in Philadelphia. Although enormously popular, he remained outside established art circles, which regarded anecdotal scenes and landscapes more highly than still lifes. Most of Harnett's supporters were middle-class businessmen, self-made, recently wealthy, and unconcerned with fashionable taste. His paintings inspired numerous followers and forgers but were largely forgotten after his death until a small exhibition in 1939 kindled modern-day appreciation.

Oil on canvas; 22 1/8 × 26 3/16 in. (56.1 × 66.5 cm); Gift of Mr. and Mrs. Roy Rike, 1962.2

Winslow Homer, American, 1836–1910
Sunlight on the Coast, 1890

THE IMAGE OF THE OCEAN crashing against the coast intrigued Winslow Homer from the time he moved to Prout's Neck, Maine, in 1883. A few years earlier (1881–83) Homer had lived in the English coastal fishing village of Cullercoats on the North Sea, painting the sea mostly as a backdrop for the people who lived there. Only in 1890, beginning with *Sunlight on the Coast,* did Homer shift away from essentially narrative subjects to focus on the pure seascape elements of rock, light, water, and sky. In his many oil and watercolor compositions dealing with this theme, he captured nature's numerous moods by portraying different types of waves, times of day, and weather conditions. Homer's understanding of the relationships among these various elements came from years of observing firsthand the seasonal changes at Prout's Neck

and from painting directly from nature rather than by imitating other artists.

The subject of *Sunlight on the Coast* is the never-ending battle between the sea and the shore, captured under specific conditions of light and weather. The painting's simplified composition, strong linear rhythms, earth-toned harmonies, and broadly textured brushwork determine its particular mood. A heavy blue-green wave rolls in and breaks over a shelf of brown rocks, spewing foam and spray. Homer successfully conveyed the wave's heaving, weighty mass and the iridescence of the swirling countercurrent. The wave's bulk, its powerful sliding, rolling motion, and its suction force as it funnels in on itself represent nature's might.

The painting's title seems curious. The scale of the wave and the darkness of the sky, sea, and fog are unsettling. The drab weather conditions not only obscure the high horizon line but also

tint the sea a cold, unappealing color. Sunlight barely pierces the darkness, although it transforms the backwash of one wave into a glittering surface and illuminates a portion of the sea and a steamship on the distant horizon. This diagonal recession in space from the dark lower left to the light upper right runs counter to the angle of the wave and conveys the vastness of the sea. As in the paintings that were to follow *Sunlight on the Coast,* Homer's depiction of the forceful interplay between the sea and the shore is an image of contemplation that manifests aspects of man's relationship with nature.

Oil on canvas; 30¼ × 48½ in. (76.9 × 123.3 cm); Gift of Edward Drummond Libbey, 1912.507

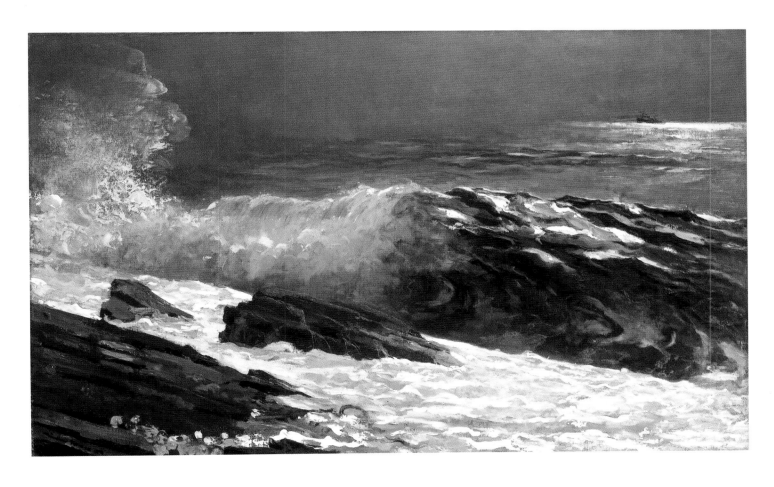

Paul Cézanne, French, 1839–1906
Avenue at Chantilly, 1888

IN 1888 PAUL CÉZANNE worked near Paris at Chantilly, where he explored the numerous shady avenues of the park surrounding its château. In addition to a group of small watercolor sketches—one very close to the Toledo Museum's painting—he painted three canvases of the receding tree-lined paths. In one, *Avenue at Chantilly,* he carefully framed with trees the gabled buildings glimpsed in the near distance, thus setting up a comparison between the built and the natural. The shuttered building and low barrier close off the avenue, removing any sense of human activity and making the only life appear to be in nature.

In *Avenue at Chantilly,* Cézanne carefully chose a centered, symmetrical, straight-on view and developed complex relations and correspondences between things. He echoed the inclined framing trees in the sloping gables, recalled the shutters and roofline in the barrier across the path, and aligned the overhanging edge of the foliage canopy with the repeated horizontals of the architecture. He disrupted a coherent recession into depth by the dense blue shadows beneath the trees, by the brightness and clarity of the distant structure, and by the broken and ragged edges of the path. In these ways he collapsed space and unified the painting's surface, making from his endlessly varied sensations of the world in continual flux a harmonious and enduring order.

As did his friend Camille Pissarro and the other landscape Impressionists, Cézanne sought through color and brushwork to express the vibration and spread of atmospheric light and to convey its effect on the landscape's appearance. He worked to translate his sensations into small, nuanced touches of color. He observed to a younger artist that painting from nature "is realizing one's sensations." Yet he also felt that "there are two things in the painter, the eye and the mind; each of them should aid the other. It is necessary to work at their mutual development, in the eye by looking at nature, in the mind by the logic of organized sensations, which provides the means of expression." In these remarks and elsewhere, Cézanne indicated that for him painting was as much a question of creating pictorial unity and coherence as of rendering his direct experiences of nature.

Oil on canvas; 32 × 25½ in. (81.3 × 64.8 cm); Gift of Mr. and Mrs. William E. Levis, 1959.13

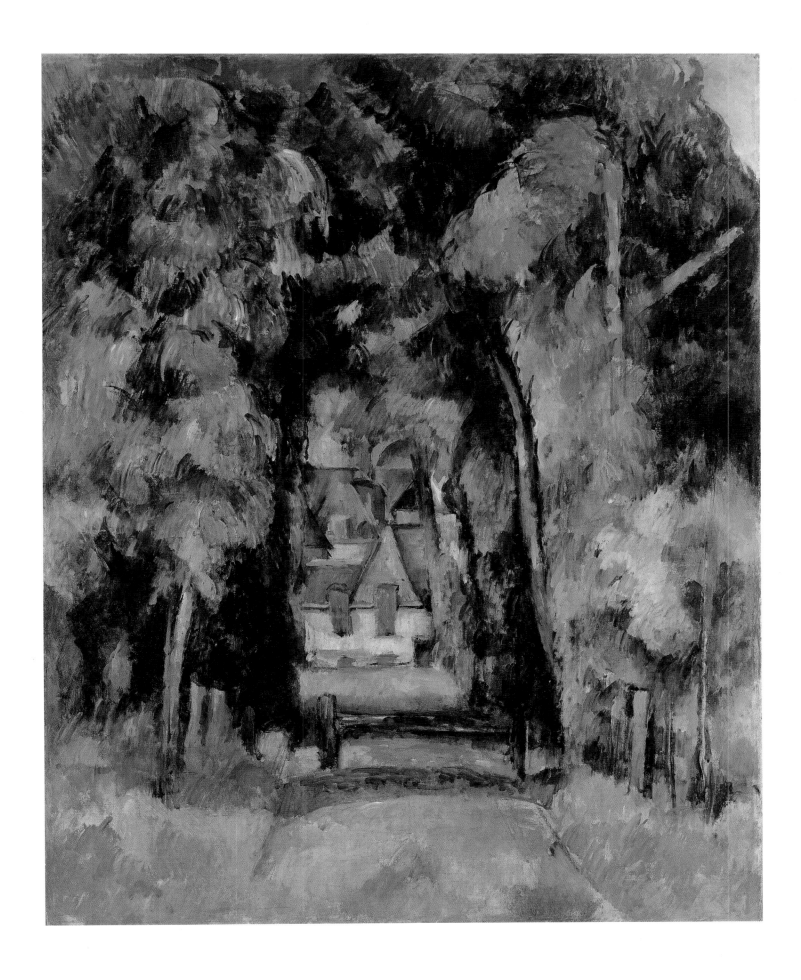

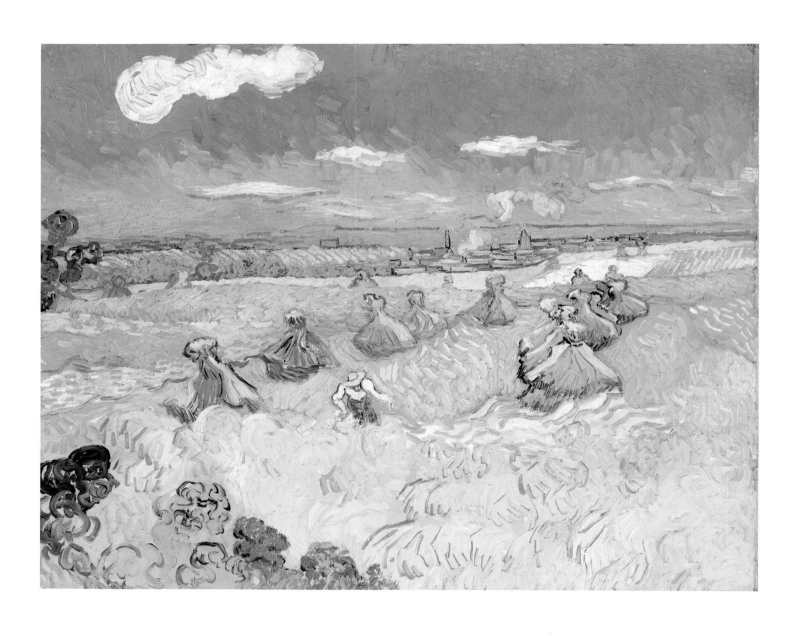

Vincent van Gogh, Dutch, 1853–1890
Wheat Fields with Reaper, Auvers, 1890

VINCENT VAN GOGH was fascinated by the vast fields of wheat that stretched above Auvers-sur-Oise, a large town north of Paris where he lived out the last two months of his life. Feeling strongly that observation was the basis for his art, he painted his landscapes out-of-doors in direct response to the motif, extending the primarily naturalistic inspiration of earlier Impressionism, while also emphasizing the subjectivity of the artist's vision. As in Impressionism, intense color is developed in closely coordinated harmonies; touch is active and accentuated, animating the landscape's features; and nature is treated in broad patterns and rhythms. But in Van Gogh's art, the color is bolder and less nuanced; the brushstrokes heavier, more regular, and more distinct; the forms and spaces more freely distorted; and the rhythms coursing and emphatic. The artist sought to express what was for him the essential character of this landscape, but also to "disentangle," as he once put it, what he understood and felt of nature's "expression and soul."

Van Gogh chose his motif from his immediate surroundings, but also saw immanent in the wheat fields and in the figure of the reaper symbolic meanings and sublime, almost religious, emotions with which he sought to invest his representation. He explained something of this significance in a letter a year earlier to his sister Wil:

Aren't we, who live on bread, to a considerable extent like wheat, at least aren't we forced to submit to growing like a plant without the power to move, by which I mean in whatever way our imagination impels us, and to being reaped when we are ripe, like the same wheat?

He expanded this idea in a letter to his brother Theo, discussing an earlier painting of a reaper:

I see in him the image of death, in the sense that humanity might be the wheat he is reaping.... But there's nothing sad in this death, it goes its way in broad daylight with a sun flooding everything with a light of pure gold...it is an image of death as the great book of nature speaks of it—but what I have sought is the "almost smiling."

In paintings such as *Wheat Fields with Reaper*, Van Gogh hoped to evoke, as he wrote to an artist friend two years earlier, "a more exalting and consoling nature than a single brief glance at reality...can let us perceive."

Oil on canvas; 29 × 36⅝ in. (73.6 × 93 cm); Purchased with funds from the Libbey Endowment, Gift of Edward Drummond Libbey, 1935.4

Paul Gauguin, French, 1848–1903
Street in Tahiti, 1891

DISSATISFIED WITH THE VALUES of modern European urban culture and wishing to return to a primitive way of life experienced in intimate association with nature, Paul Gauguin decided to leave France. He traveled to Tahiti in 1891, expecting to find an earthly paradise of mysterious religions, savage arts, and sensual pleasures. His main goal was to renew his art through contact with a non-European, preindustrial culture, but he also thought that new and exotic motifs might appeal to European dealers and collectors.

Street in Tahiti, among the first group of paintings he produced in Tahiti during his initial stay of two years, was recorded in his inventory of his paintings as *Paysage Papeete* ("Papeete Landscape"). Upon arriving in Tahiti, Gauguin lived for about three months in a rented house on the outskirts of Papeete, the shabby, Europeanized capital. Although he did not do much

painting directly from nature, preferring instead to work according to a more deliberate and synthetic method, this canvas retains traces of an earlier Impressionist landscape style. Gauguin sought to convey something of the special character of the place — the limpid light, rich color, lush vegetation, and lofty mountains. But the clear contours, tautly patterned brushstrokes, repeated curving rhythms, and simplified color he imposed on the richly varied elements of the landscape also create a unified and decorative pictorial structure. Gauguin's aim in general, like that of many other Post-Impressionist artists, was not to re-create his sensations but to develop a mysterious and suggestive equivalent for things beyond what could be directly apprehended. As he reflected later:

Eager to suggest a luxurious and untamed nature, a tropical sun that sets aglow everything around it...an immense palace decorated

by nature itself with all the richness that Tahiti contains. Whence all these fabulous colors, this inflamed, but softened, silent air. "But none of that exists!" "Yes it exists, as the equivalent of the grandeur, depth and mystery of Tahiti when it must be expressed in one square meter of canvas."

The overall effect of the landscape is sumptuous and majestic, but such minor notes of strain as the brooding woman and heavy clouds pressing down from above introduce vague undertones of sadness and disquiet into this placidly luxuriant fiction of a tropical paradise.

Oil on canvas; 45½ × 34⅞ in. (115.5 × 88.5 cm); Purchased with funds from the Libbey Endowment, Gift of Edward Drummond Libbey, 1939.82

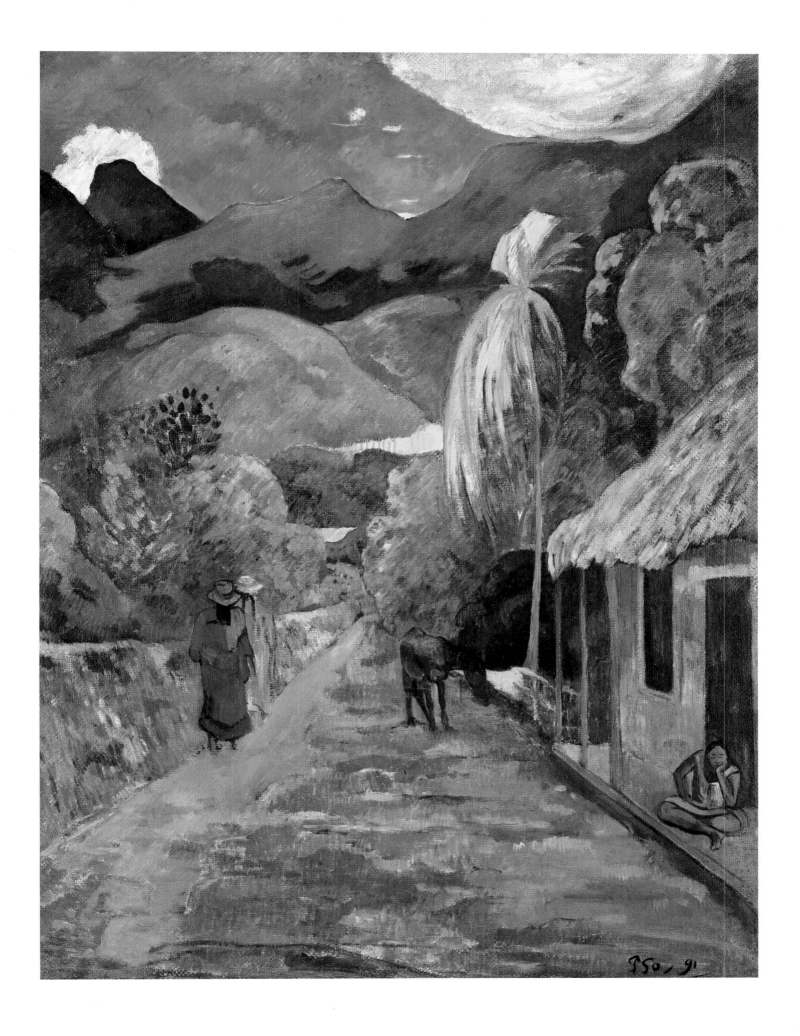

Hector Guimard, French, 1867–1942
Fireplace Mantel, 1902–3

HECTOR GUIMARD left a distinctive signature on the streets of Paris. The architect-designer most famous for his cast-iron subway entrances for the first Paris Métro line also designed this fireplace in the Art Nouveau style for Castel Val, a country house at Auvers-sur-Oise, northwest of Paris. Guimard viewed architecture as an all-embracing art and devoted as much attention to the interior as to the exterior of his buildings. He planned Castel Val like a coiled snail shell. He also designed its furnishings in many media and closely supervised the craftsmen who made them.

Art Nouveau was a decorative style, characterized by undulating lines and foliate forms, that flourished in Europe at the turn of the century. While many artists working in this style were largely content with illustrating nature, Guimard attempted to convey its abstract processes, giving his works a strong organic character. This imaginatively conceived fireplace owes much of its strong impact to the artist's ability to convey both the benign and sinister aspects of nature. The sweeping curves and leafy forms of the outer section of the mantel are carved pearwood. The carving moves the eye, setting up rhythms of curve and counter curve, while depicting lively organic motifs. The bronze inner section, on the other hand, suggests nature's gloomier side. The bronze—hard, cool, and dark—contrasts boldly with the pale pearwood. The freer, more abstract bronze forms are sharper, spikier, more fantastic—even more intimidating—than the softer, flowing pearwood. This contrast helps to form one of the most individual statements in decorative arts of the Art Nouveau period. This fireplace served a highly utilitarian, as well as aesthetic, function, however, as the louvered screen was raised and lowered with an elegant gilded bronze lever, depending upon whether or not the fireplace was in use.

Pearwood, bronze, and wrought iron; H 36¾ in. (93.3 cm), L 45¾ in. (116.2 cm), D 13¹⁵⁄₁₆ in. (35.4 cm); Purchased with funds from the Florence Scott Libbey Bequest in Memory of her Father, Maurice A. Scott, 1988.62

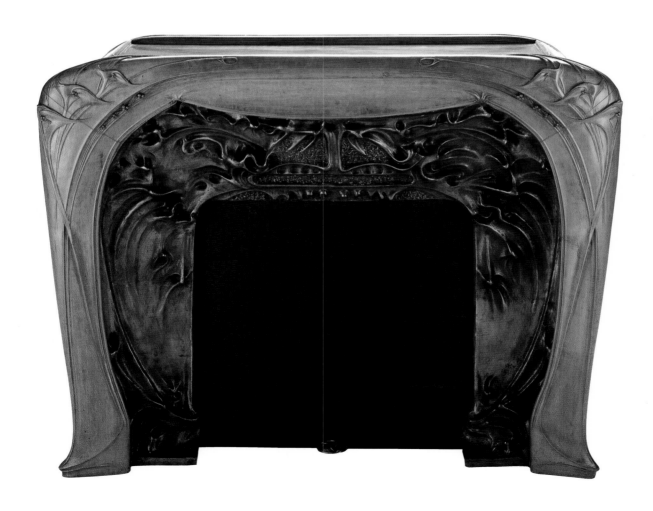

Edgar Degas, French, 1834–1917
The Dancers, about 1899

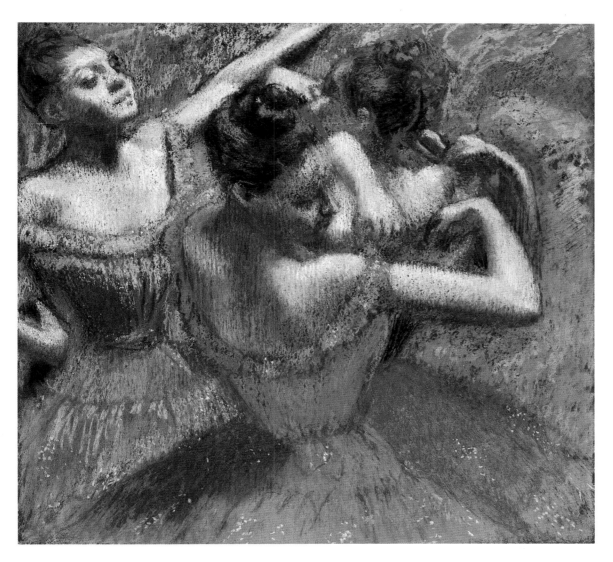

ALTHOUGH BALLET was an unusual subject for high art, there were many reasons for Edgar Degas's artistic fascination with the dance. As one of Paris's principal entertainments, it was for the bourgeois French male a familiar part of the urban scene. It offered modern women a characteristically ambiguous way to earn a living, yet also was, as Degas seems to have persuaded himself, "all that is left of the synthesized movements of the Greeks." He seems to have found appealing the conflict inherent in a theatrical subject between artifice and nature, between the charmed and make-believe world of choreographed gestures, fantastic costumes, and painted scenery, and the mundane reality of women waiting, stretching, scratching—and endlessly rehearsing. As he had remarked a decade earlier: "No art was ever less spontaneous than mine. What I do is the result of reflection and study of the great masters; of inspiration, spontaneity, temperament. . . . I know nothing."

In this late pastel, Degas deemphasized individual personality and psychology and suppressed references to the distinct social ambiance of the ballet, if not to work itself. In this and other later works, memory and imagination, "freed from nature's tyranny," as he remarked, played a more dominant role in his practices than any observed event. He worked in suites, recycling, rephrasing, and regrouping the same few figures studied from the model, from photographs, or from his own drawings, as he did here.

The actual execution of this pastel was also the result of a long, deliberate process. Degas applied the medium in layered webs of rhythmic strokes, thus achieving effects of translucency and depth and creating vibrant interactions of incandescent colors. The palette is less naturalistic than expressive.

Degas never severed his links to the model and to tradition. However, in *The Dancers* and other late works, his art, like that of many of his fellow Impressionists, became passionate and subjective, and artifice grew to dominate nature.

Pastel on paper; 24½ × 25½ in. (62.2 × 64.8 cm); Purchased with funds from the Libbey Endowment, Gift of Edward Drummond Libbey, 1928.198

147

Pierre Bonnard, French, 1867–1947
Parallèlement, 1900

PARALLÈLEMENT is the first true modern *livre d'artiste*, a book involving an artist, author, publisher, and printer from idea to design and finally publication. Everything was new. Never before had a painter been involved in the actual selection of typeface and even the color of ink to capture effectively the content of a page.

Pierre Bonnard, primarily a painter but also a successful printmaker, had worked on two other small volumes, which are music primers. *Parallèlement* was his first attempt at combining images and words. This was also

the first major book production by Ambroise Vollard, the most influential print publisher of the late nineteenth and early twentieth centuries. Vollard selected as text the evocative poems of Paul Verlaine (1844–1896) and then approached Bonnard, whose graphic style seemed particularly sympathetic to the fluid and sensuous qualities of Verlaine's literary style. Responding to the text, Bonnard drew cloudlike images across double-page spreads. The lightness of the typeface, Bonnard's wispy images, and the defiance of boundaries evoke Verlaine's reveries. The text is imbued with a nostalgia for a rather Rococo dream of transient, physical happiness. The rosy pinks of

the printing inks complete the harmony between text and image; the coarse paper adds a tactile quality.

With this book, Vollard and Bonnard redefined and set new standards for the art of the book. *Parallèlement* was also the culmination of Bonnard's work in Paris. The lithographs in this volume would be echoed in all his later work.

109 lithographs printed in rose-sanguine and 9 wood engravings printed in black plus suite of lithographs without text bound in; 11½ × 9½ in. (29.2 × 24.1 cm); Gift of Molly and Walter Bareiss, 1984.280

Camille Pissarro, French, 1830–1903
The Roofs of Old Rouen, Gray Weather, 1896

THE ROOFS OF OLD ROUEN was one of more than a dozen paintings of the city of Rouen that Camille Pissarro executed during his stay there in 1896. This was a time of strong demand for Impressionist pictures, and the artist turned to modern urban subjects of a sort typical of Impressionism of the 1870s, but that he himself had rarely treated before. He brought to these subjects his characteristic focus on the exact rendering of transitory effects— on the envelope of colored light and air—and worked to preserve his direct sensations and spontaneous responses in painting from nature. As he wrote from Rouen to an artist friend, what he sought was "to follow my sensations and thus convey life and movement,

to follow the fugitive and admirable effects of nature."

Although Pissarro had gone to Rouen to paint its bustling modern river port, a month after his arrival he came upon an unexpected view of its great Gothic cathedral from a room high up in his hotel. He wrote in his excitement to his son Lucien:

I found a really exceptional motif in a room of the hotel facing north, ice cold and without a fireplace. Just imagine: the whole of old Rouen seen above the roofs, with the cathedral, St.-Ouen church, and some fantastic roofs and turrets, really astonishing. Can you picture a size 30 canvas filled with gray, decrepit, old roofs? It's extraordinary!

Pissarro had enthusiastically admired Monet's *Rouen Cathedral* series in 1895. Out of deference to Monet, no doubt, he initially avoided the motif, but his discovery of a new and unusual view stirred his desire to paint it. Here, Pissarro transformed the way in which the cathedral was represented by embedding it in its context of urban domestic architecture. Conventionally, Gothic church architecture had been analogized with nature; Pissarro instead rooted the institutions and structures of religion in the everyday environment.

Oil on canvas; 28½ × 36 in. (72.3 × 91.4 cm); Purchased with funds from the Libbey Endowment, Gift of Edward Drummond Libbey, 1951.361

Libbey Glass Company, American
Punch Bowl and Stand and 23 Cups, 1903–4

REPORTEDLY THE LARGEST PIECE of cut glass ever made, this punch bowl was designed by the Libbey Glass Company to dazzle viewers at the Louisiana Purchase Centennial Exposition, or World's Fair, held in St. Louis in 1904. The entire process of blowing the glass blanks, deeply cutting the ornate pattern, smoothing the cuts, and polishing to give the effect of a many-faceted jewel probably required several months of intermittent labor by a team of specialized craftsmen. The bowl refracts light like a gigantic prism. Its complex pattern was reportedly designed under the guidance of William Marratt, superintendent of the Libbey cutting room, in honor of the St. Louis Exposition. The fleurs-de-lis included in the design are both the national flower of France, the country from which President Thomas Jefferson had purchased the Louisiana Territory, and symbols of the

city of St. Louis. This bowl is a duplicate, made in time for the Exposition, the original bowl having been broken in manufacture.

In 1888 Edward Drummond Libbey, later the founder of The Toledo Museum of Art, moved his New England Glass Company to Toledo. Renamed the Libbey Glass Company, it became the largest cut-glass producer in America, employing some two hundred glass blowers and more than two hundred cutters and engravers. This punch bowl was not made as a stock sale item; like a cut-glass table now in the Museum's collection, it was made as a showpiece to advertise the extraordinary skills of Libbey craftsmen, specifically at the St. Louis fair, which exhibited the most important collection of cut glass ever assembled in one place. The bowl won a gold medal, making Libbey one of only two American cut-glass firms to receive Grand Prizes.

Largely an American phenomenon, cut-glass tablewares were designed,

produced, and marketed primarily for the middle and upper-middle classes. Its opulent surfaces were well suited to the formal living patterns of the late nineteenth century. The popularity and demand for richly cut glassware began to wane shortly after it peaked about 1905, in part because of its own technical virtuosity: the increasing elaboration of patterns produced highly intricate designs at a time when fashion was dictating a more functional approach. Inexpensive pressed-glass imitations also decreased cut glass's aura of luxury. Social changes following World War I, including less formal lifestyles, further contributed to its decline.

Glass; H bowl and stand together 21½ in. (54.6 cm), DIA bowl 23⅞ in. (60.6 cm), H cup 4⅛ in. (10.5 cm), DIA cups 3⅛ in. (7.9 cm); Gift of Owens-Illinois Glass Company, 1946.27a–y

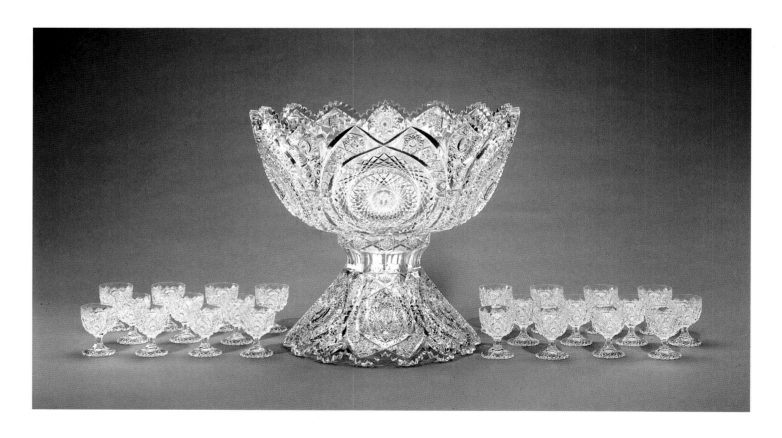

Augustus Saint-Gaudens, American (born Ireland), 1848–1907

Victory (from the Sherman Monument),
modeled 1902, this cast made about 1908

AT THE TURN OF THE CENTURY, the Civil War still remained the most stunning event in American history. Interest in the war and in history in general induced artists, among them Augustus Saint-Gaudens, to celebrate America's accomplishments by creating definitive images of its famous figures.

Regarded by his contemporaries as the foremost American sculptor of his generation, Saint-Gaudens set the standard in portraiture and memorials. Among his monuments to Civil War heroes of the Union is the over-life-size equestrian portrait of General William Tecumseh Sherman led by the allegory of Victory, of which the Museum's *Victory* is a smaller version. Saint-Gaudens began the monument in 1892 in New York, continued work in Paris, and completed it in 1902 at his Cornish, New Hampshire, studio. It was unveiled in 1903 at the southeast corner of Central Park at Fifth Avenue in New York. The memorial illustrates Saint-Gaudens's ability to combine convincingly the real with the allegorical. The carefully studied portrait, based on a bust Saint-Gaudens had made during Sherman's lifetime, contrasts with the idealized beauty of Victory.

For the figure of Victory, Saint-Gaudens was inspired by the famous Hellenistic Greek statue of the *Nike of Samothrace* and by Eugène Delacroix's painting *Liberty Leading the People* (1830), both in the Louvre, whose collections were familiar to the artist from his student days in Paris. Winged and crowned with laurel, an American eagle emblazoned across her breast, Victory conveys power and exaltation. She holds a palm branch in her left hand and raises her right arm in a gesture that is both benediction and a command to clear the way for horse and rider. Motion and purpose are conveyed through her billowing drapery, forward stride, and raised arms. In the monument, Victory leads General Sherman, whose own cape flies back as his horse surges ahead.

Saint-Gaudens frequently made reductions of his most popular large figures, often casting them with slight variations in an effort to make each unique. His desire to distribute his work commercially originated from the similar practice established in France. This cast, one of some nine reductions and covered with gold leaf like the Sherman Monument itself, was made posthumously for Mrs. Saint-Gaudens about 1908.

Gilded bronze; H 42½ in. (108 cm); Purchased with funds from the Florence Scott Libbey Bequest in Memory of her Father, Maurice A. Scott, 1986.34

Frederic Remington, American, 1861–1909
Indians Simulating Buffalo, 1908

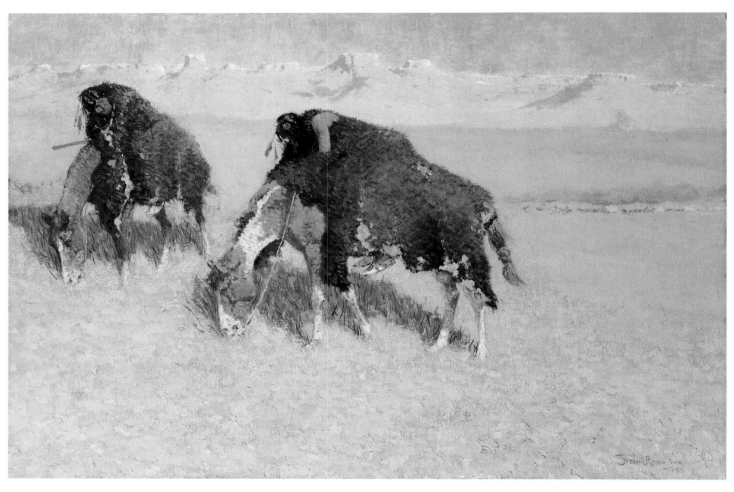

MORE THAN ANY OTHER ARTIST, Frederic Remington shaped our view of the Old West. Fascinated with the west's panorama and drama, Remington nostalgically recorded the lives and adventures of Native Americans, cavalrymen, cowboys, and settlers in paintings, magazine illustrations, and bronze sculpture. Although his images most often show Native Americans as the antagonists, the meaning behind *Indians Simulating Buffalo* is not self-evident. The painting may illustrate an already-vanished way of life of Native Americans or it may show the menace they once posed to peaceful settlers on their way to western lands.

While hunting, Native Americans often camouflaged themselves as graz- ing buffalo by slumping over their ponies and covering themselves with hides—a practice they later used to scout strangers in their territory. A wagon train barely visible in the distance suggests these men are scouts rather than hunters. Unlike many of Remington's images, the drama here lies in its implications. The viewer infers from the presence of the wagon train and the look shared between the riders the conflicts inherent in settling the west. As *Indians Simulating Buffalo* indicates, much of the strength of Remington's art lies in his ability to convey narrative through simple compositions that emphasize only the essential elements of his theme.

Remington's paintings of 1907–8 reflect increasing Impressionist influence. In this canvas, commissioned by P. F. Collier and Son and completed a year before the artist's death, then illustrated on the cover of the September 18, 1909, issue of *Collier's Magazine,* the brushstrokes delineating the buffalo robes and the strong vertical blue and reddish lines used to build up the shadows beneath them are similar to the Impressionists' brushwork. Remington also adapted the style's intense palette to record the strong sunlight and parched landscape of the western plains.

Oil on canvas; 26¹⁵/₁₆ × 40⅛ in. (68.4 × 101.9 cm); Gift of Florence Scott Libbey, 1912.1

George Wesley Bellows, American, 1882–1925
The Bridge, Blackwell's Island, 1909

THE BRIDGE, BLACKWELL'S ISLAND is a view from New York City's 59th Street of the Queensboro Bridge, which spans the East River and Welfare Island, formerly called Blackwell's Island. One of several New York river subjects that George Bellows painted between 1908 and 1913, the scene vividly captures Bellows's place and time. New York was expanding rapidly at this period and, as a modern city, generated considerable visual and physical excitement. Its urbanism and new technology enthralled Bellows, who in this painting celebrated the achievements of modern construction. Painted in December 1909, shortly after completion of the bridge, the canvas reflects

the spirit and energy of urban life. The tugboat fighting the strong current, the gritty cityscape in the distance, and the small group of engrossed onlookers are all overshadowed by the engineering feat. Bellows's use of bold colors and expressive, broad brushwork with thick dabs of pigment also serves to enhance the feeling of exuberance.

Although Bellows championed life in the city as embodying progress and modernism, his artistic style is more a fresh and vigorous mastery of an American realist tradition than a bold innovation. Never having been abroad to witness and adopt the new artistic trends of Europe, such as Fauvism and Cubism, Bellows instead identified with a group of contemporary American

realist artists. Many of these artists, called the Ash Can School because their unconventional subject matter dealt with the rougher aspects of American urban life, had begun their careers as journalists, producing illustrations for Philadelphia and New York newspapers. Their social consciousness and their adaptation of the spirited brushwork of such European masters as Frans Hals, Diego Velázquez, and Edouard Manet are reflected in Bellows's own vigorous style and themes—city streets, the waterfront, the boxing ring, and figural compositions.

Oil on canvas; 34 1/16 × 44 1/16 in. (86.5 × 112 cm); Gift of Edward Drummond Libbey, 1912.506

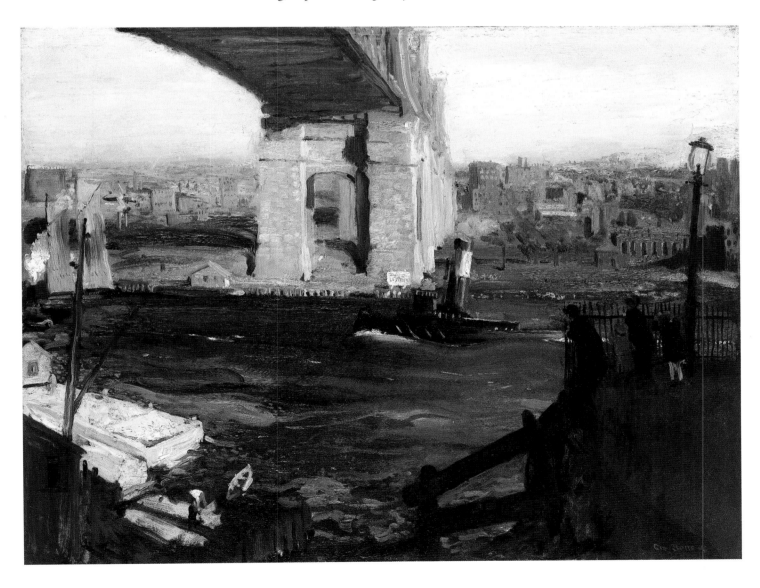

Pablo Picasso, Spanish, 1881–1973
Woman with a Crow, 1904

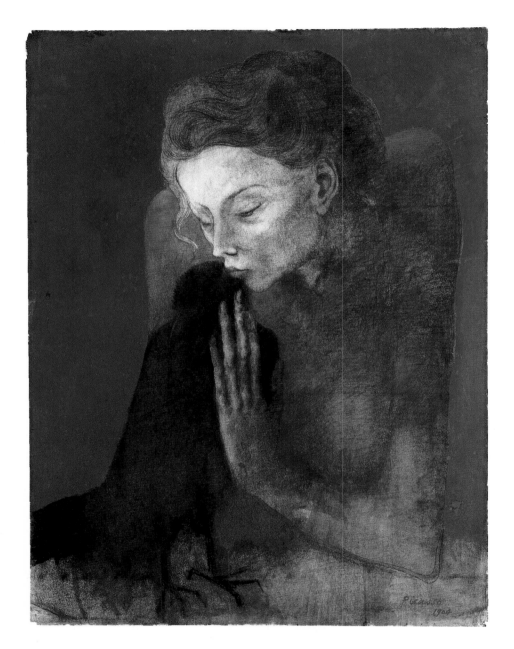

EVER RESTLESS, Pablo Picasso moved from one style and medium to another during his long and prolific career. *Woman with a Crow* was drawn during his so-called blue period, a designation for Picasso's work produced between 1901 and 1904. His images from this early period often depict downtrodden or impoverished members of society rendered in a cool, unhealthy pallor against an undifferentiated blue background. This consistently melancholy tenor reflects Picasso's material circumstances at the time and the living conditions of people in his neighborhood. It does not necessarily reflect his own emotional state or imply social criticism. Created when he was in his early twenties, these compelling works also indicate how rapidly Picasso attained artistic maturity.

Woman with a Crow is a portrait of Marguerite Luc, known as Margot, stepdaughter of Frédé Gérard, owner of Le Lapin Agile, a café Picasso frequented. Picasso represented her lovingly stroking and kissing a crow that was her pet as well as a curiosity to her father's customers. Set in an indeterminate space, Margot seems removed from everyday life. Although she is recognizable, Picasso's expressive distortions of form have depersonalized and generalized her into a type. Her gaunt face; her wide, skeletal shoulders that hunch over an extended neck; and her attenuated, scraggly limbs—especially her fingers—suggest an affinity with the bird she embraces. This elongation establishes a linear rhythm repeated throughout the composition. Except for her face, hands, and hair, the composition consists of broad expanses of only slightly modulated color. The evenly applied, intense blue background was put on after the drawing, overlapping it in several places and thus serving to flatten a space already made shallow by the flattened figure. The lack of detail, the distortions of form, and the emotional effect of the blue result in an image of isolation, enhanced by the presence of the black bird, a familiar omen of misfortune or evil.

Another version of *Woman with a Crow,* also dated 1904, exists in a private collection. Interestingly, the reverse of the Toledo Museum's drawing has a still-life watercolor of a hanging, plucked chicken done in blues and yellows in the same blue-period style.

Charcoal, pastel, and watercolor on paper mounted on pressboard; 25½ × 19½ in. (64.8 × 49.5 cm); Purchased with funds from the Libbey Endowment, Gift of Edward Drummond Libbey, 1936.4

Pablo Picasso, Spanish, 1881–1973
Woman in a Black Hat, 1909

THIS PAINTING OF Fernande Olivier, Pablo Picasso's mistress at the time and a frequent subject for many of his early works, belongs to the period in which Picasso developed Cubism, the complex, revolutionary style he and the French painter Georges Braque invented between 1907 and 1908. Prior to the invention of Cubism, artists had continued the Renaissance method of depicting the illusion of forms in space through the use of linear and aerial perspective. Cubism was a radical new way of representing images and space as if they were made up of overlapping flat planes projecting from the picture surface. In this and other early Cubist works—mainly portraits, landscapes, and still lifes, Picasso introduced the spatial flattening and faceting characteristic of "analytic" Cubism, the term applied to the first stage of the movement.

Picasso sought in Cubism a means to attain the greatest possible comprehension of the object depicted. Here, he broke down and recombined Fernande's form in totally new ways. Rather than depicting her as she appeared in the visible world by the traditional means of linear perspective, Picasso instead summarized her appearance from several points of view and over time. He fractured her facial features and right arm into various geometric shapes and contours, which were then laid over each other in overlapping planes. Both Fernande and the background have been given equal emphasis, while the range of colors has been severely restricted to permit a more intense focus on structure. The placement and modeling of some of the facets suggest projections—the nose, cheekbones, and hat brim—as well as voids, but an awareness of the canvas's flat surface pervades the composition.

After about 1911 Picasso, Braque, and other artists developed another form of Cubism, called "synthetic," in which they emphasized pattern, color, texture, line, and overlapping, sometimes transparent, flat shapes. The innovations of both phases of Cubism altered the structure of Western painting to a degree unparalleled since the Renaissance.

Oil on canvas; 28¾ × 23¾ in. (73 × 60.3 cm); Purchased with funds from the Libbey Endowment, Gift of Edward Drummond Libbey, and with funds from the Florence Scott Libbey Bequest in Memory of her Father, Maurice A. Scott, 1984.15

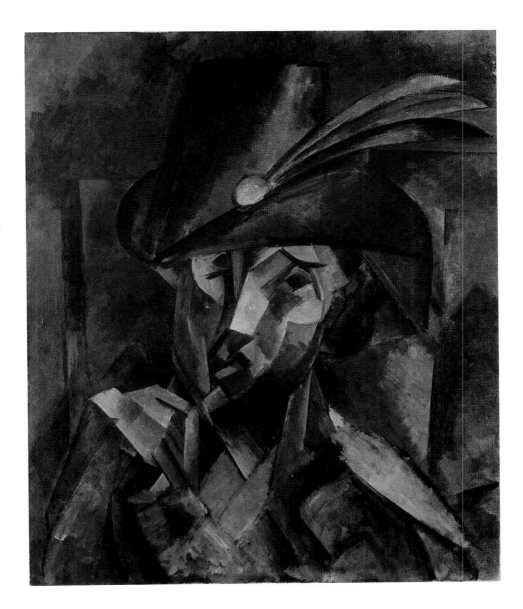

Maurice Brazil Prendergast, American (born Canada), 1858–1924
The Flying Horses, about 1902–6

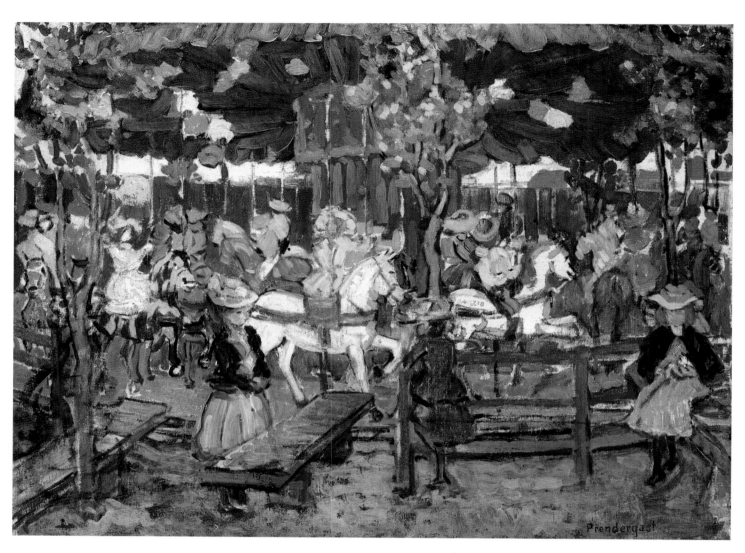

MAURICE PRENDERGAST portrayed idyllic scenes of people at leisure in public places: in playgrounds and amusement parks; on beaches, streets, or bridges; or gathered at parades and festivals. He adapted all of his American pictures from sketches done on the spot, often repeating themes. Here the subject is a merry-go-round, probably in Nahant, a coastal resort near Boston. Prendergast sought in his art to make timeless and significant the simplicity of the fleeting moment, and he experimented with form and color as ways of conveying feeling.

Despite having little artistic training, Prendergast was one of the first American artists to recognize the importance of the work of the French Symbolist painters known as the Nabis and of the Post-Impressionists. He was particularly influenced by the work of Cézanne. As these artists did before him, Prendergast rejected conventional perspective and modeling, simplifying figures and landscape into flat decorative patterns through broad brushstrokes. In *The Flying Horses* the mosaiclike strokes vary in size, shape, and direction and not only define the underlying forms but also unify the pictorial surface by fusing the foreground and background into a flat pattern. Although

this painting was done in oil, a reflection of Prendergast's watercolor technique is seen in the thin layering of pigment and the small patches of canvas left bare for luminosity and dynamism. The intense, bold colors and the fluidity and spontaneity of the brushwork capture the festive gaiety of the subject.

Oil on canvas; 23⅞ × 32⅛ in. (60.7 × 81.5 cm); Purchased with funds from the Florence Scott Libbey Bequest in Memory of her Father, Maurice A. Scott, 1957.22

Marsden Hartley, American, 1877–1943
Abstraction (Military Symbols), 1914–15

LOOKING THE WAY a brass band sounds, *Abstraction (Military Symbols)* depicts banners, flags, emblems, and elements of German officers' uniforms. While living in Berlin during the early days of World War I, Marsden Hartley created a series of paintings that reflects his fascination with the elaborate displays and medals of German military life; these remain among the most important works of his career. Spiritual by nature and influenced by mystical writings, he expressed his own emotions in *Abstraction (Military Symbols)* and the rest of the series by using a personal vocabulary of symbols derived from immediate visual experience. Hartley painted the series in homage to two friends: a young German officer, Karl von Freyburg, who had died at the front in October 1914, and another officer, Arnold Rönnebeck, Freyburg's cousin.

Abstraction (Military Symbols) evokes the militaristic pageantry and visual dynamism of Berlin at the time: long curving shapes suggest ribbons or banners; circles suggest targets, insignia, or uniform buttons; striped or checkered squares evoke regimental flags; and long vertical shapes suggest flagpoles or lances. Although the motifs derive from nature, they merge in an abstraction that combines the shallow space and flat planes of Synthetic Cubism, with which Hartley had experimented in France, with the emotional content and vivid color of German Expressionism. Hartley was one of the first American painters to come into extended contact with the German avant-garde artists

known as the Blaue Reiter ("Blue Rider"), and their expressive nonrepresentational color and symbolism greatly influenced his own emerging style. Here, Hartley simplified and distorted the objects to create powerful, decorative patterns and dynamic, pulsating rhythms that in turn convey his intense feeling. Active, broad brushstrokes call attention to the painting's rich, tactile surface, reinforcing a composition already forceful in its imagery.

After returning to America in December 1915, Hartley denied that the symbols in his military abstractions had any specific meaning:

The forms are only those which I have observed casually from day to day. There is no hidden symbolism whatsoever in them; there is no

slight intention of that anywhere. Things under observation, just pictures of any day, and hour. I have expressed only what I have seen.

Hartley's denials, however, are believed to have been prompted by concern that his paintings might inflame the intense anti-German feelings already rampant in America at the time.

Oil on canvas; 39¼ × 32 in. (99.7 × 81.3 cm); Purchased with funds from the Libbey Endowment, Gift of Edward Drummond Libbey, 1980.1013

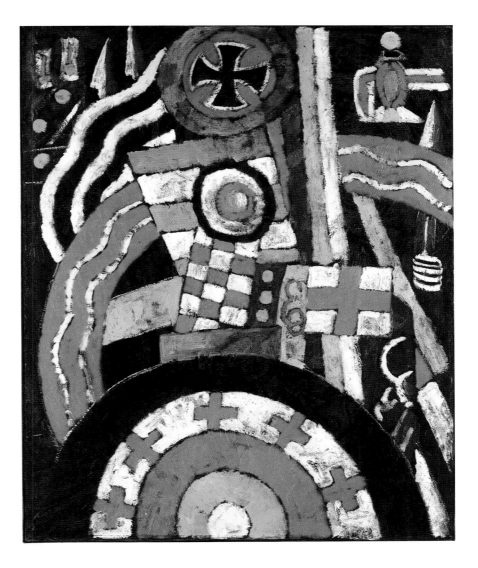

Paul Manship, American, 1885–1966
Dancer and Gazelles,
modeled 1916, this cast made about 1922

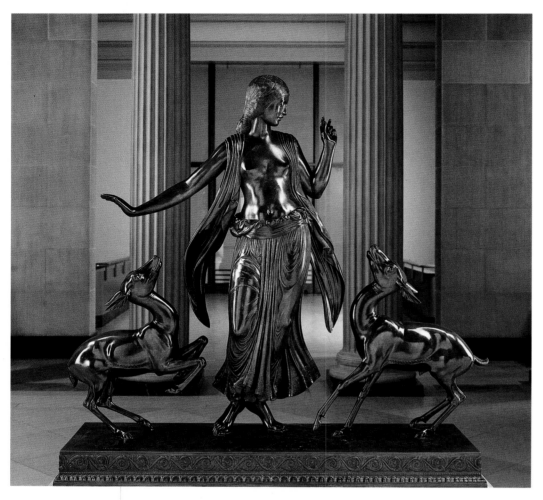

HAILED BETWEEN THE WORLD WARS as an artist of great talent and unique vision, Paul Manship was considered by fashionable taste as progressive, yet unaffected by the sometimes jarring innovations of modernism. Manship's popularity was due in part to his ability to fuse into works of great charm elements from a wide range of cultures and eras that seemed to introduce a revitalizing freshness to American sculpture.

Dancer and Gazelles manifests the free interpretation of artistic sources, deft simplification, and refined craftsmanship that characterize Manship's art. The sculpture conveys a sense of fluid, graceful motion due to its sinuous contours and abstract elegance. A woman balancing on her toes sways gently, causing her skirt to undulate. At the same time she gestures daintily to the gazelles frolicking beside her. Manship emphasized outline by silhouetting the figures in a planar, frontal, symmetrically balanced ensemble.

The diverse artistic sources that shaped *Dancer and Gazelles* are allusive rather than precise. The dancer's profile head, clinging drapery, and slightly modeled torso are reminiscent of elements found in ancient Greek and Roman sculpture, vase painting, and frescoes. The rhythmic grace of the group, the decorative detail along the sides of the base and the costume's hem, and the curvilinear contours recall painting and sculpture from India. Indeed, Manship's motif of a woman flanked by two deer may derive from a similar theme of dancing figures with animals found in Indian miniature painting.

Dancer and Gazelles is among Manship's most famous compositions. Another life-size bronze cast is in the Corcoran Gallery of Art, Washington, D.C.; twelve reduced versions, in which the gazelle at the right bears a set of horns, exist in public and private collections; an even smaller version is extant in plaster. The Museum's *Dancer and Gazelles* is admirably suited to its present location, its scale and lyrical style a harmonious foil to the severe classicism of the Libbey Court.

Bronze; H 72 in. (183 cm); Purchased with funds from the Frederick B. and Kate L. Shoemaker Fund, 1923.24

Edward Hopper, American, 1882–1967
Two on the Aisle, 1927

EDWARD HOPPER'S ENTHUSIASM for the theater began during his youth, when his mother encouraged his interest in art and theater. The interest was reinforced by Robert Henri, his favorite teacher at the New York School of Art from 1900 to 1905. Both men shared a passion for the brooding plays of the Norwegian dramatist Henrik Ibsen.

Although Hopper made three trips to Europe, he was not moved by the radical new currents in French art. Upon his return he began to work in commercial art to support himself. It was only in 1924, at the age of forty-two, that Hopper had his first solo exhibition. It proved sufficiently successful for him to devote himself full time to painting. In the same year he married Jo Nivison, a fellow painter and a former actress who also adored the theater.

Two on the Aisle was Hopper's first major painting of a theater scene, a theme to which he returned frequently throughout his career. Here he presented a moment of anticipation in which the seductiveness of the theater atmosphere—an effect heightened by the warm hues suffusing the scene—is the real theme. Strong light from unseen ceiling fixtures illuminates the setting. Its intensity is emphasized by the broadly painted lower half of the boxes, where thinly painted shadows reveal the reddish ground with the paneling outlined in black, all overlaid with a light wash of gray. Hopper once said it took him ten years to get over the bravura painting technique of Robert Henri, who in his turn had been much influenced by Manet. In this one area of the painting, Hopper returned to focus on the texture of the paint itself; the rest of the canvas is more uniform in handling. Light, not texture, is the motivating force.

The only activity in the painting is the pair settling their coats—a point reinforced by the sole pure colors in the painting: the bright green satin and gleaming white shirtfront of their costumes. The couple is, in fact, Hopper and his wife—an autobiographical note with a lighthearted undercurrent. Although the balding Hopper was protective about his appearance, here he abandoned his customary hat, revealing not only his bare scalp but also his large nose. In a further wry twist, he portrayed the frequently tardy couple as not only prompt, but early.

Two on the Aisle was included in the first retrospective of the artist in 1933 at the Museum of Modern Art in New York. Hopper's stature thenceforth as the dominant realist painter in American twentieth-century art was assured.

Oil on canvas; 40⅛ × 48¼ in. (102 × 122.5 cm); Purchased with funds from the Libbey Endowment, Gift of Edward Drummond Libbey, 1935.49

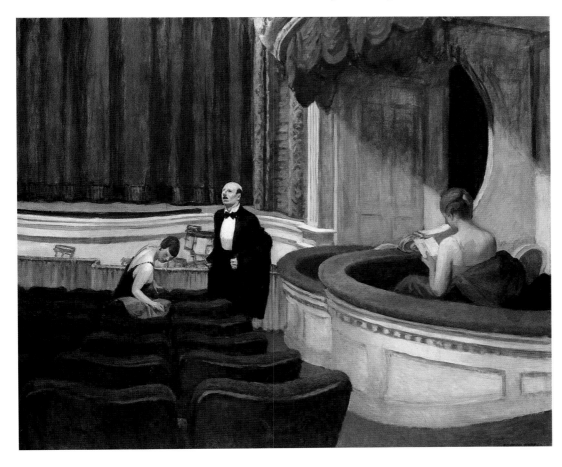

François Décorchemont, French, 1880–1971
Bowl, designed 1921, cast May 1922

In making this model, one of five versions of the design listed in the artist's archives, Décorchemont combined his earlier concern with naturalistic themes with his later interest in geometric motifs. Inspired by ancient masks, the artist depicted in relief on each side of the bowl the head of Medusa flanked by two undulating snakes. (In classical mythology Medusa, a beautiful maiden, was transformed into a hideous winged monster with staring eyes and snakes for hair.) In the lower portion of the bowl and continuing behind the snakes and masks are repeating ornamental bands molded in low relief.

The bowl's handles are formed by the entwined snakes in full relief, which continue onto the surface of the bowl and are smoothly integrated into its decoration. These delicately patterned handles, more commonly found on Décorchemont's earlier glass, are especially difficult to achieve when combining *pâte-de-verre* with the *cire perdue* technique. Décorchemont's mastery of the difficulties inherent in these multiple technical processes, as well as his creative designs, made him one of France's most renowned craftsmen.

Glass; H 6⅞ in. (17.4 cm), DIA 7⅜ in. (18.7 cm); Gift of Hugh J. Smith, Jr., 1949.1

FRANÇOIS DÉCORCHEMONT, who was one of the first glass artists of this century to design and fabricate work in his own studio rather than in a factory, played a leading role during the early twentieth century in the advancement of the *pâte-de-verre,* or "glass paste" technique. To make his early *pâte-de-verre* wares, Décorchemont mixed finely ground glass crystals with a binding agent (for example, water) to obtain a paste, to which he added metallic oxides for color. The paste was then shaped in a mold and fired.

Glass made by this technique often has matte colors.

Décorchemont's early Art Nouveau–inspired vases were distinguished by their flora and fauna decoration and were frequently embellished with masks inspired by antiquity. In 1910 he began working in the *cire perdue* ("lost wax") technique, making a plaster model of an object and a wax replica that was then encased in a refractory mold. The wax was subsequently melted away, after which the surrounding mold was filled with *pâte-de-verre*. During the 1920s, Décorchemont began to create more simplified vessels adorned with abstract patterns.

Aristide Maillol, French, 1861–1944
Monument to Debussy, 1930

BELIEVING THAT THE FEMALE FORM embodies the essence of natural beauty, Aristide Maillol devoted himself almost exclusively to modeling single female figures when he began sculpting at around age forty. This figure was originally designed for a public memorial to the composer Claude Debussy, who died in 1918. Maillol's first *Monument to Debussy,* carved in white marble, was unveiled on July 9, 1930, at Debussy's birthplace, Saint-Germain-en-Laye, near Paris. Maillol subsequently made a plaster model of the monument, from which six full-size bronzes were cast. The first measures of Debussy's orchestral work *L'Après-midi d'un faun* ("Afternoon of a Faun"), carved into the base of the marble monument, are absent in the bronze casts. This version is the first cast made, which Maillol kept for himself until 1932.

Monument to Debussy is a sculpture of quiet dignity, serenity, and simplicity—a synthesis of careful observation and subtle idealization of the human body. The figure of a young woman with stocky torso and legs kneels atop a low, inclined base. Her carefully contoured face, with its generalized features, is framed by the outline of her hair drawn smoothly into a bun at the nape of her neck. The entire composition suggests arrested motion. The figure's left hand is poised behind her while her right hand extends forward. A gentle rhythm of gracefully curving lines runs from the head, bowed as if in tribute to the composer, along the curving back, to the extended arms. This linearity contrasts with the weightiness of the woman's rounded forms. Detail is kept to a minimum. The woman's body can be broken down into a small number of compact geometric forms—legs posed triangularly, conical breasts,

bulbous stomach, and so forth. With its acute sense of form and harmonious balance of masses, *Monument to Debussy* conveys the composer's own light, fluid touch along with the weight and gravity that make both the music and the sculpture monumental.

Bronze; 35¾ × 34 × 36⅝ in. (90.8 × 86.4 × 93.0 cm); Purchased with funds from the Libbey Endowment, Gift of Edward Drummond Libbey, 1934.60

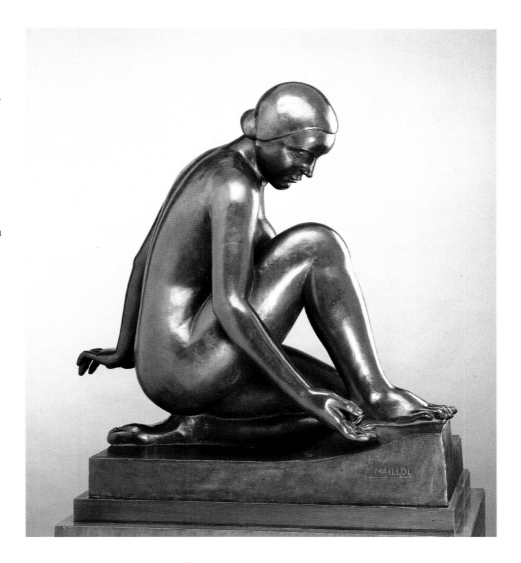

Claude Monet, French, 1840–1926
Water Lilies, about 1922

DURING THE LAST THIRTY YEARS of his life, Claude Monet made his water garden at Giverny, a quiet town on the Seine forty miles from Paris, his principal artistic theme and his final retreat from the world into a tranquil realm of meditation, reverie, and peace. Monet had long dreamed of making his water garden the subject of a grand decorative scheme. During the summer of 1914, he began work on a waterlilies project that was to consume the remaining twelve years of his life. He made large studies outdoors and painted huge canvases for the decorative cycle in a vast new studio. After protracted negotiations with the French State, he signed a contract in April 1922 to produce a painted decoration for two large oval rooms in the Orangerie des Tuileries in Paris. He immediately began to rework existing paintings with the specific sites in mind.

In revising a triptych entitled *Morning* (ultimately installed in the Orangerie), Monet rejected one of the three long canvases and substituted for it two new half-width canvases, one at each end, to frame and complete the composition. The compositional features and unusual size of the Toledo painting suggest that it was conceived as a new half-width canvas for the right side of *Morning,* then rejected. It was left unfinished in his studio at his death.

As in other late *Water Lilies* paintings, colors throughout are closely coordinated within a narrow range of hues, and bold, calligraphic brushstrokes establish intricate sequences of quivering movements across the picture surface. Visual expectations are confounded as Monet took what in the landscape appears as horizontal and raised it on a vertical plane, and turned the world upside-down by placing ground and grasses along the top. Nature is made to appear as something insubstantial, floating, suspended without gravity or depth, in ceaseless shimmering motion. As Monet remarked to a critic in 1909, his image of the water garden "evokes in you the idea of the infinite; you experience there, as in microcosm . . . the instability of the universe which transforms itself at every moment before our eyes."

Oil on canvas; 79 × 84 in. (200.7 × 213.3 cm); Purchased with funds from the Libbey Endowment, Gift of Edward Drummond Libbey, 1981.54

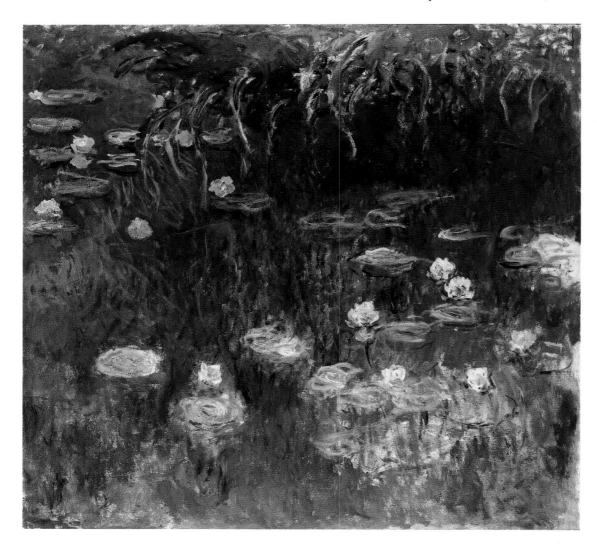

Pierre Bonnard, French, 1867–1947

The Abduction of Europa, 1919

Pierre Bonnard most often took his subjects from the ordinary, familiar world, but during the first two decades of this century he became increasingly intrigued with the imagery of pastoral myth. His interest in such subjects was related to his broader artistic goal of evoking a world of comfort and pleasure, stimulated during this period by his frequent, extended stays in the South of France. For him, as for numerous other artists and writers of the time, the Mediterranean South was a traditional and unchanging world of sunlight and careless ease, the embodiment of a premodern Arcadia.

Bonnard probably painted *The Abduction of Europa* at least in part during his stay on the Mediterranean coast in the winter of 1918–19. The landscape is related to one he did during that visit, but he replaced a goatherder and his goats with the god Zeus, transformed into a white bull, abducting the beautiful Europa across the sea to Crete. Bonnard represented the moment in the myth when Europa first mounts the bull. He surrounded the principal characters with Europa's companions, one of whom looks on with alarm, and with two fauns, the younger joyously piping to his lolling elder. He depicted Europa and the bull in playful flirtation, rather than focusing as other artists had on the young woman's struggle and distress as she is carried out to sea.

Bonnard's greatest concern in this painting, as it was generally, was not so much to illustrate a myth as to create a powerfully sensuous effect. His colors, very loosely based on those of nature, are radiant and sumptuous—a rich and nuanced harmony within a relatively narrow range of hues. He coupled the unity he attained through color to softly washed brushwork in order to establish a continuous flowing field of translucent color across the entire picture surface. Through his treatment of the subject here, Bonnard merged the mythic figures into a dreamlike harmony with nature and pictured the Mediterranean landscape as a timeless world of indolent pleasure.

Oil on canvas; 46¼ × 60¼ in. (117.5 × 153 cm); Purchased with funds from the Libbey Endowment, Gift of Edward Drummond Libbey, 1930.215

Amedeo Modigliani, Italian, 1884–1920
Paul Guillaume, 1915

PAUL GUILLAUME

SETTEMBRE 1915

modigliani

contemporary avant-garde. Versatile and enterprising, he realized the close connection between criticism and the promotion of modern art; to further his cause, in 1918 he founded the review *Les Arts à Paris*. Guillaume became one of Modigliani's earliest supporters, exhibiting his works as well as those of Picasso and Matisse. During 1914–16 when Guillaume was his dealer, Modigliani painted four portraits of him as well as executing several related drawings.

In this portrait, the twenty-three-year-old Guillaume sits in his library in front of a bookcase with an upright piano in the background. The composition consists of broad expanses of slightly modulated tones, while detail is minimized and space flattened. Guillaume's features are reduced to their essentials, giving the likeness a somewhat masklike appearance. As the Cubists had already done, Modigliani incorporated words into the composition by inscribing Guillaume's name and the painting's date in its lower corners, a practice he often employed.

Modigliani concentrated here on the sitter's features rather than his character. By carefully selecting and emphasizing a few features, such as small, pursed lips, almond-shaped eyes with no pupils or irises, and severely trimmed mustache, Modigliani provided clues to Guillaume's personality. His individuality has been reduced to the impenetrable stylization of a mask, and he becomes part of the stage set in Modigliani's highly pictorial ensemble. As in most of Modigliani's portraits, he remains distant and aloof.

Oil on board; 29½ × 20½ in. (74.9 × 52.1 cm); Gift of Mrs. C. Lockhart McKelvy, 1951.382

AMEDEO MODIGLIANI'S SITTERS — relatives, other artists, writers, musicians, actors, dealers, collectors — were drawn from Montparnasse, the bohemian district that housed the artistic life of Paris during the first decades of the twentieth century.

Modigliani, who arrived in Paris in 1906, was a key figure among this international circle.

In 1914, through his friend the poet Max Jacob, Modigliani met the art dealer and writer Paul Guillaume (1891–1934). Guillaume was a champion of both African art and the

Piet Mondrian, Dutch, 1872–1944
Composition with Red, Blue, Yellow, Black, and Gray, 1922

UNDERLYING PIET MONDRIAN'S paintings is a desire to balance opposing forces by concentrating on the subtle relationship among lines, shapes, and colors. Mondrian developed a distinct, radical painting style by eliminating recognizable objects in favor of a visual language of vertical and horizontal lines and rectangles restricted to black, white, gray, and the three primary colors (red, yellow, and blue). Mondrian believed this nonrepresentational style, which he called Neoplasticism, expressed the unity and order possible in nature when the forces of opposition that constitute the real dynamic of existence are balanced. Mondrian hoped his images of absolute harmony, clarity, and order would point the way toward a future universal utopia. This goal was first formulated in Holland around 1916–17 by Mondrian and a small group of like-minded artists and architects. Their art and ideas, collectively referred to as de Stijl ("the Style"), profoundly influenced subsequent painting as well as many aspects of modern design.

Originally owned by de Stijl architect J. J. P. Oud, this painting is dominated by a large white square surrounded by small color planes that extend to the edges of the canvas. Mondrian worked by trial and error, experimenting with the position, shape, size, and intensity of colors and lines in order to enhance their rhythms and harmony. Here, he dramatically balanced the red rectangle at the upper left of the composition with narrow yellow, blue, and black rectangles in the lower right corner. White dominates through its ample physical area. The gridlike black lines that serve as boundaries to the color planes stop short of the canvas edges, creating spatial ambiguities regarding projection and recession. Despite the painting's pristine surface, brushstrokes reminiscent of Mondrian's paintings of the 1910s are just visible. Overall, the composition's lines, colors, proportions, and rhythms constitute a nonnarrative pictorial reality that serves as an image of contemplation and reflection.

Mondrian created variations on this composition until the early 1940s when, inspired by the pulsating rhythms of New York and jazz, he switched from austere black to colored lines, and ultimately to small, multicolored, syncopated rectangles.

Oil on canvas; 16½ × 19⅛ in. (41.9 × 48.6 cm); Purchased with funds from the Libbey Endowment, Gift of Edward Drummond Libbey, 1978.44

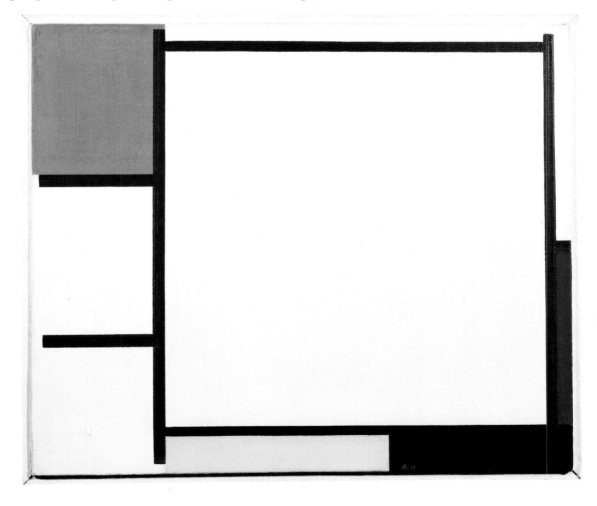

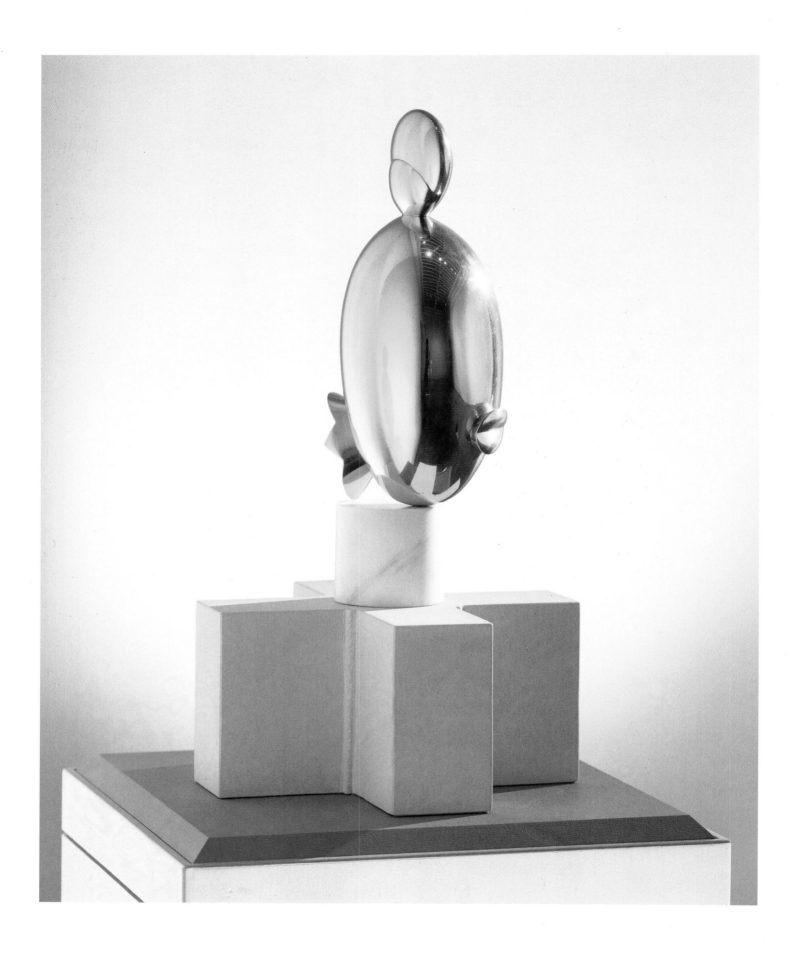

Constantin Brancusi, French (born Romania), 1876–1957
Blond Negress I, 1926

ONE OF THE MOST INNOVATIVE sculptors of the early twentieth century, Constantin Brancusi simplified outward appearances to express inner, universal beauty. This extremely refined image of a woman's head is said to have been inspired by a young African woman whom the artist saw at a reception. A smooth oval represents the head. Its geometric surface is interrupted by three details: an elegant topknot, an ornament at the lower back of the head, and lips. Brancusi poised the head on the top edge of a white marble cylinder, which in turn is mounted on a cross-shaped limestone base. He carved the first version of the head, titled *White Negress I,* in white marble in 1924.

Blond Negress I was cast in 1926. A second bronze version, *Blond Negress II,* was cast in 1933. In all versions, Brancusi deliberately chose materials that avoid reference to skin color and focused on revealing the inner radiance of the subject.

Born in Romania, Brancusi moved to Paris in 1904. During his first years there, he was influenced by the great French sculptor Auguste Rodin, who recognized Brancusi's potential and invited him to work in his studio. After only a brief period, Brancusi left in 1907, saying, "Nothing can grow under big trees." He soon found his own artistic identity, and within a few years was acknowledged as one of the leading sculptors in Paris.

Brancusi's mature work was profoundly influenced by the ancient Greek philosopher Plato's concept of ideal form. Rather than imitating nature, the artist simplified his images to the essential, ideal forms that he believed lay beneath surface appearance. While carved wood and stone sculptures established his early reputation, it is polished bronze works, such as *Blond Negress I,* that are his contribution to twentieth-century art. In his hands this traditional material took on a radically modern appearance. Its polished surface becomes almost transparent as the sculpture reflects life around it, while at the same time, the flawless form reveals the beauty within.

Bronze, marble, and limestone; H head 15¼ in. (38.7 cm); Partial Gift of an Anonymous Donor and Partial Purchase with funds from the Libbey Endowment, Gift of Edward Drummond Libbey, and with funds from the Florence Scott Libbey Bequest in Memory of her Father, Maurice A. Scott, 1991.108

Joan Miró, Spanish, 1893–1983
Woman Haunted by the Passage of the Bird-Dragonfly Omen of Bad News, 1938

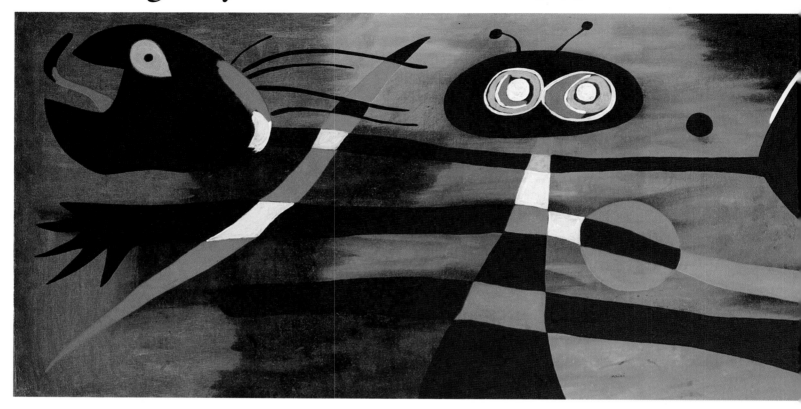

ALTHOUGH JOAN MIRÓ ASSERTED that every element in his art represented something existing in nature, his images often appear imaginary or unnatural. For him, such fanciful images expressed the subconscious rather than perceptions of the objective world. Such dreamlike, ambiguous imagery and the sense of displacement that often results were touted as ideal by Miró and other Surrealist artists. Their aim was to free the viewer's imagination through the creation of a multilayered, pictorial sign language. The three figures in this painting are a horizontal, airborne creature with a large head, open mouth, and protruding tongue; a round-eyed vertical figure with antennae; and a fierce creature with a white head, fangs, and wiry hair who gestures dramatically with its right arm while its left arm engulfs the other two figures. The middle figure appears to be paralyzed with fear.

Miró entitled the painting *Woman Haunted by the Passage of the Bird-Dragonfly Omen of Bad News* when he saw it again in 1959. Previously it had been known as "Nursery Decoration," a reference to its location, strange as it may seem, in the bedroom of the three children (mentioned in the inscription, *"pour Jacky, Peter et Pauley / Matisse"*) of Pierre Matisse, Miró's dealer and the son of Henri Matisse. As suggested in

168

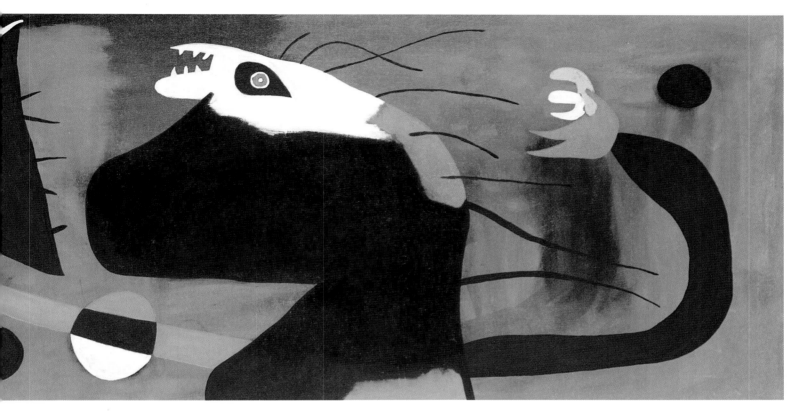

the title, an omen is a prophetic sign foretelling good or evil; it can also act as the instigator of its predictions. Folklore has assigned such roles to certain animals. Here the omen clearly is evil. *Woman Haunted . . .* captures the confusion and fury provoked by such an omen, and perhaps even represents an attempt to nullify it (by causing a commotion to drown out its evil cry or actively hunting down the creature).

The painting belongs to a group of pictures—known as his savage period— Miró painted on the eve of war between 1934 and 1939. This canvas followed the September 1938 meeting of the British prime minister Neville Chamberlain with the German dictator, Adolf Hitler, that culminated in the Munich Pact—a vain attempt to avert World War II. Miró's powerful image of aggression and fear may commemorate this event and the accompanying tensions. The confused and uncertain division between opposing forces in the painting attests to a state of extreme disorder. Furthermore, the two blackened orbs in the sky, which may suggest a double eclipse, appear as further precipitants of a disruption and doom beyond the control of mankind.

Oil on canvas; 31½ × 124 in. (80 × 315 cm); Purchased with funds from the Libbey Endowment, Gift of Edward Drummond Libbey, 1986.25

Max Beckmann, German, 1884–1950
The Trapeze, 1923

MAX BECKMANN frequently employed circus and carnival images as metaphors of human behavior, expressing his dark view of human nature and the world through the performers themselves, their costumes, attributes, and activities. *The Trapeze* depicts seven acrobats compressed within a narrow vertical space. At first glance the figures seem to be performing before an audience, but neither the oddly configured, low-slung trapeze bar nor the shallow, narrow space would actually allow a performance. Despite their exertions and attempts at coordination, the acrobats flounder and, in fact, hinder each other's efforts, forever trapped by forces greater than their own disoriented desires. Equally peculiar are their demeanors. Masked, eyes closed, or undiscerning, they are psychologically distant from one another despite being so tightly intertwined. The acidic, high-key palette adds to the feeling of oppression. The figures' frozen gestures, compactness, and precarious balance express the artist's pessimistic sense of the ambiguity of human existence.

The face of the man in brown stripes, hanging head-down like a demon in a medieval depiction of Hell, is probably a self-portrait. This figure is the only one who directly engages the viewer with an intense stare. Many of this painting's puzzling details are connected with the circus, while others, such as the potted plant and burning candles, have more obscure meanings. The painting's title refers not only to the circus performers' act but also to what Beckmann saw as the role of the artist and his art in society. He stated, "We are all tightrope walkers, and it is for the artist as for other beings: the will to reach balance and keep it."

Oil on canvas; 77⅜ × 33⅛ in. (196.5 × 84 cm); Purchased with funds from the Libbey Endowment, Gift of Edward Drummond Libbey, 1983.20

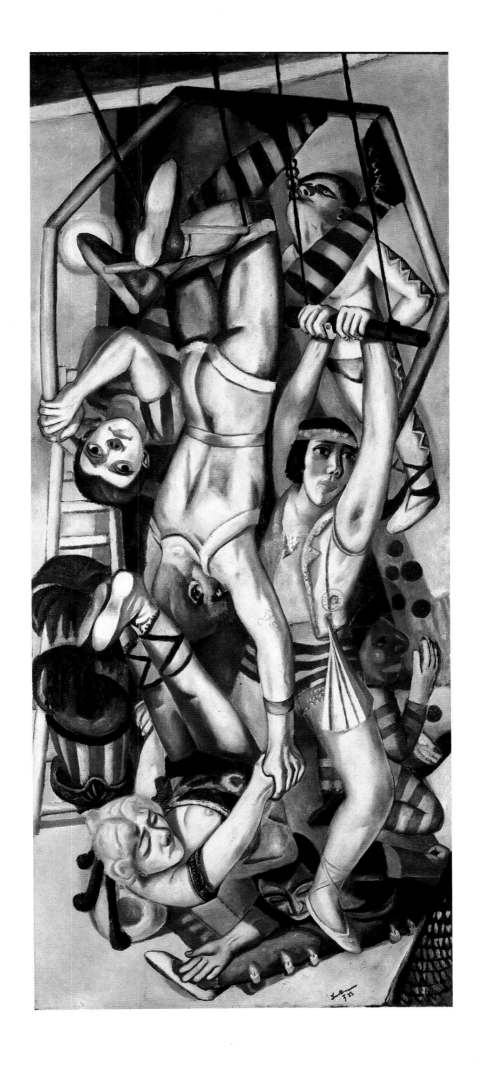

Henri Matisse, French, 1865–1954

Apollo, 1953

A CONVALESCING HENRI MATISSE turned during the final decade of his life to paper cutouts as his chief means of expression. This medium, consisting of forms cut from paper brightly colored with gouache (opaque watercolor) pigments, allowed him easily to rearrange shapes in order to explore the interaction of colors, forms, and the spaces between them. The cutouts served as independent compositions or maquettes (studies) for a great variety of projects, including stage designs, tapestries, posters, liturgical vestments, stained glass, and ceramic-tile murals such as *Apollo*.

The paper cutout of 1953 for this mural is in the Moderna Museet, Stockholm. Matisse supervised each step in the translation of *Apollo* from paper to ceramic. The mural consists of ceramic tiles set into a background of ground marble and plaster that forms a brilliant white counterpoint to the colored shapes. The entire work is divided into sixteen unequal, interlocking sections to facilitate shipping and installation. The ceramist J. L. Artigas (1892–1980) made the colored tiles near Barcelona, Spain, using glaze equivalents for Matisse's gouache pigments. Matisse himself painted the face and his signature in black on glazed white tiles before firing.

Matisse believed art that provided visual comfort, calm, and pleasure could have a benevolent, restorative effect on the viewer. Although he did not necessarily assign specific meaning to his images, his title here, *Apollo,* referring to the Greek god of agriculture and of the sun, suggests a particular theme. One interpretation is that Apollo, perhaps the blissful face crowned by a radiant sun in the center of the mural, is providing a beneficial environment for a vineyard. The vertical blue forms within orange rectangles evoke pruned grapevines, while the three crinkly forms in high relief in the lower center may represent bunches of grapes. Another interpretation is based on the myth of Apollo and the nymph Daphne who, in desperate flight from the lovesick god, begged the aid of her father, the river god Peneus, and was transformed into a laurel tree. In the ceramic, this metamorphosis may be suggested by the leaf- and stemlike forms and by the curling tendrils that frame Apollo in the symbolic shape of a heart.

Despite the associations suggested by the title and imagery, the viewer's experience of *Apollo* is more sensuous and emotional than intellectual. The bright colors and lively forms convey energy and gaiety, while the framing blue columns and overall symmetry contribute to a sense of harmony and classical order. The mural epitomizes the joyous quality that marks the art of Matisse's last years.

Ceramic tile, ground marble, and plaster; 131½ × 167½ in. (334 × 425.4 cm); Purchased with funds from the Edward Drummond Libbey Endowment, Gift of Edward Drummond Libbey, 1983.40

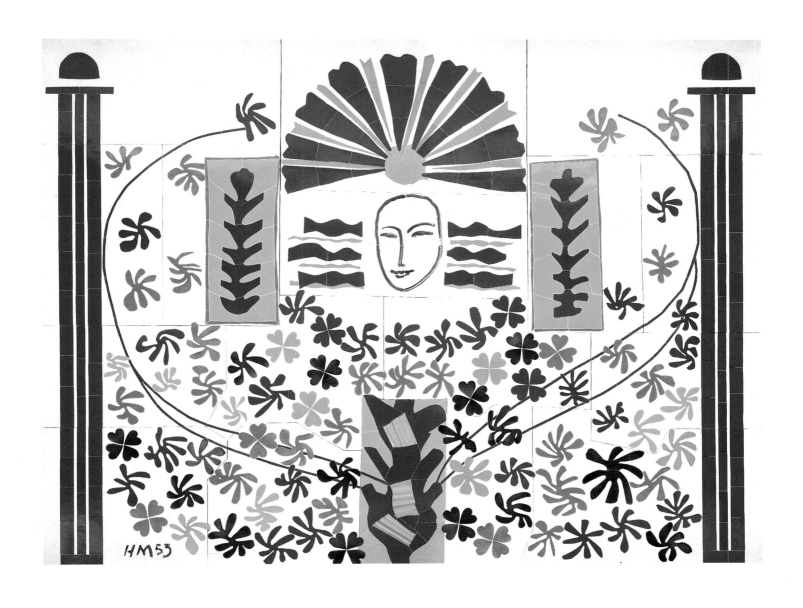

Louise Nevelson, American (born Russia), 1899–1988
Sky Presence I, 1960

OUTLANDISH AND SELF-RELIANT, Louise Nevelson could often be seen in the Lower East Side of New York City carrying pieces of wood that she collected on the streets to use in her abstract sculptural constructions. To create *Sky Presence I,* Nevelson assembled twenty-five shallow wooden boxes, each of which contains a variety of small, wooden fragments originally made for other purposes. The result is an abstract, wall-like relief meant to be seen frontally. Possessing an overall rhythm and pattern rather than one central focal point, the sculpture offers the viewer numerous visual explorations. Nevelson carefully considered the placement of every box and piece of wood in terms of its shape, direction, and juxtaposition. Curves echo one another and contrast with verticals and horizontals; rough and jagged edges balance smooth, flat pieces; and forms extend outward, casting shadows behind. Each compartment is distinct and independent, yet rhythmically in harmony with the others through the profusion of similar elements.

Nevelson further unified the sculpture by painting it black. For her, black represented mystery, night, and shadow. In addition to imparting an enigmatic quality, the color also permits an interesting play of light and shadow on the forms, especially when the work is lit (as Nevelson stipulated) with a blue light to suggest the sky at dusk. The black shadows blend together the individual forms and units, enhancing their mysterious quality. This unknown and suggestive element provokes the viewer to imagine and assign meaning to the sculpture. Although Nevelson's own thematic intention for the piece is unknown, it perhaps embodies her recurring themes of royalty, marriage, and death, metaphorically conveyed through these ordinary objects.

Nevelson's work emerged from the Cubist tradition of fracturing the representation of objects into geometric shapes, and from the playful Dada and Surrealist practice of bringing together unrelated objects to create surprising new images. The liberating potential for fantasy found in her work is likewise related to Surrealism. Nevelson eventually expanded her constructions both vertically and horizontally until she began to arrange them into thematically titled environments consisting of walls, columns, and hanging relief plaques. After a brief time in the mid-1960s when she turned to other media, she resumed constructing the wood ensembles for which she is best known.

Wood and paint; 116⅜ × 244¼ × 8¼ in. (295.5 × 620.4 × 21 cm); Purchased with funds from the Libbey Endowment, Gift of Edward Drummond Libbey, 1986.22a–y

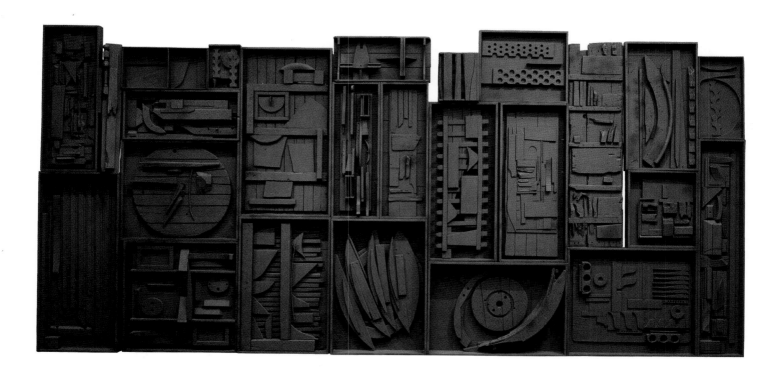

Richard Estes, American, born 1936
Helene's Florist, 1971

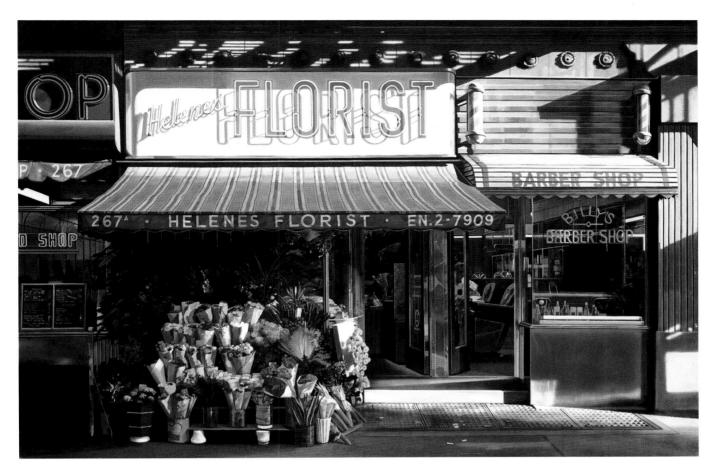

RICHARD ESTES'S seemingly objective, exacting depictions of existing urban scenes are in fact carefully edited interpretations of these views. Estes is a leading member of a group of artists called Photorealists, who base their realistic imagery on sharply focused photographs. However, unlike those who project a photograph directly onto the canvas and then trace the image, Estes works without any mechanical assistance. He begins a painting with an acrylic underdrawing, then switches to oil paint to attain more depth, subtle color, and tonal gradation.

Helene's Florist Shop was located at 267A Columbus Avenue at 72nd Street in New York City. Unlike many of Estes's other paintings, *Helene's Florist* is based on only one photograph of the site. Nevertheless, to achieve such a well-balanced, orderly composition, Estes probably made his customary adjustments and modifications to the photograph. Thus, instead of an authentic representation of a single moment in time, *Helene's Florist* appears to be a portrait of a storefront, made almost timeless by its central, frontal placement and crisp delineation. Although the doors to the florist and adjacent barbershop are invitingly open, no people are visible within or nearby. Estes frequently eliminated figures to avoid any narrative implications. He has stated: "When you add figures then people start relating to the figures and it's an emotional relationship. The painting becomes too literal, whereas without the figure it's more purely a visual experience."

As *Helene's Florist* indicates, Estes's pictures are primarily celebrations of the visual complexity of today's urban environment. Much as it may resemble a photograph, the painting has qualities not found in photography. No camera can achieve the simultaneous depth of field necessary to give such complete clarity at close and far range. This clarity presents objects in the interior and exterior with equal emphasis, thereby creating an equal relationship between the inside and outside views and providing illusionistic complexities within a setting already filled with numerous visual attractions. By giving all parts equal importance, Estes allows the viewer to shift his focus of attention across the picture. As the eye scans, the painting's vanishing point moves as well. The resulting impression is of an unusually bright place where the litter itself seems pristine and carefully placed. Even the artist's signature is neatly handled, cleverly concealed in the lettering on the adjoining restaurant's menu.

Oil on canvas; 48 × 72 in. (121.9 × 182.8 cm); Purchased with funds from the Libbey Endowment, Gift of Edward Drummond Libbey, 1976.34

Klaus Moje, German, born 1936
Untitled (Bowl or Lifesaver), 1979

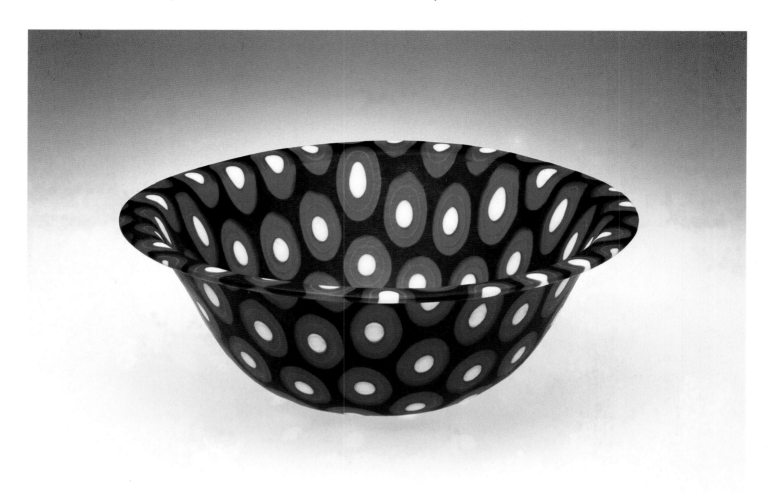

KLAUS MOJE'S *Bowl or Lifesaver* is more than a twentieth-century response to ancient Greek and Roman techniques of making mosaic glass vessels. Using modern technology, the artist has updated the process of making mosaic glass to create bold, abstract compositions in vessel forms that frequently make reference to either contemporary popular culture or, more recently, reflect his response to life in Australia, where he now lives and works.

Intrigued in the late 1960s by the colored bars produced by a German glass factory, Moje, who was then living in Hamburg, began to explore the production of mosaic glass, studying the changes in its production from ancient times to the present. By 1979, when this bowl was created, he had already developed his own method for creating this type of glass. Finding it most satisfactory to lay out the entire composition before the firing took place, he resorted entirely to cold-working methods.

To make this bowl, Moje first sliced prefabricated, multicolored rods of red, black, and white glass with a diamond saw into circular sections and then arranged them in a pattern on a kiln shelf. The design was then fired twice at closely controlled temperatures. The first firing fused the rods into a flat disk; the second caused the disk to slump into a plaster mold to form the bowl. These firings also caused the black circular canes to fuse, causing each of the red and white circles to appear as though they were floating on a hexagonal-shaped, black background. The rim and interior surface were then ground, producing a matte finish that contrasts strongly with the glossy exterior.

The effect of the large, red, playful circular forms with white centers against the black background makes this work appear to be a lighthearted composition, especially since the circular patterns are reminiscent of brightly colored, center-holed Lifesaver candies. However, this bowl, one of two such designs, represents one of Moje's most successful endeavors in exploring geometric abstraction. Its glossy and matte finishes confirm Moje's expertise in using the vessel as a dynamic, three-dimensional form.

Glass; H 3⅞ in. (9.8 cm), DIA 10⅟₁₆ in. (25.6 cm); Gift of Dorothy and George Saxe, 1993.6

© 1979 KLAUS MOJE

Dale Chihuly, American, born 1941
Pheasant Macchia Set, 1984

DALE CHIHULY'S YEAR-LONG STAY in Venice in 1968 working at the Venini factory in Murano revolutionized glass blowing in America. Enthralled with the Venetian tradition of teamwork in glass blowing, Chihuly responded by adopting the idea upon his return to the United States. The involvement of several artists working together to create complex compositions broadened the concept of studio glass making in America. Chihuly's Venetian experience also introduced the artist to the practice of blowing molten glass in open molds with patterned interiors, known as optic molds. His adoption of this process paved the way for his well-known *Sea Forms* and *Pheasant Macchia* series.

Chihuly's *Pheasant Macchia* are a subset of his larger *Macchia* series, which has continued to evolve since 1981. Most of the *Macchia* are blown, asymmetrical forms with different-colored interiors and exteriors and with bold, contrasting lip wraps. Splotches of bright color caused by rolling chips of colored glass into the outside walls of the hot blown vessels are the series's trademark. These bursts of color give the body of work its title, *"macchia"* (Italian for "stain" or "spot").

The *Pheasant Macchia* sets deviate from this formula. Rather than displaying splotches of bright color on the exterior walls, they manifest a feathery effect resembling pheasant plumage. In the set illustrated here, the design is almost realistic. By carefully rolling the partially inflated hot glass in chips of amber and silver glass and then blowing out the vessel using an optic mold, Chihuly and his team of glass blowers have replicated the layered effect of plumage. On some of the set's vessels, the glass appears iridescent, reminiscent of the impact of natural light shining directly on a bird's feathers. In addition, the rich pinkish hue of the interior of the vessels is prevalent only in the *Pheasant Macchia* series.

Thematically, this work continues Chihuly's concern with the natural phenomena of the Pacific Northwest, where he lives. Since the late 1960s he has regularly made reference in his work to native flowers, sea plants, and animals. Interestingly, Chihuly's mother was the first to make the connection between the effect of these vessels and a pheasant's plumage, thus providing the name for this small group of glass sculptures.

Glass with applied decoration; 20¾ × 17¼ × 6¾ in. (52.7 × 43.8 × 17.1 cm); Gift of the Apollo Society and the artist, 1991.19a–d

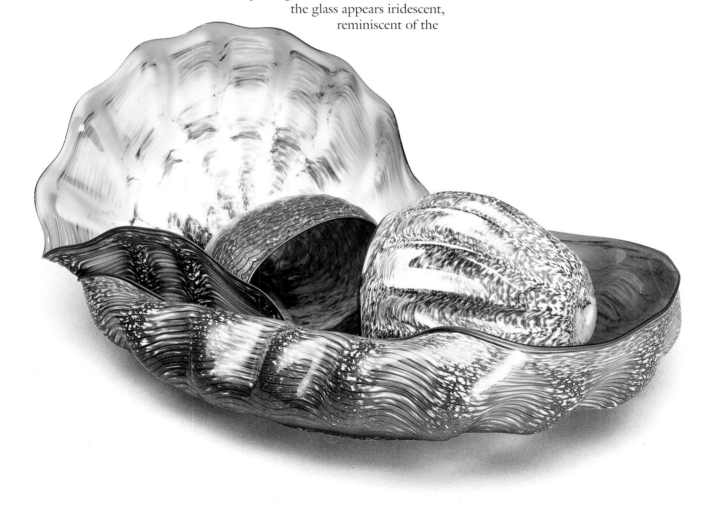

Mark di Suvero, American, born 1933
Blubber, 1979–80

MARK DI SUVERO'S SCULPTURES encourage touch and participation because they include elements that can be moved, altered, or manipulated, thus involving the viewer intellectually, physically, and emotionally with the work. *Blubber* consists of nine painted steel I-beams bolted together to form intersecting triangles and projections. A large tractor tire, split and suspended by braided steel cables from one of the horizontal I-beams, acts as a swing. Although di Suvero was not the first artist to introduce movement into sculpture, he was the first to stress human interaction over that of natural elements such as the wind. In addition to being an artwork, *Blubber* also serves as a "playground structure" that people can walk through, climb, swing on, and ride.

Di Suvero transformed standard construction I-beams from their industrial function into art material. The compo-nents themselves determined the sculp-ture's geometric configuration. As the viewer moves through *Blubber,* its net-work of triangles, diagonals, and paral-lelograms changes, revealing myriad relationships within itself and with the exterior world. A dynamic of mutual support—each element depending on a counterthrust and -weight for its bal-ance—prevails. This balance of forces becomes a metaphor for an intense concentration of energy that neither overwhelms nor threatens the viewer/ participant. Crediting his understand-ing of such structural balances to his years working in a California shipyard, di Suvero constructed *Blubber* intu-itively by trial and error with the help of a crane and assistants. Using the crane as a painter wields a brush, the artist remained physically involved in the sculpture's creation by controlling the crane as it swung the beams in place and then climbing the sculpture to secure each beam. Di Suvero's spon-taneous approach to creating *Blubber* and its open, multidirectional composi-tion correspond to the immediacy of the Abstract Expressionists' allover, ges-tural paintings. Despite its heroic size and massiveness, di Suvero has play-fully entitled the work *Blubber,* which may be a pun on the split and everted rubber tire. This element of humor, combined with its open, expansive, and inviting nature, humanizes the sculpture, which otherwise might seem cold and detached because of its indus-trial materials.

Over the years di Suvero has varied his materials as well as the scale, num-ber of elements, and settings of his works, thereby providing different kinds of visual experiences, structural complexity, and emotional and kinetic responses. Yet, throughout, mobility and participation have remained central to his work.

Steel and rubber; 35 × 25 × 60 ft. (10.7 × 7.6 × 18.3 m); Purchased with funds from the Libbey Endowment, Gift of Edward Drummond Libbey, 1984.76

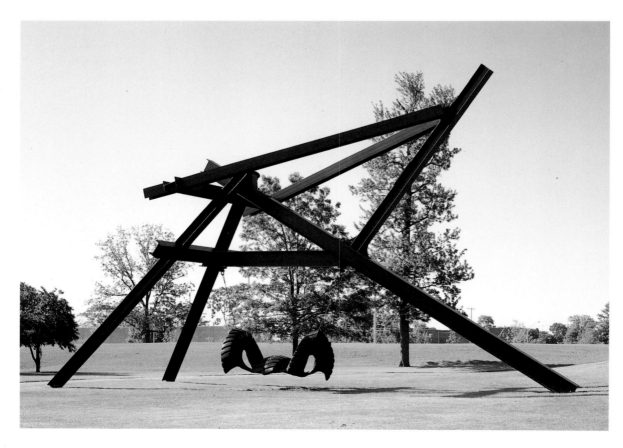

Anselm Kiefer, German, born 1945
Athanor, 1983–84

EVIL REDEEMED and humanity's cruelty purified are the themes of this powerful image based on the outdoor courtyard of Adolf Hitler's Chancellery in Berlin, designed by Albert Speer. Much of Anselm Kiefer's art explores German history and nationalism, themes that are to him moving and morally relevant. These themes are often obscure, drawn from ancient myths and religions, Wagnerian opera, biblical history, and the history of the Third Reich. This painting belongs to a series inspired by Nazi architecture. The seemingly straightforward subject is laden with references to horrible events that occurred during World War II.

Kiefer inscribed this painting's arcane title on the canvas twice: on the lintel above the center columns and at the upper left edge of the sky. The word, "athanor," means a self-feeding furnace, and is said to have been used by medieval alchemists to transform common substances into nobler material, such as base metals into gold. Although the goal of the alchemist was physical, the alchemical process was sometimes used in the Middle Ages to describe the spiritual quest by which the soul seeks perfection in heaven and becomes one with God. Conversely, because the process mysteriously hastened physical change, alchemy was sometimes condemned as unnatural and contrary to God's will, therefore evil. Here, the partly obliterated word over the doors at the end of the courtyard alludes to the doors of the ovens where millions were incinerated at Hitler's order. The black grid lines on the paving, which point to the rear of the courtyard, suggest the railroads that transported victims to their deaths. As if utilizing the alchemical approach, Hitler and other Nazis pathologically believed that they were "purifying" society by destroying Jews and other minorities they considered undesirable.

Kiefer scorched sections of this painting with a torch. The burnt sky suggests that the evil of Nazism has eternally stained even the heavens. The singed canvas also symbolizes redemptive suffering and purification through fire. Kiefer believes that artists, like alchemists, have the power to transmute events. As agents of change they may be destructive forces, echoing the notion that alchemists have links to the devil. But Kiefer's dominant belief is that art, like alchemy, can transform dross into gold, evil into good. This painting epitomizes his intense faith that in acknowledging the tragedies of history, learning from them, and transforming images associated with them into symbols of hope, humanity can achieve a better future.

Oil, acrylic, emulsion, shellac, and straw on photograph, mounted on canvas; 88½ × 149⅝ in. (225 × 380 cm); Purchased with funds from the Libbey Endowment, Gift of Edward Drummond Libbey, 1994.22

Jasper Johns, American, born 1930
Foirades/Fizzles, 1976

IN 1973 JASPER JOHNS and Samuel Beckett (1906–1989) met in Paris to discuss the possibility of collaborating on a book project. The result of their discussions and three years of effort is *Foirades/Fizzles,* published by Petersburg Press and considered one of the finest examples of twentieth-century *"livres d'artiste."* The French and English title is enigmatic, but intentionally suggestive of digestive gas and bubbles. "Foirades" comes from the French adjective meaning scared or jittery, and refers to the state of being so terrified that the body loses control. "Fizzles" may mean a hissing or sputtering sound, or an attempt that fails or ends feebly after a promising start.

Beckett provided five selections of his prose written between 1960 and 1974, ranging from the somber and despairing to the comic. His texts are printed in both French and English (the English is his own translation). Johns contributed original etchings derived from his 1972 painting *Untitled* (now in the Museum Ludwig, Cologne), a four-panel painting of crosshatching, flagstone patterns, and details of human anatomy. The double-page spread illustrated here includes the printed variations of all four panels of the painting. In addition, Johns developed full-page etchings based on the themes and patterns of *Untitled* to accompany other portions of Beckett's texts.

Using work produced independently, Johns, who was primarily responsible for the project, combined the material to produce a book that is at once intimate, powerful, and evocative. His images are visual counterparts to Beckett's stories of closed places, passages, and darkness. They do not illustrate the text, but match the author's verbal fragments with visual fragments rich with suggestions of confinement and contradiction. Johns alludes to the content of the stories through images that evoke burial and entrapment, that refer to past and future time. Ironically, the beauty of the book both draws the reader into the content and contradicts it. Beckett's stories are dark, winding dramas with no particular beginning or end, but engaging emotional tales. Johns's prints are similarly abstract patterns of experience, visual counterparts to the literary experience.

33 mixed intaglio prints (etching, aquatint, soft-ground, lift-ground, photo-etching) and one lithograph; 12 ¹⁵⁄₁₆ × 9 ¹³⁄₁₆ in. (33 × 25 cm); Mrs. George W. Stevens Book Fund, 1978.12

Chuck Close, American, born 1940
Alex, 1987

INSPIRING FIRST AWE and then intimate scrutiny, Chuck Close's large-scale portraits draw attention to process as well as image. Working from photographs taken under his direction, Close imposes a grid—which is left visible—to enlarge and transfer the image onto canvas. From a distance the thousands of tiny painted squares optically blend into an illusionistic portrait, but separate into abstract markings at close range. This dissolution of form is evident to Close; while painting he is not "conscious of making a nose or an eye but only of distributing pigment on a flat surface." Close not only uses photographs as the basis of his work, he replicates the camera's facsimile of reality, maintaining the distortions caused by the camera's limited depth of field. Here, the areas surrounding Alex's eyes are most in focus, while his ears, the tip of his nose, and the top of his hair appear fuzzy.

The reliance on photographs, the direct pose, and the larger-than-life proportions relate Close's art to the sharply focused, emotionally distant images of the Photorealists. His loose, built-up application of paint, however, is related more to Roy Lichtenstein's Pop images whose Benday dots allude to the mechanical process of a printing press. Close originally worked in black and white, but moved to color paintings achieved by sequentially overlapping the three primary hues (red, yellow, blue) in a manner similar to the photomechanical process by which color reproductions are printed. In *Alex,* he abandoned the rigidity of the three-color printing process but retained its principle.

Alex exemplifies Close's favored composition: the sitter is posed frontally and symmetrically, shown from the neck and shoulders up; the scale is

monumental. Close chooses not to paint commissioned portraits, preferring friends and relatives as subjects. Here the sitter is his friend the artist Alex Katz. By adhering to an inflexible presentation as well as a systematic technique, Close stresses the similarities between his subjects before he explores their differences. However, the subjects do differ in mood and visual interest. For example, Alex Katz's unique features project an intense, almost aggressive, personality. However, since Close stresses factual, visual information and

process, the painting's emotional power is more a by-product of the technique, scale, and iconic frontality of the image than any psychological interpretation.

Oil on canvas; 100¼ × 84 in. (254.6 × 213 cm); Gift of the Apollo Society, 1987.218

© 1987 C. CLOSE

Jennifer Bartlett, American, born 1941
Fence, 1987

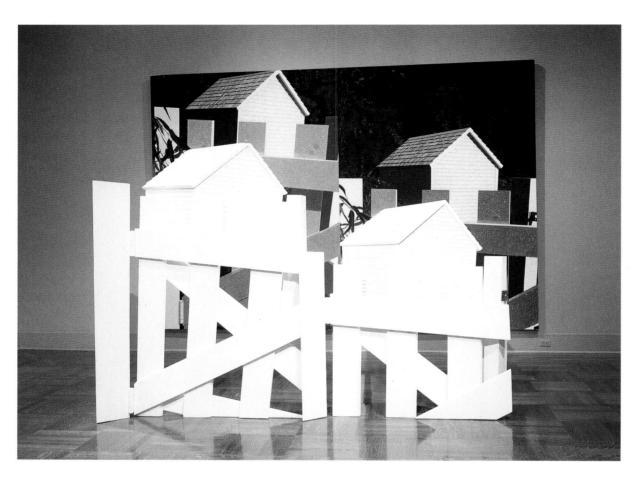

FENCE DEFIES our attempts to place it in a traditional category of art. An "installation" work, it consists of a large, bisected landscape painting in front of which stands a sculptural version of the painted image. The two sections of the painting depict the same subject—a white wooden fence in front of a white windowless building backed by shadowy trees—but from slightly different viewpoints. The sculpture re-creates the double image of the building and the fence seen in the painting. The installation seems fairly simple at first, but as the relationship of painting to sculpture is explored, the work becomes more complex and thought-provoking. As in other so-called Conceptual works of art, the emotional impact of *Fence* lies more in the questions it arouses than in its subject matter or artistic style.

The subtle shift in perspective suggested by the multiple views calls attention to how the eye focuses clearly only within a given range, readjusting itself with body, head, and eye movement. The juxtaposition of like images in different media allows the viewer to explore the progression of a motif from illusionistically depicted space into actual space. The two versions make it possible for the viewer to walk around the sculpture and up to the painting, to move in and out of the work itself, thus establishing a sense of place and presence. The sculpture and painting also allow the viewer to investigate the nature of illusion in art. The three-dimensional building and fence faithfully reproduce the foreshortened perspective used in the painting to create the illusion of depth. Thus, the sculptured houses are not three-dimensional versions of what real houses look like, but rather are three-dimensional versions of what the painted houses are like in their two-dimensional form on canvas. By exposing what was necessary to create the illusion of reality in the painting, *Fence* questions the viewer's perceptions and concept of reality. The issue is not simply what we are seeing, but how we are seeing it.

Bartlett has repeatedly used landscape images to explore issues of abstraction and reality. Her preferred motifs are houses, trees, gardens, and the ocean, which she depicts in multipart series, recasting the themes into new combinations, new media, different sequences or artistic styles.

Painting: oil on canvas; 118 × 168 in. (299.7 × 426.7 cm); sculpture: painted wood and steel; 84 × 119 × 36 in. (213.4 × 302.3 × 91.4 cm); installation floor space: 122 × 112 in. (309.9 × 284.5 cm); Purchased with funds from the Libbey Endowment, Gift of Edward Drummond Libbey, 1988.41a–i

Howard Ben Tré, American, born 1949
Bench for Claude Monod 2, 1992

HOWARD BEN TRÉ'S SCULPTURES have no parallel in the history of glass or indeed in twentieth-century art. The preeminent sculptor of monumental cast-glass forms in America, Ben Tré was a student of Dale Chihuly in the late 1970s. Today Ben Tré divides his time between his studio in Rhode Island and a glass factory in New York. He is distinguished from many contemporary American glass artists by his use of both factory and studio equipment—relying on the former to cast the large-scale forms and the latter to hand-finish their surfaces. Instead of adding color, he takes advantage of the green cast produced by the iron content of the glass, thereby rejecting the inherent transparent, glossy quality of the material in favor of a more translucent aesthetic. Ben Tré then juxtaposes against the glass patinated metals and metallic oxides.

Ben Tré has concentrated on non-functional sculptures reminiscent of artifacts from past and present civilizations, and functional benches and tables. He is a leading participant in a recent movement in which sculptors and painters have joined architects, designers, and craftsmen in creating unique or limited-edition furniture forms.

The first studio glass commissioned by the Museum in more than twenty years, *Benches for Claude Monod 1* and *2* were designed specifically for the Museum's public spaces. Dedicated to the memory of Ben Tré's friend the French glass artist Claude Monod, who was killed in 1990 in a hunting accident, they recall early olive presses—an allusion to the artist's fond memory of his first visit to Monod's country home in France, which was well stocked with wines and olives. The forms also resemble millstones used for grinding grain—a reference to Toledo's midwestern location.

The two glass-and-brass arcs that comprise *Bench 2* can be used separately or joined together to form a large circular seat. Unlike Ben Tré's earlier furniture, hollowed-out sections define the seating areas, thus dictating the number of people who can sit comfortably on the bench at one time. But unlike his more recent work, metal plays a minor role in providing accent color and surface decoration. The brass along the base and edges of the seat simply emphasizes the bench's overall form and offers structural integrity. The primary decoration remains the glass's fissures, cracks, and bubbles produced during the casting and brought out by laborious surface finishing.

Glass and brass; each section 19 3/8 × 26 5/8 × 54 in. (49.2 × 26.6 × 137.2 cm); Purchased with funds from the Libbey Endowment, Gift of Edward Drummond Libbey, 1992.19a, b

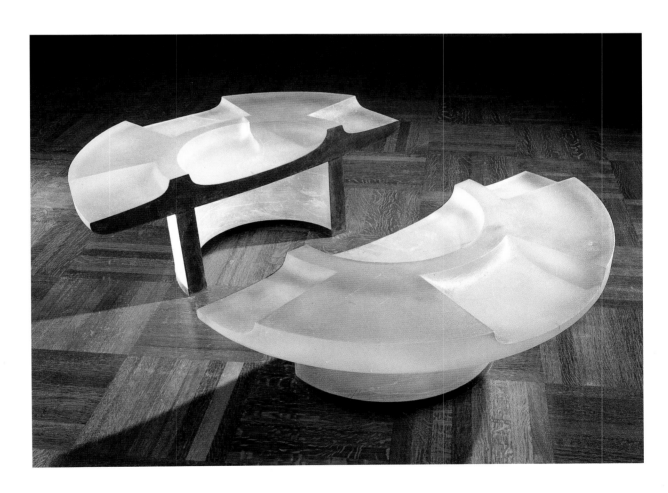

Sol LeWitt, American, born 1928
Wall Drawing #760, 1994

SOL LEWITT WAS COMMISSIONED by the Toledo Museum to transform the Lower Promenade entry to the Peristyle, the Museum's 1,710-seat theater. The curving corridor is also used as the connection between the Museum and the University of Toledo's Center for the Visual Arts. LeWitt's wall drawing glows with resonant color-shape relationships that surround the viewer walking from one end to the other. Its composition takes into account the number and placement of doors on the concave outer wall and the ends of the wall, producing a specific horizontal rhythm of rectangles. The convex inner wall was composed to correspond to the opposite side. Nine-inch black bands frame each irregular shape on a rectangular colored ground. These bands relate to the existing black marble baseboard and lift the center of the composition to offset the Promenade's relatively low ceiling. The entire wall drawing cannot be seen from one spot because of the curve of the corridor; walking through the space is the only way to view the whole composition.

Since the 1960s LeWitt has been recognized as one of the most original and influential artists identified with both the Minimal and Conceptual art movements. His work is based on the use of geometric shapes and forms that are neither abstracted from nor refer to images from nature. LeWitt has always relied on assistants to carry out his concepts. This stems from his belief that the artist's role is that of a generator of ideas rather than a craftsperson. To create this site-specific composition, LeWitt first studied the site and then referred to architectural elevation drawings of the space. The extended title follows the format devised by him to include a unique identifying number, a general description of the composition, and credit in alphabetical order to the people who actually execute the work by following his diagram and specific color directions.

In preparation for this drawing, the walls were primed with white paint. The composition was drawn directly onto the walls in pencil and then rendered in colored artists' inks. The subtle, modulated colors were created not by premixing the inks but rather by superimposing layers of red, yellow, blue, and black ink in various combinations. The irregular polygons in this drawing derive, perhaps indirectly, from works LeWitt has created since the 1960s, a progression from drawings of straight lines in four directions and from his sculpture and drawings of squares based on the isometric cube.

"The wall is bordered and divided vertically by 9-in. (23 cm) black bands. Between each band, an irregular figure with color ink washes superimposed. Color ink wash drawn by Sachiko Cho, James Easter, Edward Hill, John Hosford, V. Lynn Liming, Matthew Martin, Erin Palmer, and Rebecca Weger. July 1994." Colored artists' ink; H 9 ft. 9 in. (2.9 m); outer (concave) wall W 258 ft. (78.6 m); inner (convex) wall 219 ft. 6 in. (66.9 m); each end wall W 12 ft. 6 in. (3.8 m); Purchased with funds from the Florence Scott Libbey Bequest in Memory of her Father, Maurice A. Scott, 1994.41

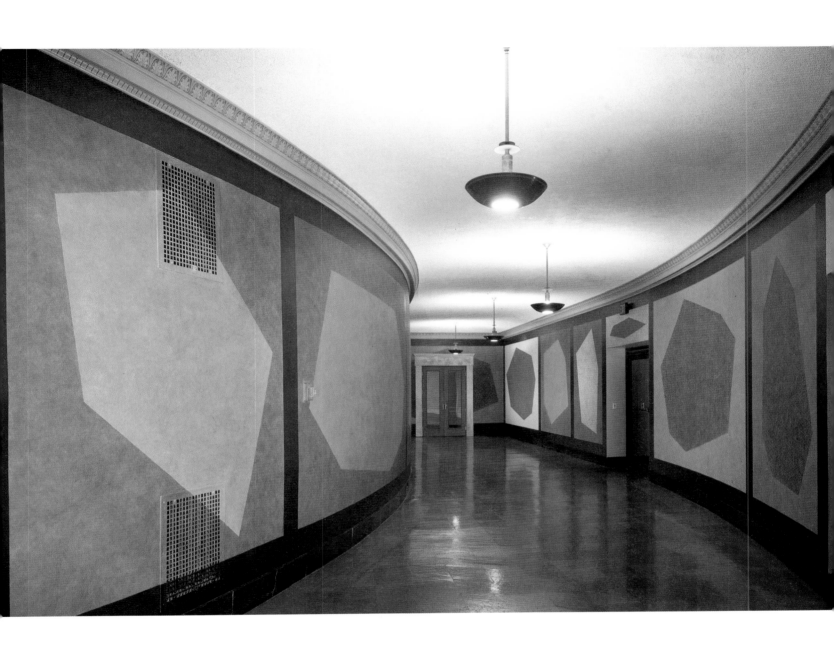

Wendell Castle, American, born 1932
Steinway Concert Grand Piano and Bench, 1994

OF THE FIVE PIANOS that the artist Wendell Castle has created since 1987, this Steinway concert grand commissioned by the Toledo Museum represents Castle's strongest challenge to traditional piano design. Consisting of a very light-colored, curly maple–veneered case that rests on two dark-colored, cocobolo-covered, semi-circular, laminated supports, Castle's composition denies the massiveness customarily associated with grand-piano design.

Castle is one of a few artists in America today who is actively involved in piano design. In the 1960s the artist made his reputation by creating furniture that questioned traditional concepts of function, design, and construction. By using wood to create highly sculptural, imaginative works that deal with larger artistic issues, he has played a prominent role in the development of hand-crafted furniture as a major art form, becoming one of the leading figures in the contemporary crafts movement.

Following his commission in 1987 by the noted piano manufacturer Steinway & Sons to create the commemorative 500,000th Steinway piano, Castle expanded his repertoire to include designs for all types of pianos. Because this piano was designed to be used regularly for performances at the Toledo Museum, Castle had to avoid alterations that might affect its exceptional tonal quality. One of the most obvious changes he made is in the piano legs. Fascinated throughout his career with the design of furniture legs, Castle decided to create for the piano two arclike supports that echo the classicizing architecture of the Peristyle, the Museum's 1,710-seat proscenium theater, where the piano is housed. By placing these "legs" at each end of the piano to cradle the case, Castle was able to minimize the bulk of the top half of the instrument. The color contrast of the light curly maple case on top of the dark cocobolo-veneered supports causes the case to appear to float in space, free from the influence of gravity.

Piano: maple, mahogany; cocobolo veneer, curly maple veneer; brass; 40⅝ × 75¼ × 111¼ in. (closed) (103.2 × 191.1 × 282.6 cm); bench: maple; cocobolo veneer; leather; 18½ × 33½ × 17 in. (47 × 85.1 × 43.2 cm); Purchased with funds from the Florence Scott Libbey Bequest in Memory of her Father, Maurice A. Scott, 1994.7a, b

Authors and Contributors

AUTHORS

(The names of authors are followed by the page numbers for the texts they wrote. Collaboration and multiple authorship are recognized by the duplication of page numbers.)

Roger M. Berkowitz, Deputy Director and Curator of Decorative Arts: pp. 70, 82–83, 95, 98, 100, 107, 108, 110, 112, 124, 126–27, 146

Marc S. Gerstein, Professor, Department of Art, The University of Toledo: pp. 115, 123, 132–33, 134–35, 140–41, 142–43, 144–45, 147, 149, 162, 163

Elaine D. Gustafson, Research Curator: pp. 36, 52, 53, 54–55, 60, 61, 80–81, 82–83, 95, 107, 108, 112, 118, 120–21, 124, 128, 130, 136, 137, 138, 139, 150, 151, 152, 153, 154, 155, 156, 157, 158, 160, 161, 164, 165, 166–67, 168–69, 170–71, 172–73, 174, 175, 178, 181, 182

William Hutton, Senior Curator: pp. 56–57, 58, 59, 63, 64, 66–67, 74–75, 76–77, 78, 79, 86–87, 92, 93, 97, 101, 103, 104, 106, 114

Sandra E. Knudsen, Coordinator of Publications: pp. 37, 44, 45, 46–47, 48, 49, 50, 51, 113, 125, 129, 131

Kurt T. Luckner, Curator of Ancient Art and Curator of Special Exhibitions: pp. 33, 34, 35, 36, 38–39, 40, 41, 42, 43, 52, 53, 54–55, 60, 61, 62

Lawrence W. Nichols, Curator of European Painting and Sculpture before 1900: pp. 68–69, 71, 72–73, 84, 85, 89, 90–91, 94, 102, 117

Robert F. Phillips, Chairman of Curatorial Department and Curator of 20th-Century Art: pp. 153, 154, 155, 156, 157, 164, 165, 166–67, 168–69, 170–71, 172–73, 174, 175, 178, 179, 180, 181, 182, 184–85

David W. Steadman, Director: pp. 88, 96, 99, 105, 109, 111, 159

Christine Swenson, Curator of Graphic Arts: pp. 65, 116, 122, 148, 180

Davira S. Taragin, Curator of 19th- and 20th-Century Glass: pp. 119, 130, 150, 160, 176, 177, 183, 186

CONTRIBUTORS

We are grateful to these individuals who generously assisted with individual entries:

Eleanor M. Alcorn, Assistant Curator, Department of European Decorative Arts and Sculpture, Museum of Fine Arts, Boston

Esin Atil, Head, Special Programs, Freer Gallery of Art, Washington, D.C.

Howard Ben Tré

Wendell Castle

Dale Chihuly

Marvin Eisenberg

Karen Giles, Assistant Chair, Museum Education, Gallery Education, The Toledo Museum of Art

Catherine Hess, Associate Curator, Sculpture and Works of Art, The J. Paul Getty Museum

Katherine Howe, Curator of American Decorative Arts, Museum of Fine Arts, Houston

June Hargrove

Carol Mattusch, Professor, Department of Art History, George Mason University

Klaus Moje

Jean-Luc Olivié, Conservateur, Le Centre du verre, Musées des Arts décoratifs, Paris

Elsie H. Peck, Associate Curator, Near Eastern Art, The Detroit Institute of Arts

Carolyn Putney, Slide Curator, The Toledo Museum of Art

Richard H. Randall, Jr.

Antony E. Raubitschek, Professor Emeritus, Department of Classics, Stanford University

Barry Rosen

Ingrid D. Rowland, Professor, Department of Art History, The University of Chicago

Stef Stahl, Chairman of Museum Education, The Toledo Museum of Art

Index